BEETHOVEN

Eminent Lives, brief biographies by distinguished authors on canonical figures, joins a long tradition in this lively form, from Plutarch's *Lives* to Vasari's *Lives of the Painters,* Dr. Johnson's *Lives of the Poets* to Lytton Strachey's *Eminent Victorians*. Pairing great subjects with writers known for their strong sensibilities and sharp, lively points of view, the Eminent Lives are ideal introductions designed to appeal to the general reader, the student, and the scholar. "To preserve a becoming brevity which excludes everything that is redundant and nothing that is significant," wrote Strachey: "That, surely, is the first duty of the biographer."

ALSO BY EDMUND MORRIS

The Rise of Theodore Roosevelt
Dutch: A Memoir of Ronald Reagan
Theodore Rex

BEETHOVEN

The Universal Composer

Edmund Morris

EMINENT LIVES

 ATLAS
BOOKS

HarperCollins*Publishers*

HarperCollins books may be purchased for educational, business, or sales promotional use. For information, please write: Special Markets Department, HarperCollins Publishers, 10 East 53rd Street, New York, NY 10022.

FIRST EDITION

Designed by Elliott Beard

Printed on acid-free paper

Library of Congress Cataloging-in-Publication Data is available upon request.

ISBN-10: 0-06-075974-7
ISBN-13: 978-0-06-075974-2

05 06 07 08 09 ❖/RRD 10 9 8 7 6 5 4 3

To Judy

Contents

This biography is a story of the life, not a survey of the work. It is intended for general readers, who may love Beethoven's music but do not necessarily have a knowledge of musical theory. Such readers should rest assured that Beethoven never felt that he was composing for other musicians, but for the human community he embraced as "Freunde" *[friends] in the last movement of his Ninth Symphony.*

However, the greatness of Beethoven's music cannot be fully expressed without some analysis and reference to technical matters. Wherever possible, this has been done in plain language. Readers seeking further clarification should consult the Glossary of Musical Terms on page 231.

Monetary values are expressed for the most part in silver florins, the basic currency of Beethoven's lifetime. Although this coin depreciated during the Napoleonic Wars and for several years was replaced with paper, it can be assumed to bear a steady relationship to the ducat (at five florins) and British pound (at ten florins).

Translations that differ from those in the standard works cited in the Bibliographical Note are by the author.

Overleaf: Beethoven in 1812. Life mask by Franz Klein.
Beethovenhaus, Bonn.

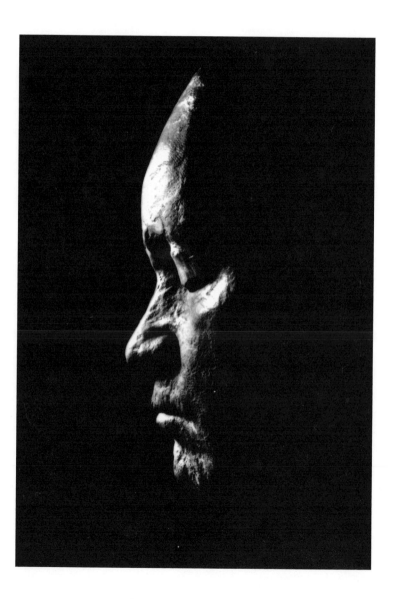

Prologue

F OR FORTY HOURS the snow tumbled over New England, settling up to six feet deep on every city, forest, and frozen river. At the blizzard's height, on Tuesday, February 7, 1978, President Carter declared coastal Massachusetts a federal disaster area. After a second record night of snow, the governor ordered all citizens not engaged in relief work to stay home. Interstate 93 ran white as a glacier, its ramps curving into the moraine of downtown Boston.

Just when the world seemed about to suffocate, the last flakes fell. But then the snow turned to ice, and the weight of precipitation became unbearable. Power grids snapped, hospitals switched to emergency supplies, stores and restaurants stayed dark. Biographical researchers trapped in digs near Harvard University found themselves with nothing to eat and nowhere to buy food. Another night of almost total silence came on. It was difficult not to think of entombment.

Thursday morning brought sunshine and a sense of life returning. Icicles sliced the light. The first shovelers got to work in front of dorm doorways. Students on skis poled across Harvard Yard.

Pedestrians struggled to follow, plunging waist-deep at every step. There was still little noise: only the dry squeak of snow underfoot, and an occasional shout. Then some invisible person threw open a second-floor window, mounted a pair of speakers on the sill, and blasted the finale of Beethoven's Fifth Symphony into the crisp air.

Nothing was ever so loud, so bright as that C-major fanfare, surging over a blare of trombones with all the force of Old Faithful. It was Carlos Kleiber's DGG recording with the Vienna Philharmonic—new then, legendary now. Skiers, shovelers, and plungers stood transfixed. After three great leaps (the last requiring an extra beat to discharge all its sound), the chords subsided, only to gather strength for higher and higher ascents, to the crest of the scale and beyond, until, geyser-like, they broke into exultant syncopations.

So far, nobody had heard a melody, or any harmonies that could not be blown through a mouth organ. And when a tune finally came, played at maximum volume by three horns, it was close to banal. So why, after the music ended ten minutes later, with forty-eight thunderclaps of C major, were some of the listeners crying?

Of all the great composers, Beethoven is the most enduring in his appeal to dilettantes and intellectuals alike. Bach and Mozart have had their periods of misapprehension—the former mocked as passé even in his own lifetime, the latter miniaturized by the Victorians. Handel, in contrast, was giantified, but as the composer of *Messiah* mainly, at cost to his operatic achievement. Haydn—Beethoven's teacher—is admired more by connoisseurs than by the general public. Schubert was still being caricatured as an idiot-savant songster long after World War II. Brahms has never gone down well in France; Bruckner is a minority taste outside the German-speaking world; and Sibelius, who once seemed sure of a seat on Parnassus,

has been replaced by the masturbatory Mahler. *Chacun âge à son goût.*

Beethoven was recognized in his teens as a genius of the first order. He was less of a prodigy than Mozart or Mendelssohn, but surpassed them in the bigness of his aspirations. From the moment he arrived in Vienna at the age of twenty-one, that city—capital of the musical world—celebrated him. Princes vied for the honor of putting him up in their palaces. (Mozart, just a few years earlier, had to dine "below the valets but above the cooks.") After Haydn died in 1809, Beethoven, not yet forty, became the world's most famous composer. He remains that almost two centuries later. Climb the mildewed stairway of the most obscure building he ever lived in, and you can be fairly sure of bumping into a Welsh choral society, or a party of reverent Japanese.

What draws them is Beethoven's universality, his ability to embrace the whole range of human emotion, from dread of death to love of life—and to the metaphysics beyond—reconciling all doubts and conflicts in a catharsis of sound. That anonymous broadcaster of the finale of the Fifth Symphony across Harvard Yard after the blizzard of '78 knew just where to drop his needle: the point at which the transition from the C-minor scherzo resolves fortissimo into C major. He also understood (even if his listeners did not) the symbolism of that transition, the most claustrophobic passage in all music. It begins with a sudden hush, as if a great weight has blocked out light and air. For a moment, all is frozen shock, the strings holding an indeterminate chord, and then an almost inaudible beating of drums is heard. Stifled moans sound in the violins: terrified, fragmentary phrases that try to rise without success. The drumbeats, hesitant at first, become a constant throb, as if hysteria is building, while the moans try again to rise. With agonizing difficulty, they begin to suc-

ceed, and the weight overhead seems to lighten. Airy woodwinds amplify a gathering crescendo, joined by trumpets and horns—then all restraint is loosened, and the whole orchestra breaks free, and every hair stands up on your neck.

There are countless moments *such* as this in Beethoven, but not one *like* this: his originality prevents him repeating himself. (At the same time, there is a signature quality, unmistakable as the hand of Picasso.) Radical to begin with, Beethoven grew more radical with age; some of his late works reinvent themselves movement by movement. The string Quartet in B-flat, Op. 130, traverses more styles in fifty minutes than Wagner did in fifty years. And after finishing it with a stupendous fugue, Beethoven still had enough inspiration left over to write an alternative finale—his last published composition— that has the effect of transforming the whole work in retrospect. The other movements still float in order astern, but they look closer and more companionable, seen from a less lofty masthead.

That fugue, by the way, known and feared by chamber musicians as the *Grosse Fuge*, a breaker of strings and burner of fingertips, was Igor Stravinsky's favorite quartet movement. There can be no better testimony to Beethoven's timelessness than the fact that Stravinsky, iconoclast supreme, measured his own modernism against something written in 1825, "this absolutely contemporary piece of music that will be contemporary forever. . . . I love it beyond any other."

Heard today for the first (or hundred and first) time, the *Grosse Fuge* still overwhelms with the sheer brutality of its sound. For more than a quarter of an hour, violins, viola, and cello squawk and scream like frenzied vultures. One can understand the rumors around *gemütlich* Vienna that Beethoven, famous for his eccentricity, had at last gone mad. Yet even as audiences recoiled from the fugue, they

had to account for the fact that it was paired with a slow cavatina, or singing movement, of indescribable beauty. If a confused brain produced the one, what all-comprehending heart poured out the other?

Contrast and conflict are essential characteristics of Beethoven's art. Throughout his life, he struggled against epic odds and prevailed with enormous courage. The odds were at various times social, sexual, psychotic, and political, but two especially tormented him: ill health and loneliness. His muscularity and ruddy complexion disguised the former, at least when he was young, and the latter was self-inflicted. He fled the palaces of his patrons, preferring to pay his own rent and compose in peace. Domestically helpless, he moved no fewer than eighty times, and lived in prosperous squalor, with history's most notorious pisspot under his grand piano. Yet he was never short of the acolytes and enablers ("Would you like to sleep with my wife?") that eminence attracts. None of them was privy to the full extent of Beethoven's bodily and mental sufferings. Two famous documents, written in secrecy and discovered only after his death, make this clear: the "Heiligenstadt Testament" of 1802 and the "Immortal Beloved" letter of 1812.

In the former, he revealed (or rather, filed away in a secret drawer) the most awful fact that a musician can face: that he was going deaf. He was thirty-one years old, and had long been tormented by buzzings and whistlings in his ears. At first, he hoped they might respond to medicine. When they did not, he had to live with them. By 1808, he could no longer hide his condition: anyone who heard him conduct or play the piano (desperately pounding the keys) could tell that Beethoven now lived in a sonic world of his own. Ten years later, people wanting to converse with him had to write

their remarks on paper. Beethoven's last, greatest works were conceived in what George Eliot calls "the roar which lies on the other side of silence."

His equally anguished love letter, addressed (but never mailed) to *die unsterbliche Geliebte*, "the Immortal Beloved," has lost none of its poignancy now that Maynard Solomon has revealed the identity of the woman involved. One senses Beethoven's acceptance that flesh was frail and music too insatiable a mistress for him ever to marry—even if the Beloved had been free to consummate their relationship.

In any case, the most frustrated of all his desires was for a boy. Psychobiographers have seized upon his struggle to win possession of his nephew, Karl, as proof that Beethoven was an incestuous homosexual. But Karl was his legal ward and none of the evidence in court proceedings surrounding the boy's custody suggests an erotic charge to the relationship. Demonstrably and pathetically, Beethoven wanted a son to bear his name and inherit his fortune. The story of that five-year litigation is an ugly one, and most of its ugliness derives from Beethoven's determination to win, no matter what pain it inflicted on the boy or on the boy's bewildered mother. Victorious at last, he sent Karl off to school, much as he dispatched a completed manuscript, and turned his furious energy on the *Missa Solemnis*.

Listening to that work today—to the seraphic "Benedictus," for example, with its violin solo floating like incense over the tenor melody—one is hard put to reconcile such tenderness with the fact that Beethoven was misanthropic and manipulative, greedy, quick to lie and cheat, so suspicious of other people's motives that he was prey to paranoid delusions. But then one has to take into contradictory account his often uproarious good humor and generosity, his Kantian ethics, his democratic pride, and the general conclusion among

all who knew him (and were hurt by him) that he was, beyond cliché, superhuman, with all the excesses that superhumanity implies: too much vigor, too much aggression, too much talent—and too little time to work them all off. In the event, he had to settle for fifty-six years.

It was a life of prodigious labor, considering his natural gifts. When Beethoven improvised at the piano, he suppurated with melody. He could go on for hours, reducing his listeners to tears, while he—never a sentimentalist—eyed them with amused contempt. "Artists are fiery; they do not weep." Yet he lacked Mozart's ability to transfer perfection straight to paper, as fast as the pen could fly. When forced to, he could compose quickly, but the results were often not good. "Great" music to him was a proper fusion of inspiration and industry—and industry implied the most logical improvement of every last structural detail. If he had to choose between the charm of a seductive tune and a figuration built out of integral coefficients, mathematical beauty won out every time.

Oddly enough, arithmetic confused him: he never learned how to multiply or divide, and had such difficulty with simple household sums as to suggest dyslexia. Here and there in his letters, "*14*" comes out as "*41*" and "*1808*" as "*1088*." Yet again—contradictions abound when discussing Beethoven—he was a rationalist who took delight in solving almost impossible problems of counterpoint. The fugue that ends the *Hammerklavier* Sonata takes a gigantic subject of one hundred and five notes (not counting a free trill) and proceeds to augment it, invert it, and even play it backward, like a tape rewound—sometimes all three processes going at once: the musical equivalent of trigonometry. Such achievements put Beethoven in the same class as music's other ranking intellectuals: Bach, Brahms, and

Webern. And none of those three could also have written *Fidelio*.

He had, besides, a mastery of musical architecture that was as instinctual as it was innovative. Again, the possibility of dyslexia arises. Some orthographically challenged people have an almost cubist ability to visualize planes and dimensions from many different angles at once. Beethoven's sound structures are full of disproportionate rooms and inner voids, with surprise changes of level, and windows full of sky; but they always balance out as total buildings, no matter how large their size. Not for nothing was Beethoven the favorite composer of Frank Lloyd Wright and Louis Kahn.

The paradox of Beethoven's "bigness" is that it is not always measurable in time or decibels. He could, and did, compose symphonies and sonatas of unprecedented length. Yet he was also a miniaturist. Some of his piano bagatelles, known as "chips from the master's workshop," last little more than a minute. One is over in just nine seconds. Chips they may be, but hold them up to the light, and they glint with precious metal. Nor are they fragmentary in form. His spatial sense was microscopic as well as telescopic: with equal sureness, he built both cells and cathedrals of sound. The last bagatelle of Op. 119 is set in the same key as the Adagio of the Ninth Symphony, and it, too, is an endless flow of melody, rising to a serene height before resolving on the simplest of cadences. It spans just 22 measures to the symphony movement's 166. Yet for the short while it lasts, it seems, in Shelley's language, to "stain the white radiance of Eternity."

Whoever chose to color the no less radiant whiteness of Harvard Yard with that fanfare after the big blizzard knew—as did the planners of Winston Churchill's funeral or witnesses to the fall of the Berlin Wall—that there are moments when only Beethoven will do.

No other composer could have achieved so instant, and so communal, a reaction among young skiers probably unable to name a single other of his works, if indeed they could even name him. Something bigger than personal identity, bigger than weather, bigger than mere melody and harmony, awoke them to the promise of the morning and the strength of their bodies. The largest mind in musical history spoke to them in 1978, as it did when the boy Beethoven made his debut in Cologne, two hundred years before.

Chapter One

The Spirit of Mozart

T HE BRITISH PLAYWRIGHT Enid Bagnold once asked a feminist what advice she would give to a twenty-three-year-old housewife who, having lost four children, found herself pregnant again by an abusive, alcoholic husband.

"I would urge her to terminate the pregnancy," the feminist replied.

"Then," said Ms. Bagnold, "you would have aborted Beethoven."

She was not quite right in her facts. Only two of those dead infants preceded little Ludwig—one of them the child of a previous marriage—and there is no evidence of Johann van Beethoven ever laying violent hands on his wife. But he was certainly a cruel father, and his alcoholism is a matter of court record in Bonn. So is his chronic lack of money, even though Johann was both a salaried singer on the staff of the Elector of Cologne and the son and heir of Kapellmeister Ludwig van Beethoven, a prosperous, retired master of music whose six-room apartment in the Rheingasse sparkled with silver and fine crystal.

Maria Magdalena van Beethoven gave birth to two more sons

who survived: Caspar Carl and Nikolaus Johann. She then produced another son and two daughters, all of whom soon died. Her final confinement left her depressed and frail, doomed to expire herself, at forty, of consumption. Slender, earnest-eyed, moralistic, genteel, she floats like a faded watercolor sketch in the van Beethoven family scrapbook, amid more robust images of men of high color and stocky build. If they look more Dutch than *Deutsche*, these bourgeois Beethovens, if they signed themselves *van* rather than *von*, suggestive of noble ancestry in the Low Countries (outside the Flemish medieval village of Betouwe), they were, by the mid-eighteenth century, established around Bonn, administrative capital of the Cologne electorate—German in culture, Roman Catholic in religion, Rhinelanders in their fondness for the grape.

Ludwig was born in town, at 515 Bonngasse, on or about December 16, 1770. The date is not definite. However, Catholic parishes of the period required neonate babies to be brought to the font within twenty-four hours, and on December 17 his baptism was registered at the church of St. Remigius. The entry, written in Latin, identifies him as "Ludovicus"—a solemnization of his name that he came to like in later life, after learning about the grandeur that was Rome. Nor, in view of *la gloire de la France*, did he ever mind being called "Louis."

He also took pleasure in the fact that old Ludwig sponsored his baptism. This made him the godson as well as the grandson of Bonn's most eminent musician. The same dark eyes that looked down on him in the font were to watch again, oil-painted but still lively, when he lay on his deathbed.

Kapellmeister van Beethoven was everything Johann was not: popular, successful, secure at court (he had served the Elector for

forty-two years), a conductor of operas and masses, a shrewd businessman. He even sang better than his son, preserving a magnificent bass voice into old age. Oddly, for a man in his position, he was not a composer. He died on Christmas Eve 1773, just in time to imprint himself on young Ludwig's dawning memory. Near and far, the old man would always float in an ambiguous sfumato, his expression kind, his turban cap pushed back. Was the vision primary or just a rearward projection of that oil painting?

The question is pertinent, and not just because Beethoven insisted that his memories of old Ludwig were "vivid." He also bizarrely believed that he had been born two years later than the register stated. Even when presented with an official transcript of the entry, courtesy of the mayor of Bonn, he rejected its "1770" and scrawled on the back, "1772." Friends were unable to shake his fixation. He told them, "There was a brother *born before me*, who was also named Ludwig . . . but who died."

In this, he was not altogether deluded. His parents had indeed baptized, and buried, a son by that name—in April 1769. Transferring the name of a dead child to the next born was common practice in Germany. Dates were never Beethoven's strong point, and his father further confused him, by lopping a year off his correct age when advertising him as a child prodigy. Still, a moment's reflection should have made the mature composer realize that being born in "1772" and having "vivid" memories of a grandfather who died one year later made no cognitive sense.

His indulgence of this paradox has been catnip to Freudians. They surmise that Beethoven did not *want* to look at any certificate legitimizing him, in order to enjoy a rumor that he was the bastard son of Frederick the Great. The story—widely circulated in his life-

time—was ridiculous. In 1772, Frederick's main squeeze was Poland, not an obscure housewife in Bonn. But Beethoven never issued a public denial. He rather basked in the supposition that royal blood flowed in his veins.

What has been called his "nobility pretense" will be discussed in another chapter. Suffice to say here that, while he might have preferred some other father than Johann van Beethoven, he always identified with the old Kapellmeister ("my excellent grandfather, whom I so resemble"), long after the name of Ludwig van Beethoven had obliterated the name of Ludwig van Beethoven.

The Bonn of his boyhood was a small, walled, black-and-white city, fifteen miles upriver from Cologne. Its peculiar chiaroscuro came from black lava streets and almost universal lime wash. Even the immense electoral palace was white, dazzling in summer but frigid looking in winter. A gilded town hall added some glitter to the market square, but elsewhere plain plaster gables predominated. One of the few buildings to escape the brush was the old stone Münster. For five centuries, its prodigious steeple had cast a wavering reflection across the Rhine, resisting the river's silvery slide. Older still were the Roman ruins around town. Exploring Bonn's black streets, hearing its church bells and Gregorian chants, Ludwig acquired a sense of the remote past, palpable yet irretrievable.

Against this he had to balance the state of the state in which he found himself. At first, of course, his worldview extended no farther than the small rear-garden apartment Johann rented in the Bonngasse.* In time, he would find that the "Germany" his parents spoke of was not a nation so much as an idea, whose main logic was lan-

*Now the Beethovenhaus museum.

guage. It comprised Austria as well as some three hundred other German-speaking kingdoms, principalities, electorates, and tiny fiefdoms. Politically if not religiously, it was still Maximilian I's *sacrum Romanum imperium nationis Germanicae*, the Holy Roman Empire of the German Nation—albeit shrunken far from Rome and loosened almost to the point of disintegration by antifeudal reforms emanating from its power center, Vienna.

Wien—the word was so constantly sounded throughout the electorate that Ludwig registered it early, forming a permanent impression of Vienna as the spiritual, political, and musical center of "Germany." In that distant capital lived the two "enlightened despots" who respectively ruled Austria-Hungary and the *sacrum imperium*: Empress Maria Theresia and her coregent son, Emperor Joseph II. Judging from reports of the old lady's health, it was only a matter of time before Joseph inherited total power. He had been chosen Holy Roman Emperor by an electoral college that was both aristocratic and ecclesiastical in temper, answering to the Pope. The electors were themselves chosen by civil or cathedral corporations in provinces outside of Austria. One of these electorates was the archbishopric of Cologne.

The monarch of Ludwig's early world, at whose pleasure his father and grandfather served, therefore rated as part prince, part priest. Archbishop Maximilian Friedrich was a relaxed little man in his late sixties, not inhospitable to a few Habsburg-style reforms. He had begun to reduce Jesuit influence on education, and had plans for a secular university in Bonn. Nevertheless, he remained a cleric; his "electoral Catholicism" was meant to show that the church could self-adjust and govern without surrendering any moral authority.

After the death of old Ludwig, Johann wrote to the Elector sug-

gesting that he was qualified to serve as Kapellmeister. Failing that, he begged an increase in salary, as he found himself "in needy circumstances," having now the burden of keeping his mother in a cloister.

Max Friedrich relieved him of his burden but ignored the suggestion. Qualified the *musicus* was not, except to sing tenor at court and give private violin and clavier lessons. Unpromoted and unrewarded, Johann set about developing his eldest son's gifts. It is difficult to establish just when he realized they were extraordinary. We know only that sometime after the birth of Caspar Carl in the spring of 1774, and before that of Nikolaus Johann in the fall of 1776, Ludwig was being taught music with a brutality that marked him for life.

Neighbors of the Beethovens—who were now living in a larger apartment in the Rheingasse—recall seeing a small boy "standing in front of the clavier and weeping." He was so short he had to climb a footstool to reach the keys. If he hesitated, his father beat him. When he was allowed off, it was only to have a violin thrust into his hands, or musical theory drummed into his head. There were few days when he was not flogged, or locked up in the cellar. Johann also deprived him of sleep, waking him at midnight for more hours of practice.

Beethoven the man never criticized his father. On the other hand, he never expressed any love for him, as he did for his mother. Children of alcoholics are often taciturn: his reticence even extended to a refusal to write the name *Johann*—except once, when compelled to, in a legal document that in any case referred to Nikolaus Johann. Yet, so far as we can judge from a few childhood anecdotes, he felt

nothing for his father but a sort of protective tenderness. Perhaps he pitied him for what he was: a man of no creative imagination. This liability was apparent whenever Ludwig, who displayed an early ability to improvise on both the clavier and the violin, departed from the notes printed in front of him. Johann would agitatedly silence his cadenzas and free variations. "You know I can't stand that."

However, Ludwig's eruptive talent could be a curse as well as a blessing. Music was like magma inside him. He was in danger of exploding unless he learned harmonic and thematic discipline. Improvisation in any performance art is usually embarrassing, because most performers are not creators. The improvisations of a genius are of a different order, frightening in their proximity to madness: one has only to read about Nijinsky's last dance, or watch films of Picasso at work. If the folly is not held at bay by structure, it can destroy. Beethoven was to become, by general assent, the greatest of all keyboard improvisers, and no small part of his effect came from an iron intellect at work, organizing themes and progressions, rejecting easy effects. It would be fair to credit at least some of this iron to his first teacher.

The sentimentalizers of Beethoven's childhood have implied that Johann was always boozy and poor, and that Maria Magdalena was trapped into a loveless marriage with him because she was lowborn and helpless. On the contrary, there is no evidence of Johann's drinking getting out of control until Ludwig was a teenager. His protestations of being "needy" after old Ludwig died may be taken with a pinch of Stassfurt salt. He earned 175 florins per annum—not much of an income, but it was steady. Count Belderbusch, the Elector's chief minister, rewarded him for occasional mysterious "espionage"

services. Johann also earned freelance fees for teaching music to the children of Bonn's diplomatic corps. Unfortunately, some foreigners paid him in wine rather than money.

As for Maria Magdalena, her background was far from humble. She came from a family of substantial burghers and public officials. Johann seemed a little awed by her, celebrating her every birthday with the utmost formality and arranging little serenades and dances in her honor. He was six to eight years older than she (the record is unclear), but he put everything he earned in her hands. "Now, woman, manage with that," he would say.

Little is known of her relations with her sons—only that she became neglectful of them, and let Ludwig run about unwashed and ill dressed. Her melancholic side got the better of her after the birth of Caspar Carl. "If you want to take my good advice," she said to Cäcilia Fischer, a young girl living in the same house, "remain single."

At 5 P.M. on March 26, 1778, Johann felt confident enough of Ludwig's keyboard prowess to present him in recital on a concert stage in Cologne. The boy was billed as his "little son of six years." Ever since Mozart had entertained Empress Maria Theresia at that age, no father wanted his own prodigy to be older. (Even Leopold Mozart had edited some of Wolfgang's later birthdays.) Ludwig was in fact seven.

If Johann was hoping that musical history would repeat itself, he was disappointed. Ludwig's recital drew little attention and no press. His program included "clavier concertos" (probably solo pieces in the style of Bach's *Italian Concerto*) and "trios." Had he played with anything like Mozart's precocity, his debut would surely have been noticed.

And his general education might have been neglected even more

than it was. Not long after this, Johann and Maria Magdalena—pregnant again—entered their eldest son at the Tirocinium, a Latin grade school. Pupils there assumed from the new boy's unkempt look, and dull air of withdrawal, that he had no mother. In the recollection of a classmate, "Not a sign was to be discovered . . . of that spark of genius which glowed so brilliantly in him afterwards." One may guess that the constant suppression of his keyboard fantasies by Johann ("More of your fooling around? . . . I'll box your ears") had begun to take its psychological toll. Even on the violin, Ludwig's fingers could not help searching out new music. "Now isn't that beautiful?" he would plead. The response was always, "You are not to do that yet."

Nevertheless, Johann's insistence on his practicing by rote laid the foundations of a formidable technique. Over the next two years, Ludwig began to take pleasure in the strength of his growing, broad-palmed hands. By his own account, he worked "prodigiously" to develop their facility. It was no longer necessary to force him to the keyboard. He kept up with the violin, too, and although he liked it less, it gave him an exceptionally nimble left hand.

Of his own accord, he took extra instruction from organists around town, gaining access to the lofts of the electoral chapel, the Münster, and the Minorite monastery. The huge sonorities of the organ, particularly in the pedal register, and its capacity to prolong tones ad infinitum, combined with yet more lessons in viola and horn to produce the characteristic "sound" of Beethoven the composer: spacious, projective, multilayered, muscular.

At school, Ludwig became more and more a creature apart, with no apparent desire for friends. He was an indifferent pupil, never

mastering more than the basics of writing and arithmetic. Yet he managed to learn elementary Latin, and later became fairly fluent in French. Anything he received as sound, he could relate to cipher. But the arbitrary rules of spelling books, and the silent language of numbers, confused him: they made no aural sense. If he had any learning disability, it was slight and, like that of Keats, quirkily adorned a large intelligence. It did not affect his passion for puns and anagrams, or for that matter his later study of counterpoint, the most sequential mental exercise conceivable. He was prolix on paper, but he had no literary inclinations: "Music comes to me more readily than words." When improvising on the piano or organ, he was clearly saying things in his natural language.

Sometime around the age of ten, Ludwig began to transcribe these utterances onto five-line staves, drawn with a rolling ruler. He was untrained in composition, but, as he afterward joked, "I wrote correctly without knowing it had to be so." For the rest of his life he liked to see notes, rather than "dry letters," coming out of his pen. (He had, besides a freak ear for timbre, the unteachable gift of perfect pitch.) His preferred data bank was to remain the twelve tones of the scale—so much closer, in their logical order, to the ten digits of mathematics than to the twenty-six mutable ciphers of the alphabet.

By the summer of 1781, Ludwig could learn nothing more from Johann. His other teachers were spreading word of his talent, and it was taken for granted that he would follow his father and grandfather into court service. That fall he was withdrawn from school, and arrangements were made for him to receive advanced instruction from Christian Gottlob Neefe.

The thirty-three-year-old Neefe, recently appointed Court Organist, was an all-around intellectual, a disciple of Goethe, and a per-

fectionist and logician trained in the law as well as music. He had studied in Leipzig, and now brought with him the pedagogical tradition of Johann Sebastian Bach. His tendency toward Calvinist severity was moderated by a knack for writing songs and operettas in the vernacular. So in addition to introducing Ludwig to Bach's *Well-Tempered Clavier*, he was able to teach him the delicate art of matching melody to the peculiarities of the human voice—its registers, ranges, susceptibility to different vowel sounds, and problems (endemic in German) with clashing consonants.

Bach was a revelation to the boy, who took to the difficult preludes and fugues with an avidity that distracted him from learning counterpoint as pure theory. He already knew plenty about song. Beethoven is so generally thought of as a symphonic composer that we tend to forget that he was the son and grandson of singers, and was steeped in opera and choir music throughout his formative years. His most sublime instrumental melodies, such as that of the slow movement in the "Archduke" Trio, tend to be vocal in character, with audible "breathing points" and hymn-like progressions. Wordless recitative and flights of quasi-operatic coloratura occur even in the late string quartets.

It is not known just when he began to study with Neefe, but the evidence points to late 1781. By June 1782, Ludwig, age eleven and a half, was already deputizing for his master as organist in the electoral chapel and bewildering the congregation with improvisations that prolonged the mass. Neefe was tolerant, but remained a strict, formulaic teacher.

His influence can be felt in Ludwig's first published composition, a set of piano variations printed late that fall in Mannheim. The theme, by an obscure composer named Dressler, is almost a carica-

ture of Classical stiffness: a lumpen little march in C minor, with a cadence as sudden as a halt order.

Possibly Neefe, in assigning this drill to Ludwig, was forcing him to write variations that "marched along" with the theme. But he succeeded only in getting the music of a bored pupil. The ninth and last variation, however, has a flash of the coming composer. After a descending shower of scales, Beethoven takes off suddenly in the remote key of A major. The effect is of a leap from the parade ground up onto the reviewing stand—before Sergeant Dressler orders him back to *terra firma*.

At least Ludwig had the thrill of seeing his name, or something like it, elegantly Frenchified on the title sheet when the printer's proofs arrived: *Louis van Betthoven agé de dix ans*. He was actually almost twelve. Once again, he was denied comparison with Mozart. No reviewer so much as mentioned his variations.

It was an unidentified correspondent of Cramer's *Magazin der Musik* who finally used the M-word, on March 2, 1783. Describing Ludwig as an eleven-year-old [*sic*], the writer reported:

He plays the clavier very skillfully and with power, reads at sight very well, and . . . plays chiefly *The Well-Tempered Clavier* of Sebastian Bach, which Herr Neefe put into his hands. Whoever knows this collection of preludes and fugues in all the keys—which might almost be called the *non plus ultra* of our art—will know what this means. [Neefe] is now training him in composition. . . . This youthful genius is deserving of help to enable him to travel. He would certainly become a second Wolfgang Amadeus Mozart if he were to continue as he has begun.

Actually, the article was written by Neefe himself. No deception was intended; contemporary style required that such reports be anonymous. Neefe was sincere in believing his pupil had a gift of Mozartian potential. But there is a hint of worry in his last two sentences. It is as if he feared Ludwig's gift was not developing as it should—cramped, perhaps by the provincialism of Bonn.

As things turned out, the boy did take a trip to Holland in October of that year, accompanied only by his mother. Our main source of information about it is a memoir written by Cäcilia Fischer and her brother Gottfried, longtime neighbors of the Beethovens. They report that Ludwig and Maria Magdalena sailed down the Rhine in freezing weather, and spent a few weeks in and around Rotterdam as the guests of a well-connected Dutchwoman. She saw to it that Ludwig played in several great houses, where his piano skills caused amazement. On November 23, he had his first paid engagement, at a royal concert in The Hague, earning sixty-three florins. That was more than any other performer received, but he groused that the Dutch were *Pfennigfuscher*—penny-pinchers. "I'll never go to Holland again."

Preadolescent sulkiness aside, his behavior was another portent of Beethoven the man: always suspicious of being cheated, always finding excuses not to travel. A more sympathetic image in the Fischer memoir penetrates the veil of privacy he drew around his family life, and reminds us that he was still half a child. It is of Maria Magdalena warming his frozen feet in her lap as they sailed back up the Rhine.

She had by then buried two more children, and her melancholy was worsened by marital and financial worries in 1784. The year began ominously, with the death in January of Johann's palace

patron, Count Belderbusch. At once, Maria Magdalena felt insecure. Her husband's voice was fraying, and she feared for his sinecure.

Clearly, Ludwig was going to have to apply for a court post. At thirteen, he was already a familiar, if probationary, *musicus* at the palace, admired for his organ playing. He had even been allowed to substitute for Neefe as "cembalist" in the orchestra—an important job, which involved keeping time at the harpsichord or clavier, filling out harmonies, and reading scores at sight. In return for these services, he was paid a "subsistence" allowance. He had developed impressively as a composer since the *Dressler Variations*, publishing several songs and three piano sonatas dedicated to Maximilian Friedrich. ("May I dare, *Most Excellent Lord!* to lay the first-fruits of my youthful work on the steps of *your* throne?")

On February 15 he sent the Elector a formal request to be appointed Assistant Court Organist. Approving his petition, a palace official noted that the elder Beethoven was "no longer able to support his family." Much of Johann's pay was now spent on alcohol: Frau Fischer caught sight of him one day, swigging from a flask while walking down the street.

No salary was fixed for Ludwig, but he won tenure just in time. Two months later, old Maximilian Friedrich died. The name of his successor—Maximilian Franz—was easy enough for everybody in Bonn to adjust to. Otherwise, momentous changes portended. The new Elector was no less a dignitary than the youngest brother of Joseph II. He was twenty-seven years old, and shared the Emperor's devotion to the principles of *Aufklärung*, the German Enlightenment. He was determined to liberalize Bonn's privileged institutions, build its university, cut down on frivolous entertainments at court, and make all his subjects, from ministers to fruit farmers, aware that

the age of feudal tyranny in western Europe was ending—something that his sister, Queen Marie Antoinette of France, preferred not to think about.

Max Franz's first actions were typical of any newly elected leader anxious to make an impression. He disbanded the court theater company, called for strict economies in all departments, and asked for evaluations of every staffer in his employ. Among these profiles were:

> J. van Beethoven, age 44 . . . has a very stale voice, has been long in service, very poor, of fair deportment and married.
>
> Christ. Gottlob Neefe, age 36 . . . organist . . . might well be dismissed, inasmuch as he is not particularly versed on the organ, moreover he is a foreigner, having no merits whatever and of the Calvinist religion.

Neefe's regrettable Reformism was Ludwig's gain. A supplementary report noted that if Neefe were let go, a substitute performer was available, who "could be had for but 150 florins." This person was "small, young, and a son of one of the court musici, and in case of need has filled the place for nearly a year very well."

Ludwig was put on the court payroll on June 27, 1784, at the suggested stipend. Neefe survived, but just barely, with his former four hundred-florin salary cut to two hundred florins. They were both listed simply as "organists," a leveling of status that did not escape Ludwig—especially when a fifty-florin raise soon gave him pay parity. He became a difficult pupil, resentful of Neefe's attempts to tone down the wildness of his musical ideas.

A general turbulence was in the air: not only whiffs of revolutionary cordite blown across the Atlantic from *Amerika* and drifting

into the Rhineland via France, but intellectual winds gathering force within the Reich itself. In Weimar, Goethe had legitimized *Sturm und Drang*, a new rhetoric of unbridled feeling; in Königsberg, Kant was arguing that reality was less objective than subjective; and in Mannheim, Friedrich von Schiller was writing poems and plays that sensationally related stage action to political action.

For the moment, the only activism that interested Ludwig was that which might further his court career. Yet he could not help breathing the air all Bonn's radical youth were breathing—especially when the Elector declared the city university open on August 9, 1785, and disciples of Schiller and Kant began lecturing on human rights and the "categorical imperative."

The latter precept, defined as the duty always to act as if one's will could transform the action into "a universal law," Ludwig could better obey in reverse, by applying a universal standard already existing—the music of Mozart—to his own attempts to "act" as a composer. Pounding away at his cembalo in the court opera orchestra, he learned the score of *Die Entführung aus dem Serail* from within, finding that its perfection was not so much achieved as innate. His study of Bach had already taught him that contrapuntal mastery, of a sort, could be gained by hard work: learning all the rules, then solving all the problems, over the course of many years. But the only way to learn from Mozart, that inexplicable genius, was to imitate him.

This he proceeded to do by using three Mozart violin sonatas as models for three large-scale piano quartets. The scale was his own: he could not help extending harmonic movement, and the range of instrumental dynamics, beyond their conventional limits. Yet he was scrupulous in matching Mozart's balance of proportions. The effect was rather like that of a copyist draftsman, enlarging an original

sketch by means of a cranked pencil holder. The mere look of his calligraphy proclaimed a mind given to complexity. Where Mozart wrote plain quavers in G minor, Ludwig wrote demisemiquavers in E-flat minor, the most brooding of keys, with six flats blackbirding each stave. The effect was more than simply visual: those flats force the violinist to finger almost every note, instead of allowing the open strings to reverberate, creating a veiled, brooding sound. As the British scholar Barry Cooper has pointed out, such refinements convey "the extraordinary acuteness of [Beethoven's] ear at this date."

Two unpublished manuscripts—a trio for the odd ensemble of piano, flute, and bassoon, and a triple concerto pitting the same group against a full orchestra—show Ludwig painstakingly teaching himself the art of instrumentation. The ability to "mix" two, or eight, or eleven different timbres in the sound lab of the brain can be attained only by practical experience, beginning at the earliest age possible. He was lucky in that he belonged to a thirty-one-piece orchestra of excellent quality, and could get colleagues to try out the new combinations he "heard" in his head.

Mistake by mistake, happy accident by calculated effect, Ludwig learned how flutes in their upper register gain an airy weightlessness over woody bassoon notes, like birds reflected in a reed pond; how the clarinet's mellowness sharpens to vinegar under stress; how *aus der Ferne*, the dimension of distance, adds a plangency to trumpet tones—and to human voices; how the oboe is independent in any company; how a single string pizzicato divides into pluck, snap, thrum, and echo; and how drums are capable of melody and harmony as well as rhythm. All these sounds, including the above liability of the clarinet, became part of his unique orchestral color.

Then suddenly, silence. For almost four years, Ludwig published

27

only a few trifles. Unless some disaster, or a self-censoring bonfire, did away with larger works he may have produced between the ages of fifteen and nineteen, his creativity appears to have gone into remission. Many things may have caused this: sexual torment, illness, inhibitions imposed by Neefe, a move of the Beethoven family to new quarters at 462 Wenzelgasse.

One guess is that he was distracted by the sheer fun of being a professional *musicus*. He accompanied early mass every morning at the Minorite Church, reveling in the organ's thirty-three stops. He also performed at festive services in the Electoral Chapel, amusing himself on one occasion by deliberately throwing the psalm-singer off key. In court, he performed piano solos or concertos on demand, and acted as *répétiteur* for the Elector's opera singers. (Those stage folk, we may presume, taught him a thing or two about sex.) When not doing cembalo duty, he had a regular seat in the string section of the orchestra, playing the viola out of preference. His love of this most subtle of string instruments—one shared by Mozart—betrays the true musician, more interested in structure than surface prominence.

Ludwig enjoyed a similarly integral feeling within the musical community of Bonn. His "good and quiet deportment" at court contrasted with his former misanthropy at school. Now, among warblers and blowers and scrapers and thumpers, he no longer seemed strange. Not to *them*, anyway: the man in the street continued to look at him askance. Full of nervous energy, he developed into a peripatetic, forever exploring the countryside around Bonn. Ambulation concentrated his thoughts to such an extent that it became a part of his creative process.

In the Fischer memoir, there is a terse word portrait of Ludwig

as he approached his adult height of just under five feet six inches: "short and thick-set, broad across the shoulders, short neck, large head, dark-brown complexion; always leaned forward a little when walking." Drawings of Beethoven *en promenade* in later life reproduce this image almost exactly. But no sketch conveys his Latin coloring, so at odds with the north German climate: thick yet fine near-black hair, dark eyes and brows, and wide, hairy-backed hands. The Fischers nicknamed him *der Spagnol*, "the Spaniard."

They might not have called him that directly, because his temper was formidable. However, he looked more truculent than he was. His habitual scowl was caused by a myopic frown, and by big teeth pushing his clamped lips forward. Except when provoked, he was mild-mannered and affectionate. He laughed loudly, but not at the kind of things other people found funny. Out-of-tune playing, painful to most musicians, cracked him up. His compulsive puns were so awkward as to be nonsensical even in German. "Right now, I am still a *Notenfuchs*," he joked to Frau Fischer when she caught him stealing her eggs, amused somehow at the notion of a "musical fox."

It was the humor, or humorlessness, of a born eccentric. Ludwig seemed unconscious of his growing peculiarity. He had a habit of falling into a near trance, in which he either sat immobile or made odd remarks from some mental dialogue. "Did I say that? I must have had a *raptus*." The word connoted, for him, a state of "lovely, deep thought" that he hated to have disturbed.

A silhouette profile of Ludwig at sixteen shows him with his head set back, his hair brushed, beribboned, and queued, and a cascade of ruffles bursting from his shirtfront. As Court Organist (his exclusive title, now that Neefe had gotten another), he was allowed to wear a sword on his left side, with a silver belt on gala occasions.

His court dress featured a sea-green frock coat, a flap-pocketed vest braided with gold cord, a pair of green, buckled knee breeches, and silk stockings with black bow-laced shoes. Under his right arm he carried a tricorn hat.

So a brilliant green butterfly metamorphosed from the shabby cocoon of Ludwig's school days. He would have been a rare teenager if he did not delight in mounting the palace organ loft in all his finery, and letting go with the loudest possible blast from the big pipes.

These were happy years for him. They might have been even happier, had tragedy not intervened in 1787, at a moment when his whole world appeared about to change gloriously. Somebody (most likely Neefe) seems to have persuaded Max Franz that there was a "second Mozart" playing in the electoral orchestra. What if young Beethoven were sent to Vienna for a year or two, as Mozart's pupil? Might he not return a potential Kapellmeister, and redound to the glory of the court of Cologne?

Max Franz appears to have agreed to sponsor such an internship, on condition that Ludwig share the costs out of his court salary. This was a heavy imposition. The Beethovens were much better off than most *musici*, earning a combined income of more than six hundred florins a year, but Johann's debts still rated them as "poor." With Maria Magdalena sick after yet another confinement and two boys still in school, they could scarcely afford to lose Ludwig. On the other hand, his future earning potential would be enhanced by association with Mozart—who could not refuse to accept him. The Elector was, after all, the brother of the Emperor; any Habsburg recommendation was tantamount to a royal order.

Ludwig probably began his nine-hundred-mile journey around

March 20. A "Herr Peethofen, Musikus von Bonn" is registered as a tavern guest in Munich on the night of April 1. That projects an arrival in Vienna about a week later. Nothing is known about his first days in the *Kaiserstadt*, except for vague anecdotes that he visited some "art-loving aristocratic families" and was "deeply impressed" by a glimpse of Emperor Joseph himself. There follows this report of his reception by Mozart, compiled by the latter's nineteenth-century biographer, Otto Jahn:

> Beethoven . . . was taken to Mozart and at that musician's request played something for him which he, taking it for granted that it was a showpiece prepared for the occasion, praised in rather a cool manner. Beethoven, observing this, begged Mozart to give him a theme for improvisation. He always played admirably when excited. . . . Mozart, whose attention and interest grew more and more, finally went silently to some friends who were sitting in an adjoining room, and said, vivaciously, "Keep your eyes on him; some day he will give the world something to talk about."

Jahn is a respected scholar, but his story has to be taken on trust. Beethoven himself never mentioned the audition. He said only that he heard Mozart play, and thought his piano style *zerhacktes*, "choppy." Possibly Mozart did give him "some instruction," as a friend claimed many years later. If so, it would have involved taking time off from the composition of *Don Giovanni*. All we know for sure is that Ludwig had less than two weeks to absorb the staggering fact that he was in Vienna, at the height of its imperial splendor, at the cusp of his own manhood. Emergency information reached

him that Maria Magdalena was critically ill, and by April 20 he was on the road back to Bonn.

Several months later, he wrote his own account of this traumatic return home:

> The nearer I came to my native city the more frequent were letters from my father urging me to travel with all possible speed, as my mother was not in a favorable state of health. I therefore hurried forward as fast as I could, although myself far from well. My longing once more to see my dying mother overcame every obstacle and assisted me in surmounting the greatest difficulties. I found my mother still alive but in the most deplorable state; her disease was consumption, and, after much pain and suffering, she died [on July 17]. She was such a kind, loving mother to me, and my best friend. Ah, who was happier than I, when I could still utter the sweet name, *Mother*, and it was heard?

Maria Magdalena's death afflicted him with asthma so severe he feared he, too, might be consumptive. "To this is added melancholy, almost as great an evil as my malady itself."

It is not surprising that he succumbed to depression, having to deal with not only grief, but also the disappointment—and financial consequence—of his fruitless Viennese venture. Hélène von Breuning, a wealthy Bonn widow, came to his emotional rescue. She offered him a part-time position as music tutor to her four children, and the run of her elegant mansion on the Münsterplatz. There, Ludwig found sanctuary from the bleakness of his own bereaved

household (made still bleaker, in November, by the death of his baby sister, Maria Margaretha), as well as a substitute mother.

Another attraction was Frau von Breuning's daughter, Eleonore, a girl of sixteen whose name would haunt his future creative consciousness. The younger children were all boys. Thirteen-year-old Stephan von Breuning was to became a close friend. For the moment, Ludwig preferred to enjoy, with Eleonore, the nearest thing to sexual intimacy permissible between teenagers in polite eighteenth-century society: thigh-to-thigh closeness on the piano bench, as they tangled fingers in piano duets.

The von Breuning mansion attracted some of the most fashionable people in Bonn, and gave Ludwig what one habitué described as "his first training in social behavior." Maria Magdalena had been a well-bred woman, and at court Ludwig had been taught to bow and scrape. But the domestic manners of people who lived under chandeliers were new to him. These he learned without trouble, being self-confident enough not to flinch when introduced to such a dignitary as "Hochfürstlich Münsterischer Obrist-Stallmeister, Sr. Excellenz der Hochwohlgeborene Herr Friedrich Rudolph Anton, Freyherr von Westerholt-Giesenberg, kurkölnischer und Hochstift-Münsterischer Geheimrath."

At the same time, Frau von Breuning protected him from social parasites. In his own phrase, "She understood how to keep the insects off the flowers." But she was unsuccessful in taming a bearish quality that Beethoven retained until the end of his days. It was the result of absentmindedness rather than indiscretion; when seized by impulse, or a wincing pun, he was unconscious of offense. "He has got his *raptus* again," she would say, in humorous resignation. He proved

more amenable to cultural guidance. From the von Breunings and their circle he learned things he had missed during his brief school days: the beauties of German literature, especially its lyric poetry, facts of ancient and modern history, geography, and science, all intermixed with gossip from the highest reaches of the Electorate. Sometimes he stayed the night, hearing at breakfast what he may have missed the night before.

Franz Gerhard Wegeler, a student from the newly constituted University of Bonn, was another regular visitor. He, too, was sweet on Eleonore—and at twenty-two, stood a better chance with her. Wegeler's obsession with science was as compulsive as Ludwig's for music. Destined to become a doctor and scholar, he joined young Stephan and Christian Neefe among the select few who could say that they "discovered" Beethoven before he fully discovered himself.

That revelation was still a few years off. In the meantime, Ludwig took advantage of Wegeler's friendship to become a parttime student at the university, going so far as to matriculate in philosophy. Scientists, jurists, theologians, and humanists were flocking to the new institution. It was an exciting time to be young and intellectually aware in Bonn. Everybody was talking about France's slide into bankruptcy, with King Louis XVI locked in a mortal struggle with his rebellious *parlements*. The flow of pre-Revolutionary propaganda over the border, displayed in every Rhineland bookstore, became a flood. Ludwig read what he could and became fluent, if not altogether literate, in the language of Rousseau.

He was not particularly interested in political ideology. A *biergarten* bull session about personalized issues—such as how Prussia would adjust to the death of Frederick the Great, or what the Pope thought about the Emperor's secularizing reforms—was the kind of

debate he sometimes enjoyed. Nor did his eager but indiscriminate reading cohere into any organized set of beliefs. Indeed, the concrete world of ordinary people and their affairs remained alien to him, although he pretended all his life to understand it. Slightly savage, with his blunt head and swarthy skin, a young Caliban, he was at home only among the sounds and sweet airs of his own island.

Shakespeare was familiar to Ludwig, thanks to Bonn's court theater. Before his nineteenth birthday, he either saw, or heard about, productions of *Hamlet*, *King Lear*, *Macbeth*, *Richard III*, *Romeo and Juliet*, and an amalgam of the "Harry" plays entitled *Sir John Falstaff.* He set himself to reading the Bard in German when the Schlegel edition began to appear. *Romeo* was to inspire a mature string quartet,* *Coriolanus* an overture, and *Macbeth* sketches for an opera.

An even more pregnant encounter, about this time, was with Schiller. *Die Räuber* had come and gone in Bonn, and *Don Carlos* was on its way, but—strange are the quirks of the creative mind—Ludwig felt drawn to an ode that even Schiller considered second-rate. Entitled *"An die Freude,"* "To Joy," it amounted to a comrade-hugging, banner-waving effusion of the sort that traditionally appeals to sentimental youth:

> *Freude, schöner Götterfunken,*
> *Tochter aus Elysium,*
> *Wir betreten feuertrunken,*
> *Himmlische, dein Heiligtum!*
> *Deine Zauber binden wieder*
> *Was der Mode Schwerd getheilt,*

* Op. 18, No. 1, second movement.

Bettler werden Fürstenbrüder,
Wo dein sanfter Flügel weilt.

Which might be rhythmically, if not rhymingly, translated as:

Joy, fair flash of God the Father,
Daughter of Elysium,
We invade all fire-drunken,
Heavenly one, your sacred shrine!
Your enchantment binds once more
What the sword of Style has cut,
Beggars change to princes' brothers
Under your soft covering wing.

The penultimate line (which Schiller toned down in future versions) was democratically thrilling, and the imagery had agreeable overtones of sex. There were many more verses, with air kisses being blown at the human race, oaths sworn to eternity, Nature's breasts lactating, stars crooning, cannibals taking sedatives, and multiple invocations of *Freude, Freude*—joy, joy—foaming in goblets and empowering the universe. A mature composer might want to block a few of these metaphors before adapting the ode to music, but a young *musicus* recovering from depression vowed that, when he had the power, he would set it "strophe by strophe."

In late January 1788, Count Ferdinand Waldstein came to live in Bonn. He was not quite twenty-six years old, a friend of Mozart's, and his Bohemian blood was blue enough to impress even the Elector. Handsome, intellectual, rich, and music-loving, he soon appeared in Frau von Breuning's salon, and found that her daughter had a

music teacher of phenomenal powers. If Ludwig was still in the midst of a compositional drought, it did not show when he sat down at the piano and allowed music to pour out of him.

Enraptured, the Count decided to do everything he could to advance Ludwig's career. An ideal agency presented itself in the Bonn *Lesegesellschaft* (literally, "Reading Society"), a new cultural club that Waldstein at once joined. Its members, who included Neefe and other self-styled illuminati, were pledged to support any project in the humanities that promoted the ideals of *Aufklärung*. They agreed that young Beethoven was one of the city's most promising assets, and gave Waldstein carte blanche to lobby for him at the palace.

Max Franz was receptive to the Count—who quickly became a court favorite—but showed no interest in favoring Ludwig over any of the other *musici*. When, in June, Ludwig begged for an increase in salary, Max Franz simply ignored the petition. Aware that the young man really was hard up with travel debts, Waldstein took to slipping him occasional sums and saying with exquisite tact that they were "gratuities" from the Elector.

In fairness to Max Franz, it should be remembered that Ludwig had done little since the publication of his childhood sonatas in 1783 to advertise himself as a composer—unless a slight piano rondo and a song entitled "To a Suckling" had enhanced his reputation. After so long a period of apparent sterility, he was beginning to look like a faded prodigy. The court register that listed him as an organist and violist did not award him the asterisks that signaled he could also write music.

Several of his colleagues were so starred: Anton Reicha, the flutist, Andreas and Bernhard Romberg, fiddling cousins from Münster, as well as Neefe and Andreas Lucchesi, Grandfather Ludwig's

successor as Kapellmeister. One wonders what young Ludwig felt about their typographical eminence.

The professional intimacy all shared was intensified in January 1789, when the Elector inaugurated a new opera company. For years, music drama had been a sometime thing in Bonn, with outside troupes visiting and local ad hoc performers never quite sure of tenure, given Max Franz's tendency to pinch *pfennigs*, and Maestro Lucchesi's need for Mediterranean vacations. At last a resident troupe was installed, and Beethoven found himself busier than he had ever been, shuttling between organ loft and theater pit and orchestra platform, while keeping up with his teaching and sporadic attendance at the university. By the end of the spring season he had played in thirteen different opera productions, and he could look forward to a fall/winter schedule that included Mozart's *Le Nozze di Figaro* and *Don Giovanni*.

When the fall season got under way (*Figaro* resounding ominously with echoes of the crash of the Bastille), Ludwig applied again for a raise. His grounds this time could not be denied: Johann van Beethoven had become too much of a public liability to continue as head of the family. Stephan von Breuning reported seeing Ludwig trying to save his drunken father from arrest by the police. On November 29, the Elector dismissed Johann from his long service as Court Tenorist, and ordered that he be pensioned off at half pay. The other half of his salary—200 florins—was to go to his son, effective January 1, 1790, along with "three measures of grain for the support of his brothers."

Ludwig thus, at nineteen, effectively became his father's keeper, responsible also for Caspar Carl and Nikolaus Johann, aged fifteen and thirteen. He was now, whether he knew his birth year or not, a

man. This realization, followed on February 24 by enormous news from Vienna, seems to have shocked his dormant creativity back to life.

The headlines were that Joseph II, "the people's Emperor," had died—and with him, all hopes of further enlightened reforms within the Reich. Just before dying, Joseph had reluctantly rescinded most of his new laws, in the face of mass defections from France of aristocrats dispossessed by the Revolution. These refugees made German princes tremble for the stability of their own *ancien régime*.

Max Franz felt more threatened than most, since his territory was so close to the French border. And as Joseph's brother, he was also personally bereaved. The Electorate went into deep mourning. Officers of the Bonn *Lesegesellschaft* called for a musical memorial to express public grief for the late Emperor. A local poet, Severin Averdonk, produced thirty-five lines of hastily written text. Before the month was out, the society announced its surprise choice as composer: a court musician still in his teens, with no experience whatsoever in articulating public grief.

How Ludwig won this honor, over so many rivals with asterisks to their names, is unknown. But he had powerful friends on the memorial committee, among them Neefe and Count Waldstein, who probably won Maz Franz's approval. Fewer than three weeks later, however, the committee cryptically noted that for "various reasons," Herr van Beethoven's grand *Cantata on the Death of Emperor Joseph II* would not be performed. Bonners could assume only that the young composer had found the project too big to handle.

Nearly a century was to pass before Johannes Brahms discovered that Ludwig had in fact produced a massive, forty-minute work for five soloists, full chorus, and an orchestra of strings, double wood-

wind, and horns. The evidence was the original handwritten score, complete down to the last double bar, and so individual in style as to tax the resources of any classically trained performers of the period. Brahms was awed. "Even if there were no name on the title page, none other could be conjectured—it is Beethoven through and through!" Modern listeners to the cantata cannot help but agree. The music of the *Joseph II* cantata is (again to quote Brahms) "beautiful and noble" in its pathos, "sublime" in its imaginative reach, and almost "violent" in the intensity of its emotions.

It begins with a held, hollow C on low strings that has no beat and no harmony. Neither loud nor particularly soft, it is an *Erdenton*, an earth note, the cantata's center of gravity. One somehow knows that whatever sounds come next will not have the hopeful glow of C major. Sure enough, the string unison gives way to an equally prolonged wind chord in C minor—a tonality that Beethoven, even at this early stage of his life, associated with tragic drama. Neither low nor high, it floats free of the *Erdenton*, a gray cloud above ground level. It was this sense of span, of extremes effortlessly held in counterpoise, that Brahms recognized as a signal of Beethoven's later style.

Another cloud, louder and darker in harmony, dissipates into a Bach-like threnody in the woodwinds. The part writing is exquisite. Only when the unison strings return, limpingly, and collapse back onto their hollow C does the chorus utter a single soft, disbelieving word: "*Tot.*"

Dead. The monosyllable resonates again, after another C in the strings, louder and darker in harmony: "*Tot.*" We realize we are listening to a repeat of the introductory dialogue, with four levels of

human voice echoing the sounds of flutes, oboes, clarinets, and bassoons. Again the Beethoven of the future, treating voices as instruments and vice versa in his Ninth Symphony. "*Tot—.*" The chorus sings it a third time, at full volume, and prolongs it for seven lung-deflating beats. The last consonant (especially dental in German) precipitates what might be called a dead silence.

Again and again in the music that ensues, the word "*tot*" is isolated, each hush emphasizing its finality. Averdonk's text is full of *Sturm und Drang* imagery, with wild seas precipitating the news of January 24: "*Joseph der grosse ist tot!*" Beethoven compensates by imposing a stern discipline on his setting, yet he is sensitive to prosody, never more than when the chorus numbly repeats, "*ist tot! Ach tot!*" as if unable to adjust to the great reformer's absence.

A bass aria comes next, seething with energy. It represents Joseph's battle against *Fanatismus*, the monster of bigotry, in figurations that writhe and stab with amazing ferocity. At times, *sforzandi* occur in different instruments a split second apart, anticipating by more than thirty years the polydynamics of the *Grosse Fuge*.

The music now becomes so beautiful as to mesmerize any listener. Averdonk's text pays tribute to the Josephinian *Aufklärung*, in words describing the ascent of mankind to the light, while the earth spins "serenely around the sun." Beethoven responds by sending a long cantilena, sung by solo soprano, on an orbital arc. Just as the melody begins its second revolution (horns calling across space), the soloist is joined by her four colleagues, each drifting in softly. This quintet floats in formation until the chorus follows on at the same five levels. Listening, one cannot fix the exact moment when the massed voices become all, in a radiant crescendo that suffuses the

aural spectrum. A phrase from Pope comes to mind: "fluid bodies half-dissolv'd in light."

When art conceals art, as it does here, technical analysis seems almost impertinent. But a close look at the orchestral score only increases one's respect for Beethoven's *trompe d'oreille*. After that horn call, strings alone accompany the solo singers. As the five voices swell, oboes and clarinets enter unobtrusively on a weak beat. Then a strong beat reinforces the word "*Licht*." Glowing midpoint of the cantata, it brings the return of the horns and a new undertone of bassoons. Only then—with twelve different tones already sounding— does the chorus begin to sing. Even now, the harmony is not quite full: Beethoven brings his top sopranos in late, and his flutes—the highest line of all—later still, like a final shaft of sunshine. Enlightenment, indeed!

He completes the cantata with a deeply moving aria consigning Joseph to the grave, and a final chorus that almost exactly replicates the first. The very young man gives himself away here, striving for a too-perfect symmetry. Nevertheless, one sees what architects see in Beethoven. The *Joseph II* cantata, looked at overall, is the sonic equivalent of Cologne Cathedral. Its twin choruses are the north and south transepts. They adjoin the two arias as chancel and nave, the second (measured in performance time, music's only dimension) being twice the length of the first. All four wings center on the heavenly cantilena. The cantilena itself pivots (at the sunburst moment described above) on the word "*Licht*." And equidistantly, at beginning and end, dark C minor harmonies echo around the monosyllable "*tot*."

The career of every artist is marked with great opportunities that

for "various reasons" come to nothing. Outside of bereavement, pain does not get much worse than the ache a designer feels for his unbuilt bridge, an actress for her canceled lead role, a sculptor whose commission is withdrawn. Even if Beethoven the slow-working perfectionist was responsible for the nonperformance of his cantata in 1790, he must still have pined to hear it. If other factors aborted the project, one does not like to imagine his feelings, at nineteen years old. He knew, beyond surmise, that he had written a masterpiece, and, as will be seen, he was able to reuse the melody of the cantilena in a later, very different work. But nothing is more evanescent than an "occasional" composition. Bonn's memorial day for Joseph II came and went, and the most magnificent music ever written in that city was abandoned to silence.

Ludwig was at any rate not held accountable. He was soon invited to write a second imperial cantata—this time to celebrate the election of Joseph II's eldest brother, Leopold, to the Holy Roman throne. Again he had to thank Count Waldstein and the *Lesegesellschaft* for favoring him. Again he wrote music of power and originality: if the *Cantata on the Accession of Leopold II* was more festive and less profound than its predecessor, then so was the occasion. And again, the work was withdrawn before its due date.

When, therefore, we come across contemporary references to "a cantata" of Beethoven's that was too difficult to perform in 1790, we cannot be sure which one is meant. This causes a biographical problem, affecting something Franz Wegeler tells us that is of vastly greater importance.

On Christmas Eve that year—Ludwig had just turned twenty—Joseph Haydn passed through Bonn. The most distinguished com-

poser of his age, he was on his way from Vienna to London for a season of concerts and royal receptions. Wegeler states that the electoral orchestra held a breakfast for its distinguished visitor. "On this occasion Beethoven showed him a cantata, which Haydn was particularly impressed by, and which made him urge Beethoven to embark on further studies."

We may assume that Ludwig would have presented the more ambitious of his two cantatas. Haydn was as sure as Brahms to have seen its quality. He would also have noticed that the *Joseph II* cantata was more homophonic than polyphonic—an indication that its young composer needed advanced instruction in counterpoint.

This was in fact the case. Neefe, for all his love of Bach, was not a skilled teacher of the rules of fugue. And the willful Ludwig had an aversion to rules of any sort: some of his progressions sounded deliberately crude. Haydn was quite capable of crude effects himself, in "peasant" minuets and "gypsy" rondos, but his counterpoint was always elegant. He said what needed to be said, and continued north. Nobody knew how long he would remain in England, or whether he would come through Bonn again on his way home.

For the next year and a half, Ludwig lived the mostly happy life of a gifted, popular youth-about-town. He remained a fixture in the salon of Frau von Breuning, bothered young Eleonore with his rough manner, attended lectures at the university, and hung out with Wegeler at the Zehrgarten, a tavern favored by the arts crowd. Not the least of its attractions was the hostess's gorgeous daughter Babette, "the belle of Bonn." There were other girls in other taverns, where Ludwig sometimes revealed himself as a prude. He was offended by public displays of lust, and sexual badinage made him shy

and morose. One young woman, encouraged by his friends, made several passes at him. He was at first cold, and then violent, giving her head a sharp smack.

Now officially enshrined as Court Pianist as well as Court Organist, Ludwig played many concertos, including those of Mozart. For his own recitals, he composed twenty-four *Variations on a Theme by Righini*, a work of flamboyant virtuosity and originality. Its coda gave an early demonstration of his freak ability to be at once augmentative and reductive. A flickering *ostinato* in the right hand slows from semiquavers to quavers—notes twice as long—then progressively to crotchets and minims, and so on. But is *slow* the right verb? Only the note values change. The pulse does not. What seems to be a vast deceleration is actually continuing momentum.

Other, slighter works poured from Ludwig's pen, but he withheld them from publication. When, on March 6, 1791, a new dance extravaganza, the *Ritterballet*, was advertised as the "composition" of Count Waldstein, he kept quiet about its true authorship. Evidently he knew better than to deny his patron a little moment of vanity.

By the time Haydn revisited Bonn, after eighteen months in England, the German scene had changed both musically and politically. Two more deaths, as epochal in their way as that of Joseph II, had shocked Vienna during the winter of 1791–1792: those of Wolfgang Amadeus Mozart on December 5, and of Emperor Leopold II on March 1.

Mozart's passing left "Papa" Haydn, at sixty, more than ever the patriarch of European musicians. Adored from St. Petersburg to Seville, he was an inspiration to court composers, proving that a man of genius could rise to high levels of social esteem while remaining,

essentially, a servant. (His employer was Prince Paul Anton Ester-házy III.) In England, he had been bowed to by the Prince of Wales and honored by Oxford University. Yet his only real ambition lay in perfecting the High Classical music style, which was largely his creation. His latest symphonies went beyond those of Mozart in combining monothematic development with harmonic adventure. At the same time, they kept fashionable shoes tapping, and the ducats rolled in. Manifestly, Haydn was the teacher to whom Ludwig should go for "further studies."

Count Waldstein and others succeeded in getting Max Franz to agree to this, after Haydn moved on to Vienna in mid-July 1792. Once again the Elector granted Ludwig extended leave for foreign study. His travel expenses would be paid, he would get a settling-in subsidy, and he had permission to stay in Vienna on salary for as long as Haydn wanted to teach him.

Had Max Franz not been distracted by ominous strategic developments, he might not have been so willing to detach one of his most useful court musicians. But the death of Leopold II—another Emperor, another brother—had put the whole notion of enlightened Habsburg despotism under threat. Ever since the fall of the Bastille, there had been an escalation of tensions between the Reich and revolutionary France. At issue was the hospitality extended by German princes toward emigrés fleeing the Jacobins. The new Emperor—Franz II, Leopold's twenty-four-year-old son—had rejected a French demand that he order these princes to stop granting asylum to counterrevolutionaries in the Rhineland. Haydn had barely unpacked in Vienna before the Robespierre insurrection brought down the French monarchy for good. All the fanatical energy of the revolutionary commune now focused on waging war against what they

saw as the absolutist threat of the Reich. Austria and Prussia united in response. On September 20, the combined German forces were repulsed by a French cannonade at Valmy, in Marne. Goethe was an eyewitness to the action. Among millions of Germans stupefied by France's sudden transformation into a kingless, bloodthirsty military machine, only he had words plain enough to articulate the message of Valmy: "This place and day marks the beginning of a new era in the history of the world."

A month later, Mainz fell, laying open the whole left bank of the Rhine, and French forces began to crowd the Electorate of Cologne south and north. It was clear that Ludwig should wind up his affairs in Bonn at once, unless he wanted to be dragooned into composing variations on "La Marseillaise."*

Quitting his birthplace was not easy, after nearly twenty-two years of intimate familiarity with its every cobblestone, coffeehouse, and linden tree. At least his brothers were practically grown, at eighteen and sixteen respectively, and had a housekeeper to look after their sodden father. Many painful farewells had to be said: to his "second family" in the Münsterplatz—Frau von Breuning and Eleonore and young Stephan; to Franz Wegeler, luscious Babette of the Zehrgarten, and countless other friends and admirers, not to mention the music-mad street person who regularly stood outside his window in the Wenzelgasse, conducting as if to spur him to further compositions.

He was gracious to Neefe ("If I ever become a great man, yours will be some of the credit") and, one hopes, to Count Waldstein, who

*A not unreasonable supposition. One of Beethoven's university friends, Eulogius Schneider, was the first to translate "La Marseillaise" into German.

wrote, in a valedictory album dated November 1, the eve of Ludwig's departure:

> *Dear Beethoven! You are off to Vienna to consummate a long-frustrated desire. Mozart's genius mourns and weeps over the death of its disciple. It found refuge, but no release with the inexhaustible Haydn; through him, now, it seeks to unite with another. By means of assiduous labor you will receive the spirit of Mozart from the hands of Haydn.*

Chapter Two

The Hands of Haydn

ONE OF THOSE MOMENTS in which youth rejoices, but which turns older heads gray, occurred on the late afternoon of November 2, 1792, as Beethoven's post coach left Koblenz for Frankfurt. Out of the thickening darkness ahead came the Hessian army, "going like the devil." Beethoven had the choice of turning back before getting run down or bribing his coachman to drive on through the advancing file, at risk of being cudgeled. There was also the interesting prospect, if they got through, of encountering the French army on its way north from Mainz.

In the far distance, about eight days further on, lay Vienna and qualified independence. Behind stretched the Rhine, Bonn, and memories of servitude. The choice was clear. He and a young fellow passenger promised the coachman a *Trinkgeld* to insist on right of way. The columns ahead parted. By breakfast time next morning Beethoven was in Frankfurt. He would never see the Rhineland again.

Vienna was to be his home for the rest of his life. During the next few years, he would be unable to resist two or three invitations

to travel outside Austria. There was even the exciting chance of a trip to London with Haydn, whom the British wanted back. But as Beethoven grew older, and the force of his career became centripetal, Vienna and its suburbs were to enfold him more and more, until he became as unbudgeable as a hermit crab.

Oddly, to the eyes of a Rhenish youth, the great city all but turned its back on the Danube, preferring to cluster along a canal several miles to the south. Its ring of stone walls, massively reinforced with towers and battlements, gave it a look of impregnability, except that it had long ago outgrown its limits, and was now surrounded with an additional belt of garden towns and princely estates. These *Vorstädte*—too close to qualify as suburbs, yet divorced from the palace-crammed inner city—promised Beethoven many pleasant walks when spring came. There were farther, whitewashed villages on the vine-striped hills rising to the southwest, looking bleak now that winter had stripped their leaves, but all with summer rooms to rent, should he ever be able to contemplate such an extravagance. Between, behind, and above them, darkly thatching the western skyline, spread the famous forest, the *Wienerwald*. In the extreme south, visible only to promenaders along the city wall, the Alps glimmered. It was difficult to look at them and not think, as did Goethe, of the land of lemon trees beyond, just as one was aware that Hungary's low-lying haze, on the left, was but a screen to the "Near" East.

Old people in Vienna could repeat the stories their parents had told them, of Turks advancing out of that haze and besieging the city until it was at the point of surrender. Other exotic invaders, peaceful or warlike, had come and gone over the centuries, leaving behind their onion domes on Viennese churches, their lilacs in Viennese parks, their paprika and flaked pastry in Viennese restaurants. Not

quite Teutonic, with its relaxed dialect, quasi-French in its recent rococo architecture, Italianate in its operatic tastes, even a touch Spanish in its social surveillance and elaborate Catholicism, Vienna was as different from Frankfurt or Berlin as Bonn was from Budapest.

Its November weather, however, was definitely German. Beethoven was fortunate in having letters of introduction and credit, signed by Count Waldstein and the Emperor's uncle, that guaranteed him board and shelter. Moving into his first solo apartment—a little attic room over a bookbinder's shop in the Alsergasse—he jotted down certain things to buy right away: a desk and a seal, an overcoat, boots, shoes, black silk stockings. "I have to equip myself completely anew." He must rent a piano and find a good wig maker, plus purveyors of firewood and coffee. In view of Vienna's agreeably large population of girls, it was also essential he learn to dance. He noted the address of a recommended instructor.

Concert tickets, manuscript paper, a seal, and other supplies had to be paid for, over and above living expenses. All this required more funds than he had brought with him, so Beethoven applied to the Elector's local agent for the hundred gold ducats he had been promised as a subsidy. To his chagrin, he became neither the first nor the last contractual artist to discover that money payable is usually money withheld. Only twenty-five ducats were on deposit for him, most of it already budgeted away. Possibly this ice-water shock was what made him, early on, determined to fight for every kreuzer he could get out of the rich and careless.

Even the full subsidy, if it ever materialized, looked like a pittance in a very expensive metropolis. One hundred ducats translated into about five hundred silver florins, which had to last him a year. But

the average annual budget of a middle-class bachelor, living simply in Vienna, was 775 florins. Who could afford dance lessons on that?

Beethoven was down to sixty-eight florins by mid-December. With what gloom may be imagined, he calculated his monthly core cost for the foreseeable future:

house rent	14 fl.
pianoforte	6 fl. 40 kr.
heating [per day]	12 kr.
food with wine	16 fl. 30 kr.

Adding a bare minimum of 17 florins for tuition and other necessities, this projected an annual budget of about 680 florins. He could count on continued quarterly payments of his two-hundred-florin salary, but even with that and his subsidy, he was looking at a hundred-florin deficit by the end of 1793. And that was assuming Max Franz kept paying. According to the latest headlines from the Rhineland front, Bonn might soon become a French city. What price the Electorate then?

Joseph Haydn was in no hurry to impoverish Beethoven. For their first few "lessons" in December, he charged only eight groschen, about the price of a couple of dinners. Perhaps this was because Haydn had little real teaching time to spare, in the busy pre-Christmas musical season. Master and pupil appear to have met only for brief conversations, pending serious sessions after the holidays. Beethoven was surely disappointed. No ambitious youth likes to travel far, at great cost, to find himself put off.

His twenty-second birthday, therefore, did not call for much celebration. Nor was there any cheer in the first personal news he received from home: his father had died on December 18 of *Brust-*

wasser, "chest dropsy." It was just as well that the news was unaccompanied by Max Franz's sour joke, "The revenues of the liquor excise have suffered a loss."

Whatever grief Beethoven felt—not enough, at any rate, to go home for the funeral—he benefited from it by inheriting half of Johann's lapsed pension. This ensured that he would be able to survive in Vienna, complete his musical education under Haydn, draw attention as a pianist, and begin to form relationships with publishers. So Johann, in death, helped launch his adult career, as the long-ago disciplinarian had lifted him weeping onto the clavier stool.

By the end of January 1793 (a month otherwise notable for the beheading of Louis XVI), he had progressed enough in his studies for Haydn to announce, tongue in cheek, that young Beethoven was ready to write "grand operas." As for Haydn himself, he would "soon be obliged to quit composing."

Master and pupil appeared ideally suited. To a superficial eye, they quaintly resembled each other, both being short and wiry, with dark, scarred faces under their powdered wigs. But Haydn's features were sharp, his nose bent sideways by an internal polyp. To help himself breathe, he let his long lower jaw hang open. It made him look older than sixty. His speech betrayed lowly origins in the Austrian Burgenland. So did a streak of peasant toughness that showed itself in business dealings. Haydn had been for thirty years a powerful Kapellmeister to the princes Esterházy, dividing his time between their palaces in Hungary and Eisenstadt, not far south of Vienna. Now he was semiretired, permitted to remain in the capital and publish his later music for private profit.

Everyone liked "Papa" except Maria Anna Haydn, reputedly the most tyrannical wife since Xanthippe. Separated from her, he lived

in an apartment on one of the city's lofty eastern fortifications. Its sunny outlook matched his own on life. Here he pursued the simple routine that suited him best, composing in the morning, correcting proofs after lunch, walking out later in the day, entertaining friends to dinner. In contrast to Beethoven, who seemed to dress with his fists, Haydn was always elegantly formal, never opening the door without first putting on his wig. He was at home to all visitors, and had an easy way of reassuring the overawed: "Consider me a man whom God has granted a talent and a good heart."

Beethoven, whose supply of awe for anybody was limited, was more interested in maximizing his own talent. He wanted a crash course in counterpoint, and within six weeks or so realized he was not going to get it from Haydn. Many reasons have been advanced as to why the two men failed to connect pedagogically (although they continued to meet *pro forma* for the rest of the year). The most convincing is that neither was suited to the study of pure theory. Some 250 of Beethoven's contrapuntal exercises survive as evidence. His part writing is full of hasty mistakes, while Haydn's corrections are few, and at times faulty in themselves. The impression is of boredom on both sides.

Counterpoint is, by its mathematical nature, an art that easily degenerates into science. When skill at weaving inversions and augmentations and transpositions becomes technique and nothing else, the notes lie on the paper like magnetized iron filings, too inhumanly patterned to amount to music. Yet skill must be acquired, even as a young composer guards against habit, the peril of technique. Haydn, whose own polyphony was marvelously flexible, made the mistake of inflicting upon Beethoven an *Elementarbuch*, or set of basic rules, rigid enough to satisfy a structural engineer.

The book posed some three hundred contrapuntal problems in two-part, three-part, and four-part harmony. Beethoven tackled most of them, while the conviction gathered within him that he needed another teacher. Haydn's teasing remark about his operatic abilities betrayed a slightly condescending attitude that Beethoven, always serious in matters of music, resented. But how to fire a great composer hailed by Austrians as "the darling of our nation"? There was such a thing as professional suicide. All he could do was hope that Haydn's next visit to Britain would be a protracted one.

In the meantime, "Papa" was happy to be associated with a brilliant twenty-two-year-old who politely bought him coffee and chocolate, and whose performances of Bach on the piano were already the talk of Viennese sophisticates. Baron Gottfried van Swieten—director of the Imperial Library, and Mozart's mentor in the field of baroque music—kept asking how the young man was getting on in his fugal studies. Haydn was gratified by such august attention. He did not doubt that Beethoven would one day engrave the words *Pupil of Haydn* on the title pages of all his compositions.

Beethoven had no objection to being identified as such in June, when Haydn took him to Eisenstadt and introduced him to Prince Anton Esterházy. A hackneyed anecdote has him arranging secretly to be supplied with contrapuntal cribs by one Johann Schenk, and laughing later about fooling Haydn. But modern scholars disbelieve it. In any case, Beethoven had much to learn from Haydn just by staying close and sharing the old composer's professional life— browsing scores, discussing points of instrumentation, attending rehearsals, and exchanging the strange half-sung, half-mimed, almost wordless sentences that musicians alone understand. A testimonial of his private regard for "Papa" is a handwritten copy of Haydn's

Quartet, Op. 20 No. 1: every note reverently transcribed, as if the mere act of doing so would help him fathom the work's craftsmanship. A remark made by Mozart comes to mind: "It was from Haydn that I first learned to write a string quartet."

Outside the narrow world of instruction, Beethoven found that his piano playing and impressive social credentials were enough to open the most gilded of doors. What other new virtuoso in town could drop the names of Count Waldstein and Max Franz, as well as those of Haydn and van Swieten? If not yet a celebrity, he was fast becoming one (and "a much more cheerful person," he wrote Eleonore von Breuning).

It was hardly coincidental that Princess Christiane Lichnowsky, a cousin of Waldstein's, lived downstairs from him at 45 Alsergasse, and that she and her husband, Prince Karl, were among the most passionate music lovers in Vienna. Love and passion were noticeably absent from other aspects of their relationship. The princess, at twenty-eight, may have reminded Beethoven of his mother: she was melancholy and maritally insecure, and a double mastectomy hardly helped her self-esteem. The prince was a large, loud man of thirty-seven, lusty and extravagant. He was gifted enough to have studied with Mozart, but had an amateur's tendency to be overawed by genius. The Lichnowskys were soon competing for Beethoven's favor, with a possessiveness that threatened to become a problem one day. For the moment, he was flattered to be the protégé of such a socially prominent couple, and became a regular at the chamber concerts they held every Friday morning in their suite.

So began the first of his close relationships with members of the city aristocracy, which within a few years would spider-spin into a network intricate enough to sustain him. Through the Lichnowskys,

he met the prince's brother, Count Moritz, and the princess's mother, Countess Maria Wilhelmine Thun, a distinguished *patronne* of Gluck, Haydn, and Mozart. The Countess's other daughter, Elisabeth, was married to the enormously wealthy Russian Ambassador, Count Andreas Kyrillovitch Razumovsky. Baron van Swieten, known to all, he already knew: a summons from that austere old noble rather touchingly reads, "If you have no other engagement, I should like to have you at my house next Wednesday with your nightcap in your bag." Other luminaries attached themselves to him (filament by glittering filament): Prince Joseph Franz Maximilian von Lobkowitz and Prince Josef Johann Nepomuk Schwartzenberg, both rich enough to afford their own private orchestras; Count Johann Georg von Browne-Camus, Count Moritz Fries, and Baron Nikolaus Zmeskall von Domanovecz of the Hungarian chancellery; Prince Innocenzo d'Erba-Odescalchi; Baron Peter von Braun, lessee of the National Theater; Count Joseph Deym (who furtively preferred to be addressed as "Herr Müller" when policemen were around); Princess Josephine Sophia, wife of Prince Johann Joseph von Liechtenstein and daughter of Joachim Egon, Landgrave of Fürstenberg-Weitra. . . . These and other polysyllabic grandees applauded his "haughty" pianism and asked him to improvise on tunes by Mozart or Salieri, in the slightly raised voices of men and women unused to any refusal, whether from virtuosos or valets. Beethoven obeyed, and hated himself for obeying, aware that they held his future in their lightly clapping hands, biding time until he could have the satisfaction of saying no. At times he vented his rage on the untitled, such as one Theodora Vocke, to whom he apologetically wrote: "I am not wicked—hot blood is my fault—my crime is that I am young."

The execution on October 16 of Queen Marie Antoinette, the first Austrian aristocrat to die in the Reign of Terror, sent a wave of insecurity through the ranks of these nobles. They were aware that the French government had offered to aid any national movement aimed at overthrowing an oligarchy.

How France managed to operate with near anarchy at the center of command and near invincibility on every battlefront no one could understand, but the threat was real enough to have caused a hitherto unthinkable alliance between England, Holland, Spain, Austria, and Prussia. The general hope was that so encircling a combination would eventually contain the force of anti-imperialism, but in the fall and early winter of 1793 Beethoven's applauders needed all the musical diversion they could get.

They also took comfort in a drastic tightening of internal security. About all that survived of *Joseph der grosse*'s liberalization program was the secret-police system he had, ironically, created to enforce it. Franz II, the current Emperor, had determined on an even more authoritarian city-state. All power now emanated from himself, all privilege resided with the nobility, all civil procedure was administered by a "subnobility" of bureaucrats, bankers, merchants, and professionals, and all labor was supplied by servants and peasants, stripped of their Josephinian rights. To ensure the stability of this neofeudal structure, Franz had reinvogorated the *Polizei* as agents of discipline, surveillance, and censorship. As a result, the Vienna of Beethoven's early experience was a city much more cramped, ideologically and socially, than little Bonn, one twentieth its size. "You dare not raise your voice here," he wrote a friend, "or the police will take you into custody."

He found relief from its brittle brilliance when he returned to his

real identity as a composer. Rejoicing in solitude, he worked long hours at the piano, analyzing his own improvised passages note by note, trying to discipline the themes and harmonies that surged into his mind. He prematurely published a set of variations for violin and piano on Mozart's aria "Se vuol ballare" from *Le Nozze di Figaro*, because he was afraid that some rival might hear it and pirate it. Even at this early stage of his career, he was obsessed with the notion of intellectual-property rights. He even sternly reminded himself, when copying out a fragment of music for study, "This entire passage has been stolen from the Mozart Symphony in C."

To his embarrassment, the violin variations were issued as his "Opus 1." A composer generally reserves that catalog number for the first printed work he deems worthy of his talents. Beethoven wished he could have announced himself to the Viennese public with something much less hasty. "I do want to see my compositions appear . . . in as perfect a form as possible." He decided to let the variations live out their shelf life, and then relegate them to the ungainly archival status of "WoO" (works without opus number), shared by all his compositions to date.

More ambitiously, he worked on a piano concerto in B-flat, an oboe concerto, a wind quintet, and a wind octet. Haydn sent copies of the last three works, plus the *Figaro* variations and a fugue, to Maximilian Franz in November, citing them as proof of the diligence of "my dear pupil Beethoven, who was so graciously entrusted to me." A year had passed since the young man's arrival in town, and Haydn was aware that the Elector (now back in Bonn, but still afraid of the French) would need some reassurance before sending out another stipend. He raised the delicate subject of money, saying that Beethoven's current allowance of five hundred florins was inadequate

"even for mere living expenses" in Vienna. To protect him from "usurers," Haydn had already advanced him another five hundred in cash. "I now request that this sum be paid him." As for future compensation, "I thought that if your Reverence would allot him 1,000 fl. for the coming year. . . ."

He assured the Elector that the investment would pay off. "Beethoven will in time become one of the greatest musical artists in Europe, and I shall be proud to call myself his teacher."

Haydn's pride did not last long. On December 23, Max Franz replied:

> The music of young Beethoven that you sent me I received with your letter. Since, however, this music, with the exception of the fugue, was composed and performed here in Bonn before he departed on his second journey, I cannot regard it as progress made in Vienna.
>
> As far as the allotment which he has had for his subsistence in Vienna is concerned, it does indeed amount to only 500 fl. But in addition to this 500 fl., his salary here of 400 fl. [i.e., including Johann's pension portion] has been continuously paid to him; he received 900 fl. for the year. I cannot, therefore, very well see why he is as much in arrears in his finances as you say.
>
> I am wondering therefore whether he had not better come back here in order to resume his work. For I very much doubt that he has made any important progress in composition, and I fear that, as in the case of his first journey to Vienna, he will bring back nothing but debts.

The reaction of Haydn to this letter can be imagined. He had not only been conned out of five hundred silver pieces, but had associated himself with the future greatness of a composer whom he had not, apparently, influenced at all. In the circumstances, he would have been excused in breaking a viola over Beethoven's wig when he saw him next. However, there were to be few, if any, further meetings between them in the new year of 1794. On January 19, Haydn left for another long visit to Britain.

How they settled their accounts is not known. Haydn was as close with a kreuzer as any of the moneymen he had mentioned, so it is safe to assume that Beethoven paid him back at full interest. In the latter's defense, we should appreciate that he was faced, through no fault of his own, with real financial difficulties during his first winter in Vienna. Johann's money had taken six months to arrive. Nor had he been lazy: his contrapuntal studies were copious, and the pieces the Elector claimed to recognize may have been in fact recomposed. Nevertheless, Haydn was entitled to feel put upon. Relations between him and his "dear pupil" were never close after that.

"Courage . . . ," Beethoven wrote in a memo to himself. "This year must determine the complete man—nothing must remain undone." With Haydn conveniently out of the way, he could now switch to a theory teacher less prestigious but more professorial: Johann Georg Albrechtsberger, the Kapellmeister of St. Stephen's Cathedral. For the next sixteen months, he studied under this immensely learned man. The arcana of their joint explorations of fugues in two, three, and four voices, double fugues and choral fugues, double and triple counterpoint, and canons in all the intervals may safely be left to musicologists. It is enough to know that while Beethoven the free spirit fought against Albrechtsberger's pedantry, his

love of struggle for struggle's sake kept him coming back for more.

In another move toward self-completion, he resumed the violin lessons he had broken off as a boy, studying three times per week with the Lichnowskys' concertmaster, a plump young virtuoso named Ignaz Schuppanzigh. Thus began a friendship incalculable in its musical worth, for Schuppanzigh's fat fingers were to usher in most of his future string quartets.

Beethoven's last links with servitude broke in October 1794, after a brilliant series of French victories finally brought the Electorate of Cologne to an end. Bonn became a graying town as its middle- and upper-class youth fled colonization. Franz Wegeler was one of the hundreds who began to arrive in Vienna that fall. Another was Carl Caspar van Beethoven, now twenty: small, redheaded, ugly, and talking of a career as a music teacher. Ludwig received him with modified rapture. Their relationship—half affectionate, half hostile—is of little consequence at this stage of the family story. But it was one day to provoke the greatest crisis in Beethoven's life.

He was in his twenty-fourth year. With the closure of Max Franz's court, he could no longer rely on a salary to support himself. From now on, he would have to capitalize on his own worth as a pianist and composer.

To this could be added a considerable endowment of social success. Wegeler (disconsolate, at twenty-nine, to have had to step down as Rector of the University of Bonn) was impressed to find his old friend—an attic dweller no longer—living in great state as a guest of the Lichnowskys. Servants in the house were under orders to answer Herr van Beethoven's bell first, should he and Prince Karl ring at the same time. Ludwig had acquired a publishing agent and talked with obvious satisfaction about "one-third discounts," although Wegeler

got the impression that he knew little about money. He was, all the same, flush enough to eat out often, having no rent to pay and no shortage of rich, pretty, young piano students. He joked about being ready for marriage. If Wegeler is to be believed, the young Beethoven was "always in love and made many conquests which would have been difficult if not impossible for many an Adonis."

Somewhere around this time, he followed the example of elegant youths in many other European cities and stopped powdering his hair. The wig and queue were abandoned, the trouser band rose to his slender midriff, his jackets became darker and more flowing, the tricorn hat gave way to small toppers worn far back, like Grandfather Ludwig's turban cap. With typical tactlessness, he wrote to inform Eleonore von Breuning that an angora waistcoat she had knitted for him was "now so out of fashion that I can keep it only in my wardrobe." She declined his request for another, but sent him a hand-stitched neck cloth, to his apologetic delight. "I hardly believed that you could think me still worth remembering."

Thus attired, Beethoven was no longer a lackey of the *ancien régime*, but a gentleman of the new, less formal age. Simultaneously, his "many conquests" allowed their hair to fall into natural curls, stepped out of their hooped skirts, and, apparently content to remain in petticoats, exposed bustlines that grew higher and skimpier every season.

One's suspicion, however, is that the *über*-Adonis made most of his victories in the music room, not the bedroom. He was still— always would be—sexually shy and deferential toward women. Surviving descriptions of him by female friends, while always affectionate, dwell with regret on his physical ugliness: the swart *Spanische* complexion, the skin pits, the springing black hair and

short legs. Only the big brow was magnificent, and the clamp of his determined mouth. His stubble was so thick he had to lather it up to his eyes. Wegeler noticed a reluctance to shave or change for dinner, which was required when supping with the posh Lichnowskys.*

He took advantage of the new, looser fashions by letting them float freely around his reed-thin body: *aufgeknöpft* ("unbuttoned") became his favorite self-description, referring as much to mood as to mode. He was almost neurotically clean, reaching for the soap whenever he saw a washbasin, wearing the freshest linen, forever polishing his snow-white teeth with a napkin. This made his rare but enormous smiles particularly radiant, surrounded as they were with darkness.

At the piano keyboard—black and white engaging with black and white—the convulsive energy that made Beethoven a peril to fine china smoothed out. "His bearing while playing," Carl Czerny wrote, "was masterfully quiet, noble, and beautiful, without the slightest grimace." He sat quietly before the instrument, and produced a large volume of tone without apparent effort. His technique was remarkably coordinated, with a relaxed wrist that could discharge chords as quickly as scales, fluid arm rotation, and skips of pinpoint accuracy. One of his specialties was a triple trill: four fingers of one hand oscillating in pairs at hummingbird speed, plus two more in the other, the volume of all swelling to *forte* before quieting to an almost inaudible vibration. Nobody could match his velocity

*This may have been due more to clumsiness than nonconformity. Beethoven was unable to handle a razor safely, or even to sharpen a pencil without help. He never learned to dance in time.

in filigree passages, or his full-voiced sonority in slow movements. Years of playing the organ had given him a perfect legato. He connected any number of inner or outer voices with ease, except when, in an effect of eerie delicacy, he purposely played the bass line staccato. Each dry note, as it died, transferred its overtones to the open strings, making them resonate unstruck—further evidence that the young Beethoven had one of the sharpest ears in musical history. He accomplished such miracles, one eyewitness recalled, "with his hands so very still . . . they seemed to glide right and left over the keys."

Beyond technique, there was an indefinable dignity to his playing, a grandeur more of soul than style, free of pomposity, devoid of display, chaste in the best Classical sense. Splendidly though he played Bach, Handel, Gluck, and Mozart, he was most persuasive in his own compositions. Czerny was not the only listener to use the word *noble* in trying to describe his pianism. "I found myself so profoundly bowed down," the Czech composer Václav Tomašek wrote after hearing him, "that I did not touch my pianoforte for several days." More than forty years later, Beethoven remained for him "the giant among piano players."

This did not mean that every attendee at Lichnowsky salon was similarly beguiled. Devotees of *galant* music making recoiled from Beethoven's occasional tendency to be brutal. They wondered why these explosions always seemed to occur at moments of maximum beauty. There seemed to be something perverse about this willful young man, as though he wanted to violate his own talent. To their watercolor notion of "composition" as something clear, pretty, and small scale, he was a dauber in oil, making slash strokes on canvases too big for the prince's drawing room.

Vienna was not yet *directoire* Paris in the spring of 1795. For that

matter, neither was Paris—quite yet. But the Revolution was now consummated, and to Beethoven's more forward-looking listeners, especially young ones, the violence and bigness of his style matched the new aesthetics of force and "unbuttoned" emotion. It was not Mozartian, not always nice—but it was irresistible.

There are two schools of academic thought as to which piano concerto Beethoven played at his public debut on March 29. Some scholars hold that it was his first, in B-flat major. Others believe it to have been his second, in C major. Yet all insist on calling it "Beethoven's Second," since it was published after the concerto he wrote second, known as "Beethoven's First." The Second is nevertheless considered his first, because he wrote its first movement in Bonn. Its second movement, however, may not be the one he wrote first; he seems to have composed a *second* second movement after writing the second movement of the First. Clarifications of this sort are what make musicological conferences so interesting.

The debut controversy might never have arisen had Beethoven's nineteenth-century biographer, Alexander Wheelock Thayer, not waved aside a firsthand account by Franz Wegeler. According to Wegeler, Beethoven, suffering from an attack of nervous colic, did not finish composing his "entirely new" concerto until the afternoon of Friday, March 27. The last sheets of manuscript were distributed among four copyists literally as he wrote them. At the rehearsal the next day, the pianoforte was found to be tuned a semitone too low. "Without a moment's delay Beethoven . . . played his part in C-sharp." Wegeler makes a point of this pitch. Thus, when Beethoven repeated the piece publicly, on Sunday afternoon, playing a correctly tuned instrument in Vienna's Burgtheater, he and the orchestra were united in C major—the defining key of his "First" Piano Concerto.

No reviews survive, but he was invited back the following day to improvise before a capacity audience. On Tuesday, March 31, he performed a Mozart concerto in the presence of the composer's widow, Constanze. Short of being commanded to play at Schönbrunn Palace, Beethoven could hardly have been more graced with Viennese favor.

He now prepared to publish an official "Opus 1" impressive enough to erase memories of those violin variations of two years before. But what should this all-important first release be? He did not feel that either of his piano concertos was good enough, and besides preferred that they remain in manuscript for a while, as unique performing repertory. The trios were more ready—he had been laboring to perfect them since Haydn's departure—and had the obvious potential of interesting three times as many people. Trusting, it seems, in three as his lucky number, he placed the first of three advertisements in the *Wiener Zeitung* on May 9, soliciting subscriptions to the trios. Three days after the last notice, he signed a publishing contract with Artaria, Vienna's top music house.

The contract, standard for its day, called for Beethoven to share the cost of a first printing of his new opus for private subscription. Such an edition, typically engraved on premium stock, was supposed to be profitable in itself. If too few customers subscribed, or the copies were priced too low, the publisher could always run off a later, cheaper impression for free-market sale. But a failed subscription boded ill for future offerings. The initial quoted price was therefore an important gamble, balancing the greed of the composer against the desire of men such as Lichnowsky to possess something newly created, semi-exclusive, and luxuriously bound.

Beethoven therefore took his future in his hands when he de-

cided to ask one gold ducat for each copy of Op. 1 ordered. At a print cost of one florin per suscription that should net him four florins for every copy—a greedy profit indeed. But before he saw any black in his budget, he had to pay Artaria 212 florins just for the plates. That investment (assuming clearance of his debt to Haydn) put him deep in the red. The forced joviality of a letter written about this time to Baron Zmeskall of the Hungarian chancellery speaks for itself: "Yes, dearest Conte, my intimate amico, times are bad. . . . We, most gracious Lord, are driven to condescend to ask you for a loan of five gulden which we will bestow upon you again in a few days."

His gamble paid off. No fewer than 249 subscribers flocked to purchase copies. Prince Lichnowsky alone ordered twenty, and may have paid for the plates as well. If so, Beethoven realized a total profit of well over one thousand florins—enough to live on for another year.

The Op. 1 trios, dedicated to Lichnowsky, were also a big success for Artaria, which reprinted them three times for popular distribution at home and abroad. Beethoven's career was thus brilliantly launched, with three works that to this day exude the delicious fragrance of youth. The first two, in E-flat major and G major, open with epigrammatic allegros that are the musical equivalent of the wordplay contests beloved of eighteenth-century French wits. Piano, violin, and cello constantly cap one another's *mots justes.* Slow movements of great melodic beauty follow, plus scherzos and finales that fizz with high spirits. The last trio, in C minor, is more somber and densely constructed. With its chromatically side-slipping initial theme and taut set of variations, it invokes Mozart's great piano concerto in the same key (of which Beethoven was once heard to say, with rare humility, "We will never be able to do anything like that").

Count Waldstein's valedictory instructions were at last fulfilled. Not only the spirit of Mozart but the hands of Haydn were palpable everywhere: in the scherzos (a form Haydn invented), in motivic play and effortless counterpoint. Yet the trios pulsated throughout with original touches—what a contemporary critic called "confused explosions of the impulsive bravado of a talented young man."

Haydn returned from England at the end of August. An oft-repeated anecdote has him listening to the trios in Lichnowsky's salon and saying, patronizingly, that Beethoven would be well advised "not to publish the third one in C minor."

With all of them already in print, this sounds like superfluous advice. The anecdote surely refers to a later Lichnowsky concert, in September or October, when Haydn was again the auditor of three new works by Beethoven. These were the Piano Sonatas, Op. 2, as yet unpublished.

Beethoven himself played the new set to Haydn. The third sonata, in C *major*, was so technically difficult as to justify his cautionary remark. Haydn was otherwise complimentary. Beethoven dedicated the sonatas to him, but persuaded himself that the old man was "envious."

Who envied whom is debatable. If Haydn's first trip to London had been successful, his second was spectacular, showering him with money and honors. During eighteen months away, he had composed five symphonies and six string quartets of sublime quality, and been besought by King George III to remain in Britain permanently. But courtier's instinct brought him home to await the orders of a new employer, Prince Nicolaus Esterházy II. Haydn found out to his relief that all that was demanded of him was one mass per year, to be sung at Eisenstadt. He retired to new lodgings in the Kruger-

strasse, and for the next two and a half years his former pupil saw little of him.

The appearance of the Op. 2 sonatas was almost anticlimactic, so steady was the flood of new compositions that now poured from Beethoven's pen. He wrote five trios for strings and a trio for piano, clarinet, and violin; a quintet for strings and another for piano and winds; a sextet for strings, another for strings and two horns, and another for winds; two cello sonatas, three violin sonatas, and seven piano sonatas. There were also scattered songs and a concert aria for soprano. In a lighter vein, he wrote mandolin music, eight sets of showy variations, and a piece of nonsense called a *Duet with Two Obbligato Eyeglasses*.

His self-discipline in the midst of inspiration becomes apparent when one notices that this flood consists almost exclusively of chamber music. And even in that category, there is a deliberate omission: the string quartet. He wanted to leave that purest of forms alone until he had mastered the art of writing for other ensembles.

Beethoven's career as a pianist burgeoned in 1796 with a five-month tour through Bohemia, Saxony, and Prussia. "I shall earn considerable money," he wrote from Prague to his youngest brother. Nikolaus Johann had inevitably followed Carl Caspar to Vienna, and was working as a clerk in a pharmacy. "Johann" and "Caspar"—to use their familiar names—were interested in Ludwig's new prosperity. As his naïve boast suggested, he was not fiscally responsible. He always wanted more money than contractors could afford, but that was a matter of pride; once ducats were credited to him, he was a free spender and generous lender. Jovially warning Johann to "beware of the whole guild of wicked women," he added, "I hope that your life

will grow in happiness and to that end I hope to contribute something." It was a letter full of sad portent for both of them.

His visit to Prussia climaxed with an improvisation before the Berlin Singakademie that so stunned the members that they crowded around his piano, weeping. He also played twice before King Friedrich Wilhelm II, who rewarded him with a gold snuffbox full of louis d'or. With another golden gift from the Elector of Saxony, and numerous fees, he was belatedly experiencing the youthful triumphs of Mozart.

Anointed by royalty and glowing with commercial success, he began to give off an unmistakable aura of celebrity. "Whoever sees Beethoven for the first time and knows nothing about him," wrote Baron Kübeck von Kubau, "would surely take him for a malicious, ill-natured, quarrelsome drunkard. . . . On the other hand, he who sees him for the first time surrounded by his fame and his glory, will surely see musical talent in every feature of an ugly face."

He was back home by the end of July, in time to hear agitated talk of "Buonaparte," the young Corsican general who was humiliating the Austrian army in Italy. Nearer home, Archduke Charles was barely holding back the French army of the Rhine. With other allied capitals treated out of the war, imperial Vienna loomed as Paris's opposite pole, the ultimate prize of revolution. It could not have been a happy city to return to.

Beethoven's summer was further clouded by an illness that Franz Wegeler reported as "dangerous." It was brought on by his hypertense habit, when hot, of standing half naked in an open window. There is some reason to believe that he succumbed to typhus, with disastrous future consequences. However, he was well enough in late November to keep a concert engagement in Pressburg, where he jok-

ingly complained that the piano was too good for him. "It robs me of the freedom to produce my own tone."

His output of chamber compositions resumed during the winter. Vienna had an insatiable appetite for this type of music. Not even the entry of Napoleon into the Tyrol in the spring of 1797 was permitted to delay the premiere of Beethoven's quintet for piano and wind instruments, Op. 16. But by April 17 the French were so close—just sixty miles from Vienna—that the city's home guard was called out. Beethoven wrote a war song for the unfurling of its banners. Fortunately for his twentieth-century reputation, an armistice was declared the next day, so the song, entitled "*Ein grosses, deutsches Volk,*" was forgotten. Joseph Haydn's earlier patriotic contribution, a superb hymn in praise of Emperor Franz II, was not. Soon known throughout Austria as the "*Kaiserlied,*" it survives today as the national anthem of Germany.

Haydn returned to apparent retirement after publishing his piece. The common assumption was that "Papa," at sixty-six, was written out. Beethoven knew better. Georg Albrechtsberger confided: "He is carrying around in his head the idea of a big oratorio which he intends to call *The Creation* and hopes to finish it very soon. . . . I think it will be very good."

Any doubts regarding that were erased when the new work received its first private performance at the Schwarzenberg Palace on March 9, 1798. Beethoven was not reported as attending, but since all Vienna's musical élite were there, from Baron van Swieten on down, his presence may be considered a virtual certainty. The effect of *The Creation* upon him was profound.

In the words of *Grove's Dictionary of Music and Musicians*, "Perhaps no other piece of music has ever enjoyed such immediate and universal acceptance." Bigger in its proportions than any oratorio

since Bach's, Handelian in the power of its choruses, yet contemporary in its melodic and harmonic language, *The Creation* amounted to a consummation of the High Classical style. Its opening orchestral number, "The Representation of Chaos," began with a held, hollow unison, and proceeded with wind chords that floated chromatically, before resolving in darkest C minor. (Where had Beethoven heard *those* sounds before?)

A bass soloist sang, "In the beginning, God created the heaven and the earth." The chorus followed on, softly singing the words of Genesis. "And God said, 'Let there be light.'" The last consonant, especially dental in German, precipitated a dead silence. (Where had Beethoven heard *that* effect before?) One of the great moments in music was coming. Haydn, conducting, remained expressionless. Even more softly, still in C minor, the chorus intoned, "And there was—" The word "*Licht*" exploded at maximum volume, in brightest C major, while the orchestra surged over a blare of trombones. (How Beethoven would revel in *that* noise one day!)

When pondering the mysteries of creation—for that matter, of *The Creation*—it is important to remember that there are only twelve tones in the Western musical scale. The deployment of those tones, and their attendant harmonies, inevitably leads to common formulations and coincidences. It is as easy to find that one composer has plagiarized another as to "prove" that Bach and Handel constantly repeated themselves. The suggestion, then, that in old age Haydn imitated some passages in a cantata Beethoven had shown him in Bonn almost eight years before may be presumptuous. And neither man could lay claim to the key of C major. But the seeds of inspiration are planted in strange places, and flower, often after long delay, without conscious watering.

More remarkable than any sounds and silences that possibly sounded familiar to Beethoven in part 1 of *The Creation* was the cantilena of Adam and Eve in part 3. Again, a long, slow melody pursued an orbital arc, softly joined the second time around by choral harmonies. Beautiful though the number was, he could at least say that here was something he had done rather better, at age nineteen.

But Vienna—fickle, fashionable, frightened Vienna—had no interest in anyone's past. It was concerned only with the celebrity of the moment, and that was, manifestly, "Papa" Haydn redux. The old man had demonstrated that Austrian culture had power to face the coming century without radical change. Maybe, with a peace treaty being negotiated on last year's armistice, the revolutionary threat of the last decade had been contained, and Vienna could recover its traditional courtly stasis.

Courtliness and containment—the twin essentials of High Classical style—were as much a part of Haydn's musical personality as wildness was a part of Beethoven's. It was just as well *he* had not been asked to compose a representation of chaos! Miraculously, Haydn had managed to do so without afflicting any powdered head with a sense of harmonic or formal disarray. On close analysis, the old man had merely postponed cadences again and again, or only half resolved them, in order to convey a vague state of disequilibrium. But his modulations fell into logical patterns, and his overall design was sonata form. Eighteenth-century to the core, he could not imagine anything "without form, and void," unless he fixed it inside the frame of Reason.

To such a man, and to such audiences, the century coming was a vast imponderable, best ignored if it could not be avoided. To Beethoven, full of pre-Romantic yearnings, it could not come too soon;

but *when* it came, he had to be established as Haydn's logical successor. Despite a catalog of works in print that now stood at twenty-three items, he was still better known as a pianist than a composer. And there were warning signs that his latest music was bothersome to orthodox opinion. A new musical magazine, the *Allgemeine Musikalische Zeitung,* accused him of "strange modulations" and other "perversities"—citing, by way of example, his "objection to customary associations." No phrase could more cogently express conservative dread of the unexpected.

Beethoven knew that he must do what Mozart had done, and present himself to Vienna as a universal talent. He needed to write a popular hit for parlor performance, then a symphony in approved Classical style, and after that an opera powerful enough to erase memories of Haydn's rather weak attempts at music drama.

Pursuant to this ambition, he canceled a fall tour of Poland, and set himself up as a self-employed artist, independent of aristocratic favor. Disregarding Prince Lichnowsky's palatial chambers, he rented an apartment in St. Petersplatz, just off the Graben in central Vienna. It was a third-floor walk-up, but it was home, for as long as his restless spirit could stay there. He cut down on social engagements, and buried himself in work.

Reclusive as he began to be, he was never monastic. Visitors were welcome, especially young ones in high-waisted dresses. Many decades later, Countess Therese Brunsvik recalled climbing those three flights of stairs "in the last year of the last century" with her sister Josephine, a volume of music under her arm. Beethoven was "very friendly," and accompanied Therese as she sang for him.

One thing struck her as odd. His piano was out of tune.

Chapter Three

The Creature of Prometheus

THE ADVERTISEMENT, in the *Allgemeine Musikalische Zeitung*, was certainly impressive. It dropped all the right names, and italicized the most important one no fewer than five times:

> Today, Wednesday, April 2, 1800, Herr *Ludwig van Beethoven* will have the honor to give a grand concert for his benefit in the Royal Imperial Court Theater beside the Burg. The pieces which will be performed are the following:
>
> A grand symphony by the late Kapellmeister Mozart.
>
> An aria from "The Creation" by the Princely Kapellmeister Herr Haydn, sung by Mlle. Saal.
>
> A grand Concerto for the pianoforte, played and composed by Herr *Ludwig van Beethoven*.
>
> A Septet, most humbly and obediently dedicated to Her Majesty the Empress, and composed by Herr *Ludwig van Beethoven* for four stringed and three wind instruments,

played by Herren Schuppanzigh, Schreiber, Schindlecker, Bär, Nickel, Matauschek and Dietzel.

A Duet from Haydn's "Creation" sung by Herr and Mlle. Saal.

Herr *Ludwig van Beethoven* will improvise on the pianoforte.

A new grand symphony with complete orchestra, composed by Herr *Ludwig van Beethoven*.

Short of strutting onstage in Johann Sebastian Bach's wig, Beethoven could hardly have done more to proclaim himself the coming man of German music. He had planned the evening's entertainment with the utmost care, in order to please a large, middlebrow audience. And please it did. "This was truly the most interesting concert in a long time," the *Zeitung* reported afterward. Beethoven the composer won praise for his "taste and feeling," as did Beethoven the pianist for his "masterly" performance at the keyboard.

Perhaps the best news was that his new Symphony in C major, Op. 21—a work so politely polished and modestly proportioned as to pass for a divertimento—had won favor for its "considerable art, novelty and a wealth of ideas." And not even the reviewer's caveat that "the wind instruments were used too much" prevented the Septet from becoming the most popular piece of music Beethoven ever wrote. Graceful, melodious, delicately scored for its unusual ensemble (clarinet, horn, bassoon, violin, viola, cello, and double bass), it proved that yesterday's dealer in "perversities" could be as *galant* as any salon entertainer. Beethoven grew to detest every mellifluous note of the Septet. "In those days I did not know how to compose."

Since the concerto he played was not billed as "new," it was unlikely to have been his third, in C minor, a big, brooding work that he would keep tinkering with for several years. A more likely candidate is its slight predecessor in B-flat, Op. 19. "Not one of my best," he admitted. But it had hummable tunes and catchy syncopations, and served its public-relations purpose.

Beethoven was established at last as a popular young composer in Europe's major music center outside of Paris and London. He was twenty-nine years old and prosperous, with a servant and a horse, and fees rolling in from publishers, impresarios, and piano pupils.* His share of the box-office receipts of his *Akademie*—as composer-benefit concerts were called in Austria—was very likely substantial. And Prince Lichnowsky had just begun to pay him an annuity of six hundred florins.

This meant that Beethoven could now afford to rent a summer apartment in one of the hillside wine villages around Vienna. By July he was quartered in Unterdöbling, about one hour's walk north of the city. The scenery there included a pretty peasant girl who was rumored to be at home in the hayloft in more ways than one. Beethoven ogled her with such fierce intensity as to make her giggle. He was unconscious of his growing strangeness: the wild black hair, the ink-blotched hands, the hummings and groanings as he responded to music in his head. (The painter August von Klöber was struck by his "listening" attitude on one of these occasions.) He had a compulsion to nail every thought before it escaped him. He would stand scribbling against tree trunks, at the side of the road, halfway

*Beethoven soon forgot about the horse, to his servant's private profit.

through eating, halfway through shaving—on fistfuls of manuscript paper or in large sketchbooks that bagged and dragged at his coat pockets. In an emergency, any wall or window shutter would do.

At Unterdöbling, he fell into the annual routine he would pursue for the rest of his life: spring, summer, and early fall spent sketching music in the woods or wine country, winter in the city rendering his sketches into finished compositions. Thus the season of growth became associated in his mind with creativity, and leafless days with copying, tryouts, rehearsals, concerts, and contracts. Throughout the year, he rose at dawn, breakfasted and brewed himself the strongest possible coffee (carefully counting out sixty beans per cup), then worked till midday at his "piano desk," which allowed him to write and play at the same time. Since he was right-handed, he tended to search out chords and figurations with his left. This habit seems to have led to another association, between sound, literally on the one hand, and craftsmanship on the other. Friends noticed that his improvisations at the keyboard usually began with a southpaw roulade in F major, as though he was channeling music down that arm.

If the word *bipolar* can be detached from its associations in another, jargon-prone age, it would seem to have applied in its fullest sense to Beethoven. Physically, psychologically, musically, socially, he stood, like Leonardo's circumscribed man, between contrary force fields. The way he held these off, while at the same time securing them, gave him his dynamism. Throughout his mature years now beginning, he fought for a balance—often precarious, yet always managed—between the rush of ideas and the constraints of intellect, between hyperactivity and ill health, gregariousness and misanthropy, ethics and mendacity, humor and depression, and other absolutes of character or fate. His very music, going back at least as far

as that unheard self-announcement, the *Cantata on the Death of Emperor Joseph II*, consisted of a clash of opposites. Whether it was major against minor over the course of an entire symphony, or the masculine-feminine contrast of craggy and seductive themes in a single movement, or the structural split, like that of xylem and phloem, in the cross-section of his tiniest motifs, all was tension, everything had to be resolved.

He spent the summer of 1800 struggling with pieces whose whole *raison d'être* seemed to be difficulty. One was the Piano Concerto in C minor, modeled only superficially on his favorite Mozart concerto, K. 491, in the same key. To Mozart, the word *concerto* derived from the Italian "*concertare,*" "to join together." To Beethoven, its semantics went back to the Latin "*concerto,*" "I strive," or Cicero's "I oppose." Mozart had not bothered to write a cadenza in his first movement, allowing the soloist an improvisatory pause before ending with piano arpeggios in quiet consonance with the orchestra. Beethoven composed a titanic cadenza that evaporated mysteriously into a diminished seventh chord—the most ambiguous in music—over quiet, threatening drum taps. His own arpeggios, when they came, were not so much consonant as distant sounding, as if no "join" between soloist and tutti was conceivable. Then a big crescendo swept them together, but they battled for supremacy until the last loud unison.

Mozart, and to a greater extent Haydn, also loomed over his other major task before fall: completion of a set of six string quartets for Prince Lobkowitz. Beethoven had been agonizing over them for the better part of two years, aware that such a connoisseur was not likely to be fooled by the success of his *Akademie*.

Lobkowitz understood that string-quartet writing was the most

rigorous of all musical disciplines. He had awarded a similar commission to Haydn, but the old man was not strong enough to deliver more than two. They were, however, superb. Behind them stretched a thirty-year production of nearly seventy quartets, matched in excellence only by the famous set that Mozart had composed in 1785—and dedicated to Haydn.

The Viennese aristocracy, often mocked for the frivolity of its operatic entertainments, was much more serious about chamber music. An almost churchly reverence obtained at venues devoted to small ensembles, such as the Friday matinée series, cohosted by Prince Lichnowsky and Count Razumovsky, that primarily showcased the string quartet. Mozart and Haydn were but two of many composers who had made the form into something of a local specialty over the last quarter century.

Beethoven therefore inherited the quartet at its peak of High Classical development. Given the sophistication of chamber-music devotees, he saw no need to cramp his own originality, as he had in his First Symphony. He was, however, new to the challenge of writing for four equal string players. It was as much theatrical as musical. Any playwright of middling skills, any young composer, could concoct a vehicle for a star and supporting cast. But a lifetime's experience of drama was needed to perfect a four-way conversation that ranged from monologue and dialogue through arguments, polite interruptions, and repartee to a final consensus, without any player feeling that he had been upstaged. "Papa" had begun to gather that experience before Beethoven was born.

All of which explained the latter's obsessive writing and rewriting before he presented his "Six Quatuors," Op. 18, to their dedicatee in mid-October. Joseph Franz von Lobkowitz was not quite

twenty-eight years old, club-footed, shy, fabulously wealthy and fabulously extravagant, a rival to Prince Lichnowsky as Beethoven's most generous patron. Securing the set was something of a coup for him, because Lichnowsky would have loved the honor.

But Lobkowitz had been the first to come up with four hundred florins in ready coin, and Beethoven—relentlessly ambitious behind his crazy-composer demeanor—wanted to make the best friend possible of the young prince. Lobkowitz was one of the last aristocrats in Vienna to maintain a full orchestra. If gratified by the quartets, he might be relied on for even more profitable commissions in future. He was a fine violinist and singer, more congenial to Beethoven than the brash Lichnowsky.

Both princes seemed unaware, as they continued to invest hugely in their music libraries, their concerts and composers, that the age of highbrow munificence was coming to an end. Already in Paris and London, the powdered patrons of pre-Revolutionary days had given way to *nouveaux riches* entrepreneurs who were less interested in culture than prodigal displays of kitsch. Austria (buffeted again by war with France, after the failure of the Peace of Campo Formio) was clearly going to have to give up its Italian possessions, and the revenues thereof. The new century now looked to be a time of economic retrenchment and ominous social change, neither of which boded well for Vienna's first families.

Or so historical hindsight would have us assume. The turn of the century was but three weeks off when Josephine Brunsvik, one of the Hungarian girls who had stood over Beethoven's out-of-tune piano the previous spring, wrote her sister a letter as innocent of great events as any page by Jane Austen. Reading it, one would not guess that Austria had just been devastatingly defeated at the battle of

Hohenlinden, and that thousands of soldiers were being carted into Vienna with revolutionary bullets in them. Josephine was now married to Count Joseph Deym, and living in an eighty-room mansion. Her letter to Therese, dated December 10, 1800, has the faded inconsequence of something stuck in a rococo scrapbook. But it is worth quoting because it mentions the first known performance of Beethoven's Op. 18:

> We had music in honor of the archduchess. . . . Our rooms were so beautiful that you would have been enchanted. All the doors were opened and everything lit up. I assure you it was a splendid sight! Beethoven played the sonata with violoncello, I played the last of the three sonatas [for piano and violin, Op. 12] with Schuppanzigh . . . who played divinely like everybody else. Then Beethoven like a true angel let us hear his new still unpublished quartets, which are the most excellent of their kind. The renowned Kraft undertook the 'cello part, Schuppanzigh the first violin. Imagine what a pleasure it was!

Imagination, alas, is all there is to evoke any more of that long-ago evening, with candles flaring down the halls of the great house and the sound of new music rolling unencumbered from room to room. Listening to Beethoven's Op. 18 quartets now, one hears little more than the graceful melodies, the transparent counterpoint, the thematic economy of High Classicism. But the *more* that sounds so slight to us now—insistent repetitions, delays of resolution, modulations away from central keys—was, to the young people named in Josephine's letter, big with change.

Older ears were less thrilled. As far as Haydn was concerned, all that was big about Beethoven was his self-importance. "How goes it with our Great Mogul?" he would say to mutual acquaintances, clearly peeved that his former pupil no longer paid court. But the two composers appeared together amicably in the new year, at a benefit concert for Vienna's war wounded. Haydn conducted a pair of his symphonies, and Beethoven accompanied a horn player in his Sonata for Piano and Horn, Op. 17.

It was a solemn occasion, with the Peace of Lunéville about to be signed. Austria's humiliation at Hohenlinden was compounded by its loss of the western Rhineland as well as Italy, while Great Britain and Russia could no longer be counted on as allies against Napoleon Bonaparte.

Beethoven shared the general unease about the rise of that ultimate *petit homme bourgeois* to supreme power. As First Consul of France, Napoleon now loomed so large in German imagination as to assume godlike proportions—inspiring to some, threatening to others. Beethoven wavered between these attitudes, but, being more susceptible to myth than ideology, was inclined to marvel at the man's seemingly superhuman abilities. There was a degree of self-identification in this admiration. Napoleon was only a year older than himself, also a poor child of the provinces and an immigrant to the center of power, whose nature was to fight and refashion the law to his own advantage. Both men thrilled to the idea of a new order—Napoleon in society, Beethoven in harmony. They shared an essentially eighteenth-century faith in reason, and equated the popular will with vulgarity.

A major difference, of course, was that only one was aware of the other in 1801. Beethoven intended to adjust that inequity. "It's a

shame that I do not understand war as well as I do the art of music. I would conquer him."

Instead, he was himself conquered—invaded, rather—around this time by a musical theme that was Napoleonic in its power to take over everything in sight. At first it sounded so trivial, so tum-tee-tum, that he published it in a set of party pieces for Viennese youth to dance to. No doubt he expected to forget it. But something about its rhythmic vigor stuck in his mind when he received a commission to write a ballet for the court spring season, entitled *The Creatures of Prometheus*.

Whether or not Salvatore Viganò, the choreographer, overtly meant to identify Napoleon with Prometheus, he admitted the plot of his ballet was "heroic" and "allegorical." It represented the fire-bringer of Greek legend as a titan capable of transforming clay into flesh. Descending deus ex machina upon a pair of statues, male and female, Prometheus found them, in Viganò's words, "in a state of ignorance," unable to feel or think. He warmed them to life with his torch, then "refined them through science and art, and imparted to them morals."

No scenario could be more calculated to appeal to Beethoven. He wrote the music—an overture, sixteen scenes, and a finale—rapidly, resisting any impulse to weigh it down with symphonic ideas. But when he came to the last number, with Prometheus, Pan, and a company of fauns caught up in a whirling celebration, he found that his little *contredanse*, rescored for full orchestra, struck the right triumphant note.

The Creatures of Prometheus was a smash hit, and played twenty-seven performances at the Imperial Court Theater. Beethoven's professional advance now seemed unstoppable. His Septet, early piano

concertos, and First Symphony were finding high favor all over Germany, and the Septet had even succeeded in London: his first taste of overseas fame. He had ten piano sonatas in print, and several more composed, plus a couple of dozen other chamber works published or ready to publish. Commissions were coming in faster than he could handle them. He boasted that he could sell any new piece six or seven times over—"I ask and they pay." He had new rooms in the Seilerstätte with a fine view west across the ramparts. And there was at last a woman in his life who appeared to be in love with him: a sixteen-year-old Italian countess named Giulietta Guicciardi. Beethoven would appear to have reached that intoxicating first plateau of success, when a man still young realizes that, bar unforeseen calamity, he is destined for higher and higher altitudes.

Then, on June 29, 1801, he wrote a shock letter to Franz Wegeler, who was once again living in Bonn.

> For the last three years my hearing has become weaker and weaker. The trouble is supposed to have been caused by the condition of my abdomen. . . . I have been constantly afflicted with diarrhea and have been suffering in consequence from an extraordinary debility. Frank* tried to *tone up* my constitution with strengthening medicines and my hearing with almond oil, but . . . my deafness became even worse and my abdomen continued to be in the same state as before. Such was my condition until the autumn of last year; and sometimes I gave way to despair. . . .
>
> During this last winter I was truly wretched, for I had

*Dr. Johann Frank, director of the Vienna General Hospital.

really dreadful attacks of colic . . . and thus I remained until about four weeks ago when I went to see Vering.* Well, he succeeded in checking almost completely this violent diarrhea. He prescribed tepid baths in the Danube, to which I had always to add a bottle of strengthening ingredients, . . . pills for my stomach and an infusion for my ear. As a result I have been feeling, I may say, stronger and better; but my ears continue to buzz and hum day and night.

In all biography, there are few images more grotesquely sad than that of Beethoven, racked with cramps, bathing in fortified river water and trying to drown the noise in his head with almond oil.

Elsewhere in his letter, he described his health as "a jealous demon" who never left him alone for long. Wegeler did not need to be reminded of the nervous colic that had preceded the première of Beethoven's first piano concerto, nor of the mysterious illness that nearly killed him in 1796. To a man of music, deafness was the most demonic plague of all:

I must confess that I lead a miserable life. For almost two years I have ceased to attend any social functions, just because I find it impossible to say to people: I am deaf. If I had any other profession, I might be able to cope with my infirmity; but in my profession it is a terrible handicap. . . . Let me tell you that in the theater I have to place myself quite close to the orchestra in order to be able to understand what the actor is saying, and that at a distance I cannot hear the high in-

*Dr. Gerhard von Vering, an eminent Viennese physician.

struments or voices. As for the spoken voice it is surprising that some people have never noticed my deafness; but since I have always been liable to fits of absentmindedness, they attribute my hardness of hearing to that. Sometimes too I can hardly hear a person who speaks softly; I can hear sounds, but cannot make out the words. But if anyone shouts, I can't bear it.

Wegeler was medically trained, and able to read this poignant information (symptomatic of the neuro-auditory disease tinnitus) with some detachment. One wonders, however, what he made of the sudden change of tone when Beethoven, sounding almost cheerful, began to boast of how busy he was.

A distinguishing characteristic of the creative mind is that it can accept reversals of fortune without emotional damage—indeed, process them at once into something rich and strange. Ordinary psyches often react to bad news with a momentary thrill, seeing the world, for once, in jagged clarity, as if lightning has just struck. But then darkness and dysfunction rush in. A mind such as Beethoven's remains illumined, or sees in the darkness shapes it never saw before, which inspire rather than terrify. This "altered state" (*raptus*, he would say) makes art of the shapes, while holding in counterpoise "such dualities as intellect and intuition, the conscious and the unconscious, mental health and mental disorder, the conventional and the unconventional, complexity and simplicity."*

Thus, when Beethoven confessed his deafness to another close friend, Karl Amenda, two days later, he borrowed the language and

*These are the words of the creativity specialist Frank Barron.

symbols of his new ballet scenario. "Your B is leading an unhappy life, quarreling with nature and its creator, . . . cursing the latter for surrendering his creatures to the merest accident." Even in the grip of catastrophe, he was still thinking of Prometheus, but thinking ahead rather than back, as the very etymology of the god's name encouraged him to do: forward to a new consummation of the gifts within him.

He was not finished with the bringer of creative fire, any more than he was with Napoleon, the torchbearer of revolution. Notwithstanding the success of *The Creatures of Prometheus*, he still did not feel he had made the most of that surging theme.

"Well, I heard your ballet yesterday," Haydn said when they ran into each other, "and it pleased me very much!"

"O dear Papa, you are very kind, but it is very far from being a *Creation*!"

Haydn was not sure how to take this. After a pause, he said, "Well, that is true," and walked on.

Beethoven spent the summer of 1801 at Hetzendorf, a village just beyond the Schönbrunn park. The imminent publication of his First Symphony seems to have stimulated him to begin his Second, in D major, a work of much larger proportions and less cautious style. Work on it proceeded slowly, because he was also composing a quintet in strings, two violin sonatas, and no fewer than four piano sonatas, one of which was unlike any music ever written before.

Instead of beginning with the "calling-card" announcement of key and first theme that had become a cliché of Classicism, it emerged from silence almost inaudibly at first, as if Beethoven was testing the limits of his once-phenomenal hearing. In Italian, he di-

rected that both pedals of the piano be held down nonstop, rarify-ing the sonority yet lengthening the reverberation (*Si deve suonare tutto questo pezzo delicatissimamente e senza sordino*). Quiet undula-tions of C-sharp minor succeeded one another, their overtones mixing and dissolving. Far beneath them, empty octaves moved with extreme slowness, while the undulations hardly changed level. The effect was of an almost immobile pool of harmony: dark water before moonrise. When a theme did float in above (still pianissimo), it was at first more monotonal than melodic. The note G-sharp chimed softly and repeatedly. Every now and again a minor ninth, one of the most painful discords in music, shivered the surface of the pool until the undulations smoothed it out. For more than six minutes this hypnotic balance of action and inaction persisted, centering on the paradox of a climax with no increase in volume: the music simply evaporated into a sort of spiraling mist that fell without condensing.

It was the sound of Chopin—specifically, his nocturne in the same key, right down to the minor ninths—conceived almost ten years before Chopin was born. It was even the sound of Debussy, a hundred years off, in its washes of pure color and separation of reg-isters. Yet the most extraordinary thing about this first movement of Beethoven's *Sonata quasi una Fantasia*, Op. 27 No. 2 (soon nicknamed the "Moonlight"), was that it was cast in regular sonata form. Not now, or ever, could he be called a Romantic; his fantasy was always *quasi*, his structure always rational.

If the movement's exploration of the most delicate possible aural nuances can be heard as a deafening man's attempt to hold on to the sensuality of pure sound, then the finale that followed, after a dance-like interlude, was just as physical: it leaped out of the lower regis-

ter of the instrument with tigerish force. Again, nothing like it had been heard before. Again, Beethoven anticipated Chopin, switching from pure euphony to feral violence.

"I will seize Fate by the throat," he wrote, in another letter to Wegeler. "It will certainly not bend and crush me completely."

Beethoven scholars endlessly debate the parameters of his famous "three periods" of compositional style (when they are not proposing that he had four or five). The first is most often characterized as "Classical," the middle period as "heroic," and the third as "sublime." Such restrictive adjectives ignore his ability to write a heroic memorial cantata at nineteen, or a dance as *galant* as the fourth movement of his late Op. 130 Quartet. Nor do they apply to a work as unique as the "Moonlight" Sonata—"one of those poems," Hector Berlioz remarked, "that human language does not know how to qualify."

However, Beethoven did, on the whole, compose quite differently in his thirties than he had in his twenties, and would change his style yet again in the metaphysical music of his last years. Perhaps it is only the notion of hard parameters that merits debate. Beethoven's periods are like the "color-fields" of Mark Rothko, in that they are perfectly distinct yet ambiguously linked. On close inspection, what seems to be division is only transition. The brushwork is that of one artist, changing as he paints. Most of the compositions Beethoven worked on through the spring of 1802—in particular the delightful Second Symphony—have this dissolving quality. They sometimes seem to flow one way, sometimes the other.

So did his hearing ability, and as a result, his moods. "I will not play for such swine!" he shouted during a recital at Count von Browne's summer palace in Baden. A young couple was talking in

the doorway of the next room. Beethoven was going through a prolonged health crisis, and was not sure from day to day whether it would be resolved medically, creatively, or sexually in marriage. Dr. Vering's treatments for deafness extended to the regular application of bark "vesicatories" on the upper arms. These painful implants, which had to remain in place for days, "until the bark has had its effect," kept him from his piano-desk.

"People speak of the wonders of *galvanism*," he wrote Wegeler in desperation. "What do you say to that?" At least his intestinal complaint seemed to be responding to hydropathic and herbal treatments. "I am living more pleasantly now, since I mingle more with people. You will scarcely believe how lonely and sad my life has been for the last two years."

Evidently he had begun to master the deaf person's art of pretending to hear more than he did. In fact, he still heard enough to get by: clinical "stone" deafness was many years away. A discreet awareness of his problem spread among Vienna's well-informed. Therese Brunsvik understood the out-of-tune piano, Haydn the failure to make calls, Lichnowsky and Lobkowitz the fear of large receptions, and little Carl Czerny, his youngest pupil, why Herr Beethoven sometimes wore cotton plugs in his ears, dabbed with yellow medicine.

Beethoven admitted to Franz Wegeler that the alleviation of his loneliness had been wrought by another pupil, "a dear fascinating girl who loves me and whom I love." This was undoubtedly Countess Giulietta Guicciardi. He dedicated the "Moonlight" Sonata to her, and toyed with the idea of a proposal. "Unfortunately she is not of my class." Self-abasement was so uncharacteristic of Beethoven that one can only assume that he was looking for a reason to be rejected.

Throughout his life he was attracted to women who were well-born, musical, and sexually unavailable.

Giulietta was of noble ancestry, but he flattered himself he was, too—if the *van* in his name meant anything. She was not at present engaged. There was, however, another young composer who loved her: Count Wenzel Gallenberg. With almost comical perversity, Beethoven encouraged their romance, even arranging a loan to improve Gallenberg's financial eligibility. When Giulietta finally added her own person—and title—to the transaction, he could enjoy a melancholy pretense: "She loved me very much, far more than ever she did her husband."

Wegeler, married himself now to Eleonore von Breuning, was afraid that Beethoven would lapse back into despair. He begged him to return to Bonn and the bosom of his former substitute family. Beethoven sent a brusque reply. "Don't flatter yourself I could be happy living with you in Bonn. What's there, after all, to lighten my spirits?" Only in Vienna could he find fulfillment in his art. "Every day I approach a destiny which I feel but cannot describe."

He was not short of Rhenish company. Aside from his brothers (Caspar now handled some of his business affairs), two other Bonners visited him daily. One was Stephan von Breuning, now twenty-seven and working as an executive in the Teutonic Order, an ecclesiastical group once dominated by Max Franz. The other was Ferdinand Ries, a handsome, talented, capable seventeen-year-old who had come south to study piano with Beethoven.

In April, Beethoven rented a farmhouse in Heiligenstadt, a high, secluded spa on the hills northwest of Vienna.* His ear doctor had

*The house is now a museum at Probusgasse 6, Vienna 19.

recommended the place as much for its peacefulness as for its mineral springs, believing that relief from city noise might prove therapeutic.

Ries went out there often, and found Beethoven restless and reluctant to teach. "After breakfast he would say, 'Let us first take a short walk.' We went, and frequently did not return until three or four o'clock, after having eaten something in a village." One day the boy heard "a shepherd who was piping very agreeably in the woods on a flute made of a twig of elder." Without thinking, Ries called attention to this distant music. Beethoven strained his ears for a full half hour as they walked toward it, but could hear nothing—at which, Ries recalled, "he became extremely quiet and morose."

"Suicidal" might be a more cogent word. For the rest of that summer Beethoven struggled with black gloom as he realized that his deafness was progressive, and likely incurable. Autumn found him still at Heiligenstadt. The woods turned bleak, matching his mood. In early October he drew a large double sheet of legal paper toward him and addressed it to his brothers, adding, *To be read and executed after my death.* Then he dated it *Heiglnstadt* [he never could spell that word], *October 6, 1802.*

There followed a long screed, unmatched in the history of music for poignancy. He kept it tacit all his life. It was a communication primarily with himself: Will telling Mind why suicide was not an option.

For my brothers . . .

O you men who think or say that I am malevolent, stubborn or misanthropic, how greatly do you wrong me. You do not know the secret cause which makes me seem that way to you. . . . For 6 [sic] years now I have been hopelessly afflicted, made

worse by senseless physicians, from year to year deceived with hopes of improvement, finally compelled to face the prospect of a lasting malady (whose cure will take years or perhaps be impossible). Though born with a fiery, active temperament, even susceptible to the diversions of society, I was soon compelled to withdraw myself, to live life alone. . . . It was impossible for me to say to people, "Speak louder, shout, for I am deaf." Ah, how could I possibly admit an infirmity in the one sense which ought to be more perfect in me than in others, a sense which I once possessed in the highest perfection. . . . For me there can be no relaxation with my fellow-men, no refined conversations, no mutual exchange of ideas. I must live almost alone like one who has been banished. . . . If I approach near to people a hot terror seizes upon me and I fear being exposed to the danger that my condition might be noticed. Thus it has been during the last six months which I have spent in the country. . . . What a humiliation for me when someone standing next to me heard a flute in the distance and I heard nothing, or someone heard a shepherd singing and again I heard nothing. Such incidents drove me almost to despair, a little more of that and I would have ended my life—it was only my art that held me back. Ah, it seemed to me impossible to leave the world until I had brought forth all that I felt was within me.

The document became maudlin as Beethoven wrote on, with invocations of "Patience" and "the inexorable Parcae" that could have been lifted straight out of Goethe's *Sorrows of Young Werther*. He did not fail to mention the withered leaves falling outside his window: "So likewise has my hope been blighted." He asked his brothers to

"attach this written document" to a medical certificate of his deafness after he died, "so that . . . the world may come reconciled to me after my death." He declared them his heirs, and asked them to preserve a quartet of fine instruments Prince Lichnowsky had given him.

All this began to cheer him up, as confession to Franz Wegeler had the year before. He signed off with the hope that death would come later rather than sooner—at least not "before I have had the chance to develop all my artistic capacities."

The "Heiligenstadt Testament" has become a basic text of Beethoven biography. Never again, except in a different instance ten years later, did he reveal himself so openly and touchingly. And both revelations were in fact concealments, stashed for posterity in a secret drawer of his desk. Writing them and suppressing them, he accepted loneliness as a precondition for the life of an artist.

The incident of the shepherd's flute, with its pantheistic overtones, seems to have symbolized for him more than anything else the fleeting nature of the muse. Some later lines by John Keats, also Hellenic in reference, expressed the consolation Beethoven took, that what could not be heard in his ear was within easy reach of his mind: "*Heard melodies are sweet, but those unheard / Are sweeter.*"

Circumstantial evidence, backdated from the Testament, indicates that soon after his walk with Ries, in June or July 1802, Beethoven began to compose some piano variations on just such an "unheard" melody. Several more mundane promptings may have combined to spur his inspiration: Haydn's praise of *The Creatures of Prometheus*; Napoleon's Imperial Recess, secularizing ecclesiastical territories in the Rhineland; a rich woman's silly suggestion that he write a sonata celebrating the French Revolution.

The result, at first, seemed hardly music at all. Four quiet, slow tones sounded in the middle of the keyboard: E-flat, B-flat above, B-flat below, E-flat again. No sequence could be more trite, but at least it held together. Two more E-flats followed at the same speed, but this time Beethoven inserted a D between them, confirming E-flat as his tonic key. With three ladder-like steps down, he returned to the lower B-flat, confirming it as the dominant.

A puzzling, four-beat silence ensued, broken by a sudden loud rat-a-tat on the B-flat. Then another silence ended softly and hesitantly on the same pitch, as though Beethoven was wondering where to go next. He settled for a moment on G, apparently lost interest, and closed with a quick cadence on E-flat.

To vary such a grotesque clutch of notes would seem an exercise in futility, akin to the decoration of scaffolding. But as Beethoven repeated his sequence again and again, adding graceful embellishments, it revealed itself as only the footprint of a theme *not yet played*. More precisely, that theme was being piped somewhere—and in perfect step, too!—but as yet beyond the range of human ears. Variations One through Three were sweet in harmony, but the melody, when it at last sang out in Variation Four, was sweeter still: nothing less than Beethoven's Prometheus tune, the dance that had ended his ballet in such pagan triumph.

Fifteen variations, and a big fugue, were needed before he had exhausted its pianistic potential. And still he had greater plans for it. "I live only in my notes, and one composition is scarcely done before another is begun."

Chapter Four

The Cold Dungeon

BEETHOVEN's "Prometheus" Variations, as he wanted his latest work to be called, filled the piano with more sound than any set written before. But one wooden instrument with only sixty keys was simply inadequate to the volume of music that continued to rise within him whenever his thoughts turned to the First Consul of France. Sometime during the early months of 1803 he doodled a three-note variant of his Prometheus tune. This triad, or basic chordal mass, began to swell with growth like the stump of a grapevine. The first shoots were fragile, and few seemed worthy of development, although there was one long, trembling, dominant-seventh suspension that intrigued him.

Gradually his sketches disclosed the outline of a symphony of such epic sweep that he had to give it the name "Bonaparte." Its first movement alone was big enough to swallow up most of Mozart's "Jupiter" Symphony, hitherto the exemplar of majesty in orchestral music. Beethoven intended to balance it against a funeral march of matching proportions, a propulsive scherzo that would broaden halfway into a choir of horns in three-part harmony, and a "grand

finale" based on the Prometheus tune. This last movement was to be cast in a form never before attempted—part Classical variation, part an imperious exercise of will on intractable materials: godly fire applied to clay, the Code Napoléon transforming old laws.

Even Mozart would have had to clear his calendar for so ambitious a project. To Beethoven, however, a symphony in honor of Napoleon was just one item among many that year, inaugurating a decade of production that for fecundity, originality, and sheer sustained quality has no parallel in the history of music. Almost all his so-called heroic works appeared during this period, along with others alternately intimate, experimental, progressive, occasional, and commercial. Except in the last two categories, he seemed incapable of penning a meretricious note. A high seriousness possessed him, different from the conceit of lesser artists. Even when he double-dealt with publishers and impresarios, or bullied the most faithful of his friends (Schuppanzigh and Zmeskall were "instruments upon which I play as I please"), his intent was simple and singular: to allow the flood of music that the Heiligenstadt Testament had released to pour through him with the least possible restriction—time being short and his flesh demonstrably weak.

Before his next great emotional crisis in 1812, he was to compose an opera, six symphonies, four solo concertos, five string quartets, six string sonatas, seven piano sonatas, five sets of piano variations, four overtures, three suites of incidental music for the stage, four trios, two sextets, seventy-two songs, an oratorio, and a mass—not to mention such hard-to-classify works as a triple concerto, three astonishingly beautiful *equali* for four trombones, and a "Choral Fantasy," consisting in equal parts of piano improvisation, concerto, and secular cantata. In the first five categories, every single work was a

masterpiece and remains a cornerstone of the repertory. Only two or three deliberately down-market items prevent the same being said of the piano sonatas.

On April 4, 1803, Beethoven held another *Akademie* in Vienna, appearing as both pianist and conductor. (A curious fact about his hearing loss, as he remarked, was that it troubled him least in musical performance.) The program, which netted him 1,800 florins, was built around première performances of his Second Symphony in D major, Op. 36, Third Piano Concerto, Op. 37, and a new oratorio written with remarkable speed, *Christus am Ölberg*. Better known in English as *The Mount of Olives*, it was destined to become enormously popular during the Victorian era. But many a modern listener, offered a time machine and only one selection to hear that evening, would settle for Ludwig van Beethoven, pianist, improvising on the exquisite *"Kaiserlied"* of Joseph Haydn.

The old man now was in a state of decline as sad as it was rare, a kind of torture inflicted by the body on the brain. He complained that his head was full of music beyond anything he had composed before, but that he simply could not write it down. Seeking solace in religion, and in a steady succession of visits by Haydn worshipers from around the world, he was good for little else but a daily session at his piano, playing that same anthem over and over.*

On May 24 Beethoven appeared again in public with the fiddler George Bridgetower, playing his titanic new Op. 47, the "Kreutzer" Sonata.† Universally recognized as a summit of the violin literature,

*Haydn's visiting card for this period was engraved, *Hin ist alle meine Kraft, alt und swach bin ich* ("Gone is all my strength, old and frail am I").
†It was named for the French virtuoso Rodolphe Kreutzer.

it pulsates with such tumescent power that Tolstoy was impelled to write a short story, "The Kreutzer Sonata," warning against its alarming effect on the libido.

Sex appears to have had something to do with Beethoven's refusal to associate with Bridgetower afterward. The latter said only that they "had a quarrel about a girl."

Meanwhile, more publications were issued by a lengthening list of houses in competition for Beethoven works. They included his Piano Sonatas Op. 31, Nos. 1, 2, and 3, and the "Prometheus" Variations, which he boasted were written in "quite a new style." His recent *Akademie* could now be seen as a French door closing gracefully on the past, with the lovely Larghetto of the Second Symphony and his tribute to Haydn saying the last things he could say about the Age of Enlightenment.

Just the opening bars of the three new sonatas showed how much Beethoven's style had changed. The first, in G major, started with a spasmodic disjunction between right hand and left, as if one (but which?) had come down too soon on the keyboard. The soft A-major haze introducing the second sonata turned out to be a mirage that burned off a hard landscape in D minor. The third sonata seemed so uncertain of itself that its initial three-note phrase belonged to no key whatever. And these beginnings were mere tokens of the shocks Beethoven had in store for any pianist capable of negotiating his formidable technical demands: unpredictable silences, off-beat cadences, ricochet repeated notes, gorgeous melodies mystifyingly interrupted with drum taps or reverse vamps, and, weirdest of all, two long stretches of recitative in the D-minor sonata, played *pianissimo* with both pedals down, in imitation of a voice echoing from the depths of a vault.

Was he conveying, from his own auditory cavern, what deafness *sounded* like? If so, these recitatives are among the most terrifying passages in music, akin to the last bars of Bach's *The Art of Fugue* and Sibelius's Fourth Symphony in their power to chill the heart.

Since the beginning of 1803, Beethoven had been living rent free in one of Vienna's major concert complexes, the Theater-an-der-Wien.* It was operated by the impresario Emanuel Schikaneder, who had made a fortune out of Mozart's *The Magic Flute,* and now seemed intent on bankrupting himself with a lavish new opera, *Vestas Feuer* (Vestal Flame), scripted by himself and set to music—he hoped—by Beethoven.

The free apartment, and a handsome stipend, were advance inducements. Beethoven was willing to sign a contract, although he might be thought to have had enough of fire mythology. For several years he had been secretly preparing to write an opera. He had even taken lessons in vocal composition and Italian declamation from Antonio Salieri, the Court Kapellmeister. But Schikaneder's libretto failed to inspire him. He sketched a few pages of music, felt no flame rising, and decided to try again in the fall.

Spring had returned to the Wienerwald. It was time for him to quit the city—but not immediately for his usual rented space in some high village. During the previous summer at Heiligenstadt, Beethoven had gotten to enjoy bathing in hot springs. The sulfurous steam seemed to benefit his chronic intestinal trouble, if not his hearing. This year he headed south for a few weeks in the fashionable spa of

*"Wien" in this case denoted not the city but the River Wien, a minor tributary of the Danube beneath the southern ramparts. The theater still stands.

Baden, before moving for the rest of the season to a house in Oberdöbling, overlooking the Krottenbach gorge. It was quiet enough there for him to hear—close up—the undulant trickling of a mountain stream. He tried to transcribe the sound in his sketchbook, noting, "The bigger the brook, the deeper the tone."*

Generally—and obviously—speaking, a successful man's life expands in its middle years, with affluence and influence causing him to travel widely and accumulate new experiences. It is a contradictory fact that as Beethoven's worldly horizons narrowed, and his routine rigidified, the scope of his genius grew. There was quite enough variety *for him,* in the twenty-three years he had left: different spas, different hill towns, and so many changes of city address that he once found himself paying four different rents simultaneously. But the very force of all this mobility (even from the country, he was forever catching coaches back into Vienna) spins into a biographical blur. There is really only one story: that wherever he went, Beethoven was at home only in his head. As he put it himself, sounding just like Coriolanus, "My world is elsewhere."

No doubt his deafness contributed to the air of seclusion that settled on him a little more densely day by day. But then one remembers the withdrawn schoolboy, the *raptus*-prone adolescent, the young pianist lost in improvisatory fantasies. They were essentially the same person as the already notorious eccentric of 1803, so possessed with music that when he behaved rationally, politely, and responsibly—as he was always capable of doing—it was somehow more surprising than his loud roars and arm-waving in the woods.

The word *peripatetic* has been used to characterize Beethoven's

*This was the genesis of his future Sixth Symphony in F major, the *Pastorale.*

uncontrollable restlessness when composing. He seemed to need physical movement to help organize the "movements" of his music. Any change of scene, whether from town to country or just out into the street, was enough to stimulate his creativity. Ideas often absorbed him so much he forgot to eat. Tavernkeepers got used to him sitting for hours at an empty table, staring into space, then calling impatiently for his bill. At other times he would dine, guzzle a whole bottle of wine, and hurry off without paying, pursued by angry waiters. His metabolism was as hyperreactive as a boy's. Food and alcohol made him thrum with energy, sometimes sending him twice around the city at a fast clip (his beaver hat threatening to fall off) before he could bring himself to sit down again. In the country, he would continue walking and sketching until the twilight was too thick for him to see his way.

A sociable urge usually affected him at night, when he would return to the tavern for company, or show up at some aristocrat's summer palace for music making. He generally went to bed early, but ideas often jerked him from sleep and had to be recorded before they went the way of dreams.

Always a scribbler, Beethoven was by now the most prodigious note taker in musical history, his sketchbooks and bundles of loose score paper bulking to the point that every move threatened archival chaos. Somehow, he kept track of every hieroglyph. Sketches were more valuable to him than completed manuscripts, which he regarded as superfluous once published.

His main projects in the summer of 1803 were his new symphony, growing more enormous by the day, and a "Grand Sonata" for piano in C major, dedicated to Count Waldstein. The latter work, blazingly virtuosic, was probably stimulated by a surprise gift that arrived in

August from Paris: a piano made by the prestigious firm of Erard. It served as a pleasing token that his fame had now spread to the heart of Consular France.

At least some of Beethoven's tavern musings that August were not about dominant-seventh suspensions. He wondered if he could parlay a dedication to Napoleon into a profitable trip to Paris. Ferdinand Ries was alarmed to see the names *Buonaparte* and *Luigi van Beethoven* scrawled across the top and bottom of the first page of the symphony manuscript, the white space between enigmatically unbridged. He got the impression that Beethoven was hoping for a court appointment under Napoleon, and confessed to a mutual friend that the prospect "makes me extraordinarily sorrowful."

Neither the trip nor the appointment ever came about. Beethoven may have been fantasizing without intent, as he had about marrying Giulietta Guicciardi. Yet his later behavior shows that he was not above floating rumors of emigration from time to time, in order to remind the Viennese that he had other options.

The symphony was ready enough by early fall for him to play some of it on the piano to his pupil. Ries wrote home: "In his own testimony it is the greatest work he has yet written. . . . I believe heaven and earth will tremble at its performance." Beethoven also tried out its Promethean finale on Stephan von Breuning and another young Rhinelander, the artist Willibrord Mähler. They were less impressed with it than by a staggering two-hour improvisation that followed. Mähler was struck by the quietness of Beethoven's hands, "the fingers alone doing the work."

Shortly afterward, when he painted a portrait of the composer, he rendered those hands with particular plasticity. The left lightly dangles a lyre; the right is flexed as if about to conduct. Noticeable

is the broad span of the palm and the taper of the fingers, surprising in such a stocky man. Beethoven is still worldly enough to sport what looks like an expensive haircut, and dress in a fashionable shawl-collared coat that permits a maximum display of snowy linen at breast and throat. The face under the magnificent forehead has an introvert's stiffness: even the bright brown eyes slightly avoid the viewer's gaze.*

Minus the lyre, and plus a pair of thick, concave spectacles, this is more or less what members of Prince Lobkowitz's orchestra saw in early June 1804, when Beethoven led them in the first rehearsal of his *Sinfonia Grande intitulata Bonaparte.* Just two weeks before, Napoleon had been proclaimed Emperor of France. So much for Ries's famous story about Beethoven flying into a rage at the news ("He will place himself above everyone else and become a tyrant!"), tearing the top page off his score, and retitling it *Sinfonia Eroica.*

Biographical portraits, unlike painted ones, tend to accrete extra details and drama—usually melodrama—over time. Ries was the best friend Beethoven ever had, neither cowed nor seduced by him. A man of impeccable honesty, he was persuaded by Franz Wegeler in 1837 to collaborate on *Biographische Notizen über Ludwig van Beethoven,* a scrupulous little memoir that remains one of the primary sources of Beethoven scholarship. But Ries at fifty-four was as prone as Wegeler to misdate incidents in the long-distant past. There is no doubt that Beethoven did become furiously disillusioned with Napoleon at some point in 1804 or 1805. A copyist's score of the symphony does survive with the Emperor's name erased so fiercely that

*Beethoven's copy of this portrait now hangs in the Music Division of the New York Public Library for the Performing Arts.

a hole is worn through the paper. Nevertheless, it was still *intitulata Bonaparte* when Beethoven offered it to his Leipzig publisher, Breitkopf & Härtel, in midsummer 1804.

In attempting to re-create its sonic impact at that first rehearsal in the Lobkowitz palace, perhaps we should postpone questions of nomenclature and think of it simply as Beethoven's Third Symphony in E-flat major, Op. 55. The palace still stands in the heart of Vienna.* Anyone can walk into the second-floor concert hall and, having at first gotten used to its disconcerting smallness, imagine two fortissimo chords of E-flat major exploding around the room. They were the cannon shots of a new symphonic language, remarkable not for mere loudness (Haydn's *Creation* had made just as much noise) but for a discharge of energy that almost immediately drove the E-flat in the low strings down to C-sharp—a pitch so remote from the tonic that it seemed a miracle that Beethoven could modulate back home only twelve bars later. He did so after a long, ecstatic suspension that was the musical equivalent of a waterfowl's speeding weightlessness just before it returns to *aqua firma.* The ecstasy came from a sense of aerodynamic momentum, unforced by any hurry.

Indeed, there was a propulsiveness to the unfolding of this vast opening allegro that made it sound both speedy *and* slow. Its pulsations were so steady that they could be felt even after syncopations powerful enough to stop any Classical symphony. When, in the development, Beethoven added discords to his off beats—harmony and rhythm colliding with equal violence—he succeeded in stopping his own. The Lobkowitz players broke down in confusion, and he was obliged to start again.

*It is now the Österreichisches Theatermuseum.

Ries, standing next to Beethoven as he conducted, nearly caused another halt. When the development finally reached the long, dominant-seventh string tremolo that Beethoven had adapted from his sketchbook, a solo horn softly sounded the opening triad against the harmony. "That damned horn player!" Ries exclaimed. "Can't he count?"

For a moment, Beethoven seemed about to hit him.

One can understand the youth's reaction, because what he had just heard—the anticipation of a resolution—went against every tenet of Classical procedure. A dominant seventh's desire to resolve onto the tonic is the most powerful force in Western music: to prevent it doing so amounts to coitus interruptus. Beethoven had not been so perverse. He had merely inserted a pre-echo of the resolution, which (even as Ries protested) arrived with a huge crescendo. Only a modern mind was capable of such fusion in 1804. The effect is as thrilling today as it was then—unlike its clichéd equivalent in film editing, the audio cross-cut in advance of a video dissolve.

Nothing is known of the other rehearsals necessary for Beethoven to teach the Lobkowitz players his symphony, except that he sometimes had trouble balancing the wind parts. ("You cannot conceive . . . what an indescribable, I might say, fearful effect the gradual loss of his hearing has had upon him," Stephan von Breuning wrote home.) We cannot even be sure that Beethoven conducted the first private performance, because Prince Lobkowitz soon removed to his summer palace in Bohemia, taking the orchestra, and apparently the score, with him.*

Under the system of aristocratic patronage then prevailing, the

*Beethoven's original manuscript has been lost.

purchaser of a major piece of music held exclusive performing rights for up to one year. After that, the composer was free to earn more money by shopping it around to concert managers and publishers. His alternative was to dedicate the work to some rich or majestic person, who might (or might not) reward him a stack of gold. In this case, typical of Beethoven's convoluted business dealings, Lobkowitz had offered the enormous sum of four hundred ducats for a symphony inscribed to Napoleon, but as yet not dedicated to either man. There was no assurance that the First Consul would even accept a dedication, let alone come up with a competitive number of louis d'or. Relations with France were again worsening, after a year and a half of false security instilled by the Imperial Recess. Nevertheless, Beethoven was still talking about his "Bonaparte" symphony in August, long after Lobkowitz had left town.

His sketchbook for this period amounts to inspirational bedlam. To examine it is to be awed by the number of projects Beethoven was able to work on simultaneously. Aside from masses of Prometheus/Bonaparte material, there are scenes for *Vestas Feuer* and for another opera (discussed below); revisions of *The Mount of Olives;* drafts of three piano sonatas and the Triple Concerto; and eerie, sonogram-like images of his future Fourth Piano Concerto and Fifth and Sixth Symphonies. Ries describes him being seized by one idea when they were on a country walk:

The entire way he had hummed, or sometimes even howled, to himself—up and down, without singing any definite notes. When I asked what this was, he replied, "A theme for the last Allegro of the sonata has just occurred to me" (in F minor, Op. 57). When we [returned home] he rushed to the piano

without taking off his hat. I took a seat in the corner and he soon forgot about me. He stormed on for at least an hour. . . . Finally he got up, was surprised to see me still there, and said, "I cannot give you a lesson today. I still have work to do."

Ries, who performed the Third Piano Concerto under Beethoven's baton at the Augarten Festival that summer, really needed no further instruction. He was by now more of an administrative assistant, helping his master supervise copyists, keep accounts, and check a steady flow of proofs from half a dozen music engravers—work that for eyestrain may be compared to motherboard assembly. (For example, the Second Symphony's opening page contains 1,925 separate ciphers, the music itself lasting no longer than fifteen seconds.) Caspar served as Beethoven's manager, dealing with publishers, piano manufacturers, concert agents, and total strangers wanting to see what a genius looked like. Even so, many managed to plague the always-approachable composer.

"I am not safe from people," Beethoven complained. "I must flee in order to be alone."

His desire for solitude was sometimes qualified by other considerations. One evening Ries found him at home on the sofa with "a handsome young woman." Not wanting to interrupt their tête-à-tête, Ries tried to withdraw, but Beethoven insisted that he entertain them with music. The piano stool was so positioned that Ries could not see what was going on behind him as he played. But his teacher's commands were intriguing: "Ries! Play something romantic!" Soon after, "Something melancholy!" Then, "Something passionate!"

When the woman finally left, Ries was surprised to hear that Beethoven did not know who she was. They followed her to see

where she lived. The moon was bright, "but suddenly she disappeared."

A trivial anecdote, perhaps, yet Goethe might have made poetry out of it: the parlor, the piano, the erotic tension in the room, the two men slinking down the street, Gretchen vanishing in the moonlight. *Ries! Spielen sie etwas verliebtes . . . melancholisches . . . liedenschaftlich!* Beethoven's language was typical of the new vocabulary of feeling that had taken over German discourse. The nineteenth century was young, and so, at a stretch, was he. It is necessary to remember that Beethoven still perversely believed he had been born in December 1772. This made him, in his own mind, thirty-one when he returned to Vienna in the late fall of 1804 and threw himself into the pursuit of Josephine Deym-Brunsvik.

The truth was that he was about to begin his thirty-fifth year, and had never been sexually attractive to women. Almost a decade before, a singer had spurned his advances, "because he was so ugly, and half crazy!" Giulietta Guicciardi may have loved him for his mind, but she had given her body to Wenzel Gallenberg. Now, through the unexpected death of Count Deym, Josephine became available. Or so Beethoven persuaded himself: she still took piano lessons from him, and treated him with affection.

By early 1805 he was visiting her every day. Clearly in love with love, he wrote her maudlin letters in the best romantic style, complete with breathless dashes and italic emphases: "Oh you, you make me hope that *your heart* will long—beat for me—Mine can only—cease—to beat for you—when—*it no longer beats—Beloved J.*" He continued to hope through spring, to the alarm of Josephine's sister Therese ("Pepi and Beethoven, what shall become of it? She should be on her guard!") and the applause of Prince Lichnowsky, himself a serial seducer.

Josephine, perhaps noticing that Beethoven's beating heart did not prompt him to use the intimate pronoun "*Du,*" declined with exquisite tact. "I love you inexpressibly," she wrote, "as one gentle soul loves another." She regretted that sex was so important to him: "The pleasure of your acquaintance would have been the finest jewel of my life if you could have loved me less sensually."

Beethoven sublimated his frustration on *Leonore,* the operatic scenario that had invaded his sketchbook the year before. (*Vestas Feuer* was now decisively abandoned.) In all creative respects, *Leonore* seemed made for him. The very name of its heroine evoked his first love, while its thematic subtitle, *L'Amour Conjugale,* gave him the chance to express, in music, a happiness he might never achieve in life. Not that the plot called for much in the way of cozy domestic sentiment. It spoke to him, indeed, exactly as he had spoken to Ries: *Spielen sie etwas verliebtes . . . melancholisches . . . liedenschaftlich!*

The original melodrama of *Léonore*, by Jean-Nicolas Bouilly, was based on a real incident during the French Revolution. A young woman disguised as a boy had insinuated herself into a state penitentiary in Touraine and freed her husband from political imprisonment. As dramatized by Bouilly (and adapted for Beethoven by Joseph Sonnleithner, secretary of the Court Theater) this incident became so obviously allegorical, in its profeminist and antistatist implications, that both librettists had played safe by transferring the action to seventeenth-century Spain. The incarcerated aristocrat received the vaguely classical name of "Florestan," while the prison governor detaining him without trial became "Pizarro." Thus neither could be associated with any political system north of the Pyrenees.

Beethoven was less interested in the plot's ideology than its Promethean parallels (Leonore, full of loving fire, descending into

the cold dungeon and bringing liberty to its immobilized prisoners). Personally, he responded to her physical courage in behalf of Florestan as the reverse of Josephine's sexual timidity. Most primary of all was the central symbol of a man walled off from the sounds of the outside world.

Three years before, in the *de profundis* recitatives of his D minor piano sonata, Beethoven had expressed the isolation he felt in his own dungeon of deafness. Now he had the full resources of opera to dramatize it. From the moment that he copied the words of Florestan's monologue, he identified with his hero metaphorically as well as musically:

> *Gott! Welch Dunkel hier!* God! What darkness here!
> *O grauenvolle Stille!* O gruesome silence!

Reaching back even farther into private memory, he wrote an orchestral prelude beginning with the same antiphony he had used to open the *Cantata on the Death of Emperor Joseph II*: a held, hollow C on low strings, followed by a despairing wind chord in the minor.*

Conscious that he was risking a new form of composition at the height of his career, he labored to express every nuance of Sonnleithner's libretto, with a fanaticism unusual even for him. He filled four large sketchbooks, of which 346 pages survive, with musical ideas before he felt ready to embark on the full score.

The cross-fertilization characteristic of Beethoven's works operated not only back and forth in time (he seemed to remember every

*Later, Beethoven transposed this whole sequence a fourth higher, to suit Florestan's tenor voice.

note he ever wrote) but indiscriminately between genres. Just one hammering motif—three quick taps followed by a slower—riveted together the totally different first movements of a sonata, a concerto, and a symphony. A duet that had refused to come to life in *Vestas Feuer* quickened joyously when transferred to *Leonore*. And before he was through with his rescue drama, he was again to quote movingly from the *Joseph II* cantata. It was as if some ideas, not fully realized at first, tormented him until they had served every possible purpose.

Perhaps the most resolving moment of all occurred on April 7, 1805, at the first public performance of his Third Symphony. There could have been few in the Theater-an-der-Wien whose hearts did not lift when Beethoven, conducting, suddenly slowed the pace of the finale and allowed all three horns, doubled by bass strings, to sing out the Prometheus theme fortissimo in a catharsis of sound.

There was no longer any question of his naming the symphony after Bonaparte, particularly now that Franz II had restyled himself "Franz I, Emperor of Austria" in a reaction to Napoleon's assumption of the purple. With yet another war on its way, Beethoven could not afford to be considered unpatriotic. Just twelve days before the symphony's premiere, Napoleon had announced that he was adding the iron crown of Italy to his collection of imperial headwear ("God gave it to me"), and begun to distribute among members of his family fiefs that formerly belonged to Franz. It was clear that he viewed himself as a modern Charlemagne, even though Franz's change of title had signaled the final dissolution of the Holy Roman Empire.

Beethoven had an almost American mistrust of any conflation of church and state. His page-tearing fit of rage against Bonaparte therefore probably occurred around this time. He dedicated the

manuscript to Prince Lobkowitz, and when he prepared it for publication, significantly used his best Italian to call it *SINFONIA EROICA . . . composta per festiggiare il souvenire di un grand Uomo*: "Heroic Symphony . . . composed to celebrate the memory of a great Man."

Initial reactions to the work were negative. Its enormous length alienated many concertgoers ("I'd give a kreuzer if it would stop," one was heard complaining). The correspondent of the *Allgemeine Musikalische Zeitung* wrote, "This reviewer belongs to Herr van Beethoven's sincerest admirers, but in this composition he must confess that he finds too much that is glaring and bizarre."

Noteworthy in much of the criticism leveled against Beethoven, however, was a tone of respectful self-doubt, as if failure to appreciate his music might be the listener's problem, rather than the composer's. "If you fancy you can injure *me* by publishing articles of that kind," Beethoven wrote the owners of the *Zeitung*, "you are very much mistaken." The magazine agreed. In a reappraisal of the *Eroica* that still stands, its editor declared, "The voices of all specialists, reviewers included, are in this united. . . . [The symphony] is certainly . . . one of the most original, most sublime, and most profound products the entire genre of music has ever exhibited."

On August 9, 1805, Austria allowed Russia to coax it into a Third Coalition against France, along with Britain and Sweden. Ill prepared for the consequences, it quickly careened toward a showdown with Napoleon's forces on the upper Danube. Beethoven was less aware of the ominous situation than most Germans, for he had taken a summer house at Hetzendorf within pining distance of Josephine Deym, and was working with maniacal intensity on the score of *Leonore*. It was ready by early fall, and scheduled for production at

the Theater-an-der-Wien on October 15. Then, in a disagreeable double blow, Beethoven was informed that his opera had been banned, pending clearance by the imperial censor, and that its name was being changed. It was no longer *Leonore,* but *Fidelio.*

The postponement was not unwelcome, since Beethoven had still to compose an overture,* and with Anna Milder, a soprano only twenty years old, cast in the leading role, he needed all the rehearsal time he could get. But the title change was, in his view, deeply damaging. "Fidelio" (faithful one) is what Leonore calls herself when disguised as a boy, in order to gain access to her husband's prison. Beethoven felt that to name the opera after a fake character was to vitiate it—in effect, to change its sex. He had poured some of his most rapturous music into the story of the real woman who reveals herself in act 2 as someone willing to die for love: "*Ja, sieh hier Leonore!*"

Unfortunately, he was not the first composer to set Bouilly's story to music. Others had already adapted it as *Léonore, Leonore,* and *Leonora* in Paris, Dresden, and Padua. So *Fidelio* his version became in Vienna, and in perpetuity.

On October 5, just after the libretto had been adjusted to the censor's satisfaction, news came that Napoleon's forces had encircled the Austrian army, under General Karl Mack, at Ulm. Two weeks later, as advertisements announced that *Fidelio* would make its debut on November 20, Mack surrendered. Salzburg fell within another ten days. From then on, Beethoven—rehearsing frantically, racked with nervous diarrhea ("my usual sickness"), picking fights with everybody from Ries to Prince Lobkowitz—was engaged in a

*Now known, confusingly, as the *Leonore II* Overture.

grotesque race with Napoleon, as to which man should "take" Vienna first.

The Emperor won. On November 13, to a crashing of drums, his vanguard of fifteen thousand men entered the city in battle order, making a mockery of the little platoon of sentries marching about the stage of the Theater-an-der-Wien. Almost all the aristocrats Beethoven relied on for patronage fled the capital. To the numb disbelief of two and a half million Austrians, Napoleon occupied Schönbrunn Palace.

Fidelio opened five nights later to a half-empty house. Most of the evening's attendees were French officers who understood little of the German dialogue and had probably never heard of Beethoven. Not that Austrians in the audience liked his opera any better. A terse review in *Freymüthige* summed up the worst disappointment of his career: "A new Beethoven opera, *Fidelio* or *Die eheliche Liebe* has not pleased. It was given only a few times and after the first performance [the theater] remained completely empty. . . . The music was really way below the expectations of amateur and professional alike."

One Promethean intervention might have rescued *Fidelio* before Beethoven, humiliated, withdrew it: a visit by Napoleon to the Theater-an-der-Wien, and some sign of approval from the imperial box. But such a fantasy was not to be. Bonaparte had a tin ear for German music. He soon left town for Austerlitz, where, on December 2, he inflicted upon a combined Russo-Austrian force one of the most devastating defeats in military history. The five-month war was over, and his domination of continental Europe complete. Strategists in London and St. Petersburg trembled for the future of their empires.

When Beethoven had recovered from his own rout, he drastically

revised and shortened *Fidelio*, with a view to making it work better as drama. Some splendid music was sacrificed in the process. Hoping against hope that he might be able to revive the name *Leonore*, he wrote a new overture under that title.* But when the opera was restaged in March and April 1806, it was again called *Fidelio,* and again failed to please. Deeply depressed, he withdrew his score for what everybody assumed was the last time.

"He has lost a great deal of his desire and love for his work through the treatment he has received," Stephan von Breuning wrote Wegeler.

If so, one must regard as underproductive a year in which Beethoven went on to complete his Fourth Piano Concerto, Op. 58, and Violin Concerto, Op. 61, both works of extreme lyrical beauty; a Fourth Symphony, Op. 60, that was as slender and polished as the *Eroica* had been massive and craggy; the *Coriolan* Overture, Op. 62; Thirty-two Variations for Piano in C minor (a masterly chaconne which Beethoven unaccountably disparaged, declining even to give it an opus number); the aptly named "Appassionata" Sonata, Op. 57; and three cerebral string Quartets, Op. 59, commissioned by Count Andreas Razumovsky, the Russian Ambassador in Vienna. This mass of music was remarkable not only for its uniform, bar-by-bar excellence but for a stylistic range that can only be called Protean. Leaving aside the variations, themselves kaleidoscopic, the sonatas comprised twenty-three movements with virtually nothing in common, except that undefinable Beethoven "sound." The finale of the "Appassionata" (his country-walk inspiration of two summers

*The great *Leonore III* Overture. *Leonore I*, composed for an out-of-town performance, followed in 1808.

before) is a savage *perpetuum mobile* that sounds, toward the end, as if it has been written by someone capable of murder. The Andante of Op. 58 is an essay in persuasive rhetoric, the solo piano hypnotizing a ferocious orchestra with sentences, at first, almost too quiet to be heard. The finale of Op. 60 is a study in flickering light. And would any first-time listener, hearing the four dry drum taps at the beginning of Op. 61, imagine that a violin concerto is coming?

As for the great triptych now known as the "Razumovsky" Quartets, it amounts, in the words of Lewis Lockwood, to "a continental divide in the history of the quartet comparable to the *Eroica* and the 'Waldstein.'" Uncompromising in their severity and intellectual rigor, these pieces disconcerted everybody who heard or attempted to perform them. Bernhard Romberg, a colleague from Beethoven's Bonn days, actually stomped on the cello part of the first quartet when he found it required him to play drum-like tattoos on one string. The violinist Felix Radicati wondered aloud if the quartets really were music. Beethoven ignored his sarcasm: "They are not for you, but for a later age."

The immense opening movement of No. 1 grows directly, like a sequoia from a cone, out of a tiny phrase at the end of Beethoven's previous quartet set, Op. 18. Seeded thus in one century, it helped propagate the music of another: Schumann, Mendelssohn, and Brahms all took it as a model. Even Wagner studied it in old age, while the strange silences, taut motifs, and harmonic ambiguities of No. 2 spoke to Schoenberg. The introduction to No. 3 illustrates Beethoven's love of mysterious openings, which may or may not be organic. In this case, mystery goes too far: no amount of listening makes sense of the harmonic drift. But the quartet becomes more logical as it proceeds, and ends with a fugue of coruscating virtuos-

ity. The figurations are rapid enough to fray the smoothest bow-strings. One gets the sensation of a mind on fire. But the counter-point is impeccable, and shows that by 1806 Beethoven was the equal of Haydn and Mozart—if not Bach—in any species of polyphony.*

"I am thinking of devoting myself entirely to this type of com-position," he wrote Breitkopf & Härtel.

The scholar-pianist Charles Rosen, who, with Lockwood, has done much in recent years to illuminate Beethoven's standing in German intellectual history, quotes a remark by Friedrich von Schlegel to the effect that musicians tend to be more rational in their works than they are in their everyday lives. This certainly applies to Beethoven during the three years he spent composing *Fidelio* and the other works mentioned above. From the *Eroica* Symphony onward, the music is that of a genius in absolute control. But the social be-havior is degenerate. His quarrels with intimates are increasingly violent. Aside from Caspar and Johann van Beethoven, whom Ludwig tends to fight on sight, Stephan von Breuning and Ferdi-nand Ries suffer furious tirades and prolonged estrangements. He tries to break a chair over Prince Lichnowsky's head; he stands in the doorway of Prince Lobkowitz's palace like a street psychotic, roar-ing, "*Lobkowitz is a donkey!*" Orchestra players who bungle his com-plicated scores in rehearsal do so "on purpose." Service providers, from landlords to the humblest waiters, are determined to cheat him of his money (although, between spasms of suspicion, Beethoven is the most careless of spenders). Those who supply his income—pub-lishers, licensers, concert agents—are just as mendacious. Having al-

*Some measures from the manuscript are reproduced on the front cover of this book.

lowed *Fidelio* to play only five ill-attended performances, he cannot understand that he might be responsible for the opera's failure to recoup its costs. The villain must be Baron von Braun, the gentle-manly manager of the Theater-an-der-Wien, whom Beethoven accuses point-blank of "fraud."

A cryptic note, found among his sketches for the sad, slow move-ment of the first "Razumovsky" Quartet, should also be mentioned. "A weeping willow or acacia tree," Beethoven scrawls, "onto the grave of my brother." This was written around the time Caspar van Beetho-ven, age thirty-two, married Johanna Reiss, a middle-class Viennese girl of nineteen. She was five months pregnant. Ludwig, increasingly paranoiac, appears to have seen Johanna as a lethal threat to the family circle. His reaction was to punish his brother for loving anyone other than himself. By the time young Karl was born on Sep-tember 4, 1806, Caspar was no longer authorized to represent Ludwig in business.

Under the weeping willow of imagination, a narcissus had taken deep root.

Stephan von Breuning, endlessly forgiving and worried about the introverted quality of the "Razumovsky" Quartets, tried—in verse—to encourage Beethoven to recover his more public strain. "Thou hast but begun," he wrote. "Thy dazzling sound has glory, strength, and depth. . . . A golden river flowing rich and full." This was pretty well an advance description of the music that Beethoven continued to compose through 1808, as if the quartets had never happened. Starting with the Violin Concerto, which premièred in Vienna just before Christmas 1806, he produced a series of large-scale composi-tions whose mostly major harmonies, thrilling climaxes, and inde-scribable nobility of expression still proclaim, two centuries later, the

"heroic" Beethoven. It is hard to think of any contemporary classical-music radio station or website that does not attempt to beat to death, on a daily basis, the Fifth and Sixth Symphonies, the "Emperor" Concerto, the *Coriolan* and *Leonore I* Overtures, and *Choral Fantasy*—while fortunately neglecting such other masterpieces as the Cello Sonata, Op. 69, the "Ghost" and E-flat major Trios, Op. 70, and the little known, tranquilly lovely Mass in C major.

These were years of almost unalloyed success for him, although Prince Nicolaus Esterházy did not like the Mass, and Prince Lichnowsky felt obliged, in view of the chair-swinging incident, to suspend his annuity. Baron Ignaz von Gleichenstein, his new manager, hardly noticed the six-hundred-florin loss: money poured in faster than manuscripts went out. Count Oppersdorff offered him one thousand ducats for the Fourth and Fifth Symphonies, without having heard a note of the latter. The London publisher Muzio Clementi offered £260, or roughly 2,600 florins, for British rights to a batch of works that Beethoven promptly resold in Vienna for another 1,500 florins. And in a "crowning" *coup de richesse*, the new King of Westphalia (a.k.a. Jérôme Bonaparte) offered him the part-time position of Kapellmeister in Kassel, for a salary of six hundred ducats, plus many benefits.

The last offer came at an opportune moment, in October 1808. Beethoven had for some time been threatening to leave Austria. He did not seriously envisage a life elsewhere, but as middle age approached he felt that Vienna's city fathers should honor him with a sinecure. He was, after all, one of the few local eminences who had not been in some way diminished by the rise of Napoleon. Haydn was still alive, but barely. By general consent, the future of German music rested in Beethoven's powerful hands.

His first move had been to petition the directorate of the Vienna Imperial Court Theater to retain him as an in-house opera composer, at 2,400 florins annually. If nothing else, the language of the petition, written in the third-person singular, showed that Beethoven had survived the disaster of *Fidelio* with ego intact:

> The undersigned may flatter himself that so far during the period of his stay in Vienna he has won a certain amount of favor and appreciation . . . both at home and abroad.
>
> Nevertheless, he has had to contend with all sorts of difficulties, and as yet he has not been fortunate enough to establish himself here in a position compatible to his desire to live entirely for art. . . .
>
> Since on the whole the aim which he has ever pursued in his career has been much less to earn his daily bread than to raise the taste of the public and to let his genius soar to greater heights and even to perfection, the inevitable result has been that the undersigned has sacrificed to the Muse both material profit and his own advantage.

The theater directorate having ignored this petition, Beethoven seized on King Jérôme's offer as a warning that his genius might well soar to foreign parts, if Vienna did not soon secure him. He allowed it to be bruited about that he was thinking of a kapellmeistership in the north, and then threw himself into preparations for an *Akademie* to end all *Akademies,* which would show the city's "princely rabble" what the word "genius" really meant.

The concert was scheduled for Thursday, December 22, 1808, in the Theater-an-der-Wien. Beethoven announced that all items on

the program were going to be "entirely new, and not yet heard by the public"—a careful redundancy to cover the fact that he had performed at least one selection, his Fourth Piano Concerto, privately in the Lobkowitz palace. He also avoided saying that the evening was likely to last at least four hours. Part 1 would consist of his "Symphony No. 5" in F major, "entitled: *A Recollection of Country Life.*" (This awkward appellation, one of the very few Beethoven ever bestowed on a work, soon became *Pastorale-Sinfonie.*) Then would come an aria, "Ah! perfido," for solo soprano, the Gloria from his C major Mass, then the concerto with himself as soloist. After the intermission would come his "Symphony No. 6" in C minor, followed by the Sanctus from the mass, and a solo piano improvisation by himself. The concert's grand climax was to be a "Fantasia for the pianoforte which ends with the gradual entrance of the entire orchestra and the introduction of choruses as a finale."

Informed readers will notice that Beethoven appears to have transposed the numbering of his two symphonies—the *Pastorale* being known today as his Sixth, and the C minor as his Fifth. But this was not the case in 1808. Having published neither yet, he thought of them in the order he had completed them. Although begun earlier, the Fifth (as we will dutifully call it) in fact postdated the *Pastorale.* He considered it to be as great a work as the *Eroica,* and could not wait for the moment when "three trombones and flautine" [piccolo] would erupt from the orchestra with a joyful noise—"more noise than 6 kettledrums and better noise at that."

But first, as a favor in exchange for free use of the theater, he had to conduct the same orchestra in a fund-raiser concert on November 15. Either in rehearsal or performance—accounts vary—Beethoven knocked over a candelabrum, or a choirboy, or both. He angered

most of the players with his peremptory manner. This did not augur well for the great night on December 22, which he was hoping would bring in more money than he had ever earned before.

It turned out to be an evening of such bitter cold that the cavernous auditorium, decorated in arctic blue and white, never warmed up. The soprano was a terrified stand-in (Beethoven having warred with his billed soloist), and the chorus and orchestra were underrehearsed. Beethoven, no doubt hampered by his deafness, did not allow enough dynamic contrasts: as the music writer Johann Reichardt drily noted, "One can easily have too much of a good thing—and still more of a loud."

When, after more than three and a half hours of music, Beethoven launched into the solo introduction to his *Choral Fantasy*, Op. 80, the music was almost as new to the orchestra as to the audience. He had left much of it unwritten until the last minute: the ink on some of the voice parts, according to one participant, was still wet. Inevitably a moment came, about halfway through, when he had to avert discordant disaster, call a halt, and begin the whole long piece over again.

Perhaps here it would be merciful to draw, in Mark Twain's words, "the curtain of charity over the rest of the scene."

Chapter Five

The Immortal Beloved

O N JANUARY 7, 1809, Beethoven accepted Jérôme Bonaparte's offer of a court appointment in Kassel. This signaled that he was ready, in his thirty-ninth year, to relocate from a world capital to a provincial one, and give up all the patronage and business goodwill that he had built up in Vienna over the last decade and a half.

The decision made no sense to anyone except, apparently, himself. Although his freezing *Akademie* had been a trial for all concerned, the city's musical élite had respectfully attended, from Prince Lobkowitz, immovable in a box overlooking the stage, to the young piano prodigy Ignaz Moscheles in a corner of the gallery. Nor had Beethoven's reputation been affected by the failure of *Fidelio*. Rather to his annoyance, he was still regarded as a great instrumental composer. All the big works he had written since 1805 had won favor except the Mass in C (of which he remained proud) and the "Razumovsky" Quartets. Even the latter had begun to impress connoisseurs, in a chilly sort of way. During 1808, there had been no fewer than thirty-two public performances of his works in Vienna, as opposed to five of Haydn's and only two of Mozart's. His powerful new

Fifth Symphony was clearly destined to be as big a hit as the *Eroica*—if the Sixth's delicious depictions of the Viennese country-side did not charm audiences even more.

Actually, Beethoven had no more intention of removing to West-phalia in the new year of 1809 than he did to Portuguese East Africa. He was again setting himself up as a Viennese cultural icon, and for an urgent financial reason. It was that familiar embarrassment of the successful man: a cash-flow problem.

To a large extent he had brought it on himself by devoting so much unrewarded time to *Fidelio*, and biting the hand of Prince Lichnowsky, who had fed him so generously over the years. The two men were friends again, but Lichnowsky had not shown any sign of reopening his purse. Nor had the English pounds promised by Clementi come through yet, and Count Oppersdorf owed him 150 ducats. Beethoven had also gambled expensively by hiring a huge number of performers for his *Akademie*—four solo singers, full chorus, and enlarged orchestra. The "benefit" accruing to him in ticket sales is not known, but was probably slight in view of the weather, and reported rows of empty seats.

Such occasional coincidences of bad judgment and bad luck were to be expected in the career of a freelance composer—not that any composer had yet had such freedom. Beethoven could doubtless have recovered, had his stock of banknotes not been depreciated by a fall in the value of the Viennese silver florin. This inflation, brought about by the long cost of fighting Napoleon, had begun to trouble Austri-ans other than himself. It helped explain why he was finding both pa-trons and publishers harder to bargain with, and slower to pay.

His instinct, based upon an extremely shrewd sense of self-worth, was to stop bargaining and start bullying. In a letter that he

could be sure Breitkopf & Härtel would leak all over Germany, he announced that he was going to Kassel "as Kapellmeister at a yearly salary of 600 gold ducats." All that was wanting was King Jérôme's official decree. As soon as that arrived, he would start to pack. Then came some adept image management:

> Abusive articles about my latest concert will perhaps be sent again from here to the *Musikalische Zeitung*. I certainly don't want everything that is written against me to be suppressed. But people should bear in mind that nobody in Vienna has more private enemies than I have. This is the more understandable since the state of music here is becoming worse and worse.

He went on to admit that there had been a breakdown during performance of the *Choral Fantasy* "in the simplest, plainest place in the world," whereupon "I stopped them suddenly and loudly called out '*Once again*'—such a thing had never happened to them before." But what could be done in a city dominated by the likes of Antonio Salieri, the Emperor's archconservative master of music?

The subtext of Beethoven's letter was clear: only he could save Vienna from musical decline, caused by its humiliations in war and infatuation with cheap Italian operas. But he was tired of being left naked to his "enemies." Unless something was done to give him permanence and power, he would take his genius elsewhere.

Before mailing the letter to Leipzig, he took extra care to circulate its contents by writing on the back of the envelope, "I am asking you to say nothing with certainty about my appointment in Westphalia until I write to you that I have received my decree."

Beethoven was now living in a building in the Krugerstrasse owned by Countess Anna Marie Erdödy, one of the most ardent of his admirers, and just downstairs from the Lichnowskys' new apartment. A biographer should resist the speculation that his envelope was allowed to lie upside down on a silver tray in the hall, preparatory to being posted, but the fact is that Countess Erdödy at once embarked on a frantic campaign to keep Beethoven in Vienna. Working with Baron von Gleichenstein, she lobbied some of the city's richest patrons, in the hope of negotiating an annuity he could not refuse—and the King of Westphalia could not match.

At this critical point of his career, it might be well to take a look at the myth of "Beethoven Hero," the irresistible force of nature who rose from poverty and, thrusting aside princes and plutocrats, became the first proudly independent, middle-class musical "genius." As myths go, it is not unfounded. Although "hero" and "genius" are now buzzwords of everyday speech, Beethoven's long struggle against deafness and his even longer, tormented struggle for "perfection of the work"—Yeats's alternative to making art of life—were heroic enough to compare with, say, that of Milton against blindness, or that of Jean Moulin against Vichy France. And if the originality, fertility, and reach of his imagination did not qualify him as a genius, then some other superlative, not presently available in English, will have to be coined. It is also true that Beethoven forsook plush life the moment he could afford to in 1795, and when he later, loudly, compared certain aristocrats to donkeys and swine, he was in a way proclaiming his independence.

But as Maynard Solomon and especially the British sociologist Tia DeNora have shown, Beethoven never espoused bourgeois values. "I don't write for the galleries!" he said to Count von Braun,

when that gentlemen told him *Fidelio* should be made more crowd-pleasing. Beethoven might better have proclaimed the *inter*dependence between himself and his preferred audience—Vienna's well-born, well-educated, ultrasophisticated rich. Just as he needed them for their money and their private concert halls (which he found more congenial than public auditoriums), they needed him to give them a sense of collective worth that went beyond wealth. Not one of his patrons could be described as nouveau riche, or as ever adhering to any ideology leftward of say, Emperor Joseph's. Indeed, now that Joseph was dead—*Ach, tot!*—they had almost all moved rightward, bracing at the threat of Napoleonism.

The Lichnowskys and Lobkowitzes and Razumovskys, the Erdödys, Brauns, and Brownes, "dear fascinating" Giulietta and the regrettably chaste Josephine, lordly Prince Schwarzenberg, kindly Prince Kinsky, and many other blue-bloods, from Count Anton Apponyi to "His Highly Well-Well-Bestborn, the Herr von Zmeskall": these were Beethoven's ideal subscribers, his dedicatees, the butts of his clumsy jokes, the luxuriators in his rare but surprisingly deft flattery. Even when he insulted them, or behaved like a squat, absent-minded bear, spitting into their gilt mirrors, he satisfied the common craving of socialites to be around somebody who, for a change, was "real"—a "genius," an undisciplined freak (unlike the formal, deferential Haydn), an "artist" wholly devoted to a "higher genre" of music, itself the most elevated of all the arts.

They were not in the least dilettantish in their patronage of him, any more than he was cynical in playing along—quite literally, sometimes, since most of them were skilled musical performers. Princess Lichnowsky, who like her husband had studied with Mozart, was capable of rendering the score of *Fidelio* at sight; Count Moritz Lich-

nowsky was a pianist and future friend of Chopin's; Lobkowitz was a bass singer and string player; Razumovsky often played second fiddle in his own quartet; Zmeskall was an excellent cellist; and Baroness Ertmann, one of the finest pianists in Europe, could play anything Beethoven wrote, including the fiendishly difficult "Waldstein" Sonata. Others among his eminent acquaintance were librettists, bibliophiles, stage producers, and composers. Even old Baron van Swieten had once written twelve youthful symphonies—"as stiff as himself," Haydn joked.

It had been the Baron—dead now—who, in 1793, had started Beethoven out on the road of "genius" signposted by Neefe and Waldstein. One remembers him monitoring the young man's fugal studies and inviting him to sleep over in his palace, full of the city's best minds. In addition to being Imperial Librarian and head of the Austrian education department, van Swieten had founded the *Gesellschaft der associierten Cavaliere*, or GAC, an exclusively aristocratic arts-patronage society, reminiscent of the *Lesegesellschaft* that had promoted Ludwig's fortunes in Bonn.

Thus, Beethoven had been from the very start of his career a darling of the informed, the privileged, and the powerful. To claim, along with his mythifying biographers, that he simply punched his way up Parnassus is, in DeNora's words, "to mystify genius" and to ignore the extent to which his success "was the product of social mediation."

Almost all Beethoven's Viennese backers were members of the GAC. They regarded it as their mandate to preserve and perform the best music of the past, while encouraging a present music that would be equally inspiring to future generations. When Beethoven wrote in his leak letter to Breitkopf, "The state of music here is becoming

worse and worse," he could have been quoting one of the city aristocrats who believed that the larger, popular audience Emanuel Schikaneder wanted to bring into the Theater-an-der-Wien represented a vulgar threat. *Their* ideal audience was one that remained the same size and observed the same etiquette, while improving itself through repeated exposure to masterworks of "the higher genre."

For his part, Beethoven was gentlemanly in giving his noble backers the respect they deserved. He pondered the dedication of each new opus with the same care he gave to its key and tempo instructions. His First Symphony had gone to van Swieten. Of sixty-one other dedicatees he had chosen for works published through January 1809, fifty-three, or 87 percent, were titled aristocrats. Obsequious as this behavior may seem, it related strictly to business, since dedications were a major source of income for a composer. Some grandees would actually bid for the honor of sharing the same curlicues with him on the title page of a sonata or concerto.

Again, the phenomenon was that of interdependence, of pride on both sides, quite different from a hack musician's one-way dependence on the popular market. Unlike Mozart or Haydn, Beethoven never allowed himself to be "bought." When Count Razumovsky asked him to include some Russian tunes in Op. 59, he chose such elliptical fragments of folk song that they were barely recognizable. Only at the very end of No. 1 did he allow a few bars of slow, sentimental Russian melody. One can see the ambassador's handsome head swaying in pleasure before Beethoven cut in with an abrupt final cadence.

It might be wondered, given his *entente cordiale* with the Viennese musical establishment, why he went to such lengths to alarm it with his "acceptance" of King Jérôme's offer. But his financial need

was real, and the times were dire. Incredibly, a rearmed Austria, determined to throw aside the Peace of Tilsit, was facing yet another war against France. If Napoleon invaded again, the instability of the florin was sure to worsen, and even princes might look to their portfolios. The failure of the Court Theater's GAC-dominated directorate to give him a stipend was already an ominous sign.

Given Beethoven's narcissistic tendencies, he may have felt that his patrons were taking him too much for granted, assuming that because he was middle-aged, often ill, and hard of hearing, he would never consider a foreign position. If so, Countess Erdödy's alarm was enough to shake their complacency. Three members of the high nobility quickly clubbed together to offer Beethoven a guaranteed annuity of four thousand florins, on condition that he promised never to quit the domains of "His Austrian Imperial Majesty."

The respectful language of the contract, dated March 1, 1809, promised in return "to place Herr van Beethoven in a position where the necessaries of life shall not cause him embarrassment nor clog his powerful genius." It unqualifiedly confirmed, for the first time in music history, the superior status of the artist in society. Receiving it—and turning down Jérôme Bonaparte—gave him an erotic charge.

"You will see from the enclosed document," he wrote von Gleichenstein, "how honorable my remaining here has now become for me. . . . Now you can help me to look for a wife. Indeed you might find some beautiful girl at F[reiburg] where you are at present, and one who would perhaps now and then grant a sigh to my harmonies."

The thrill he felt was the greater because his copy of the contract was handed to him personally by Archduke Rudolph, the Emperor's

youngest brother. Rudolph was one of its three cosigners, at 1,500 florins per annum, the others being Prince Lobkowitz at 700 florins and Prince Kinsky at 1,800 florins. For a Habsburg to sign and deliver such a solemn instrument of security amounted, as far as Beethoven was concerned, to an imperial decree. Deep inside the bosom of the now-certified "genius," Kapellmeister van Beethoven's grandson still coveted court favor.

The Archduke had just turned twenty-one. He already knew Beethoven well, having studied the piano with him for at least a year. A gifted musician, with a keyboard command that enabled him to manage most of his teacher's sonatas, he wanted to learn how to compose. His relationship with Beethoven was an awkward, but extremely affectionate, mix of pupil and teacher, boy and man, aristocrat and commoner. Rudolph was an expressionless, gentle-mannered youth with small, sleepy eyes and the usual Habsburg jaw, in this case heavy rather than long. Epilepsy was his cross, and music his salvation. As the last son of a Holy Roman Emperor, he was a clear candidate for a high position in the Catholic priesthood.

In exchange for the Archduke's generosity, Beethoven had a Fifth Piano Concerto almost ready for him to practice. It was likely to stretch the young man in more ways than one, being the longest and most difficult showpiece yet attempted in the concerto literature. Beethoven himself would never play it publicly.* Cast in E-flat major—the golden-toned key of the *Eroica* Symphony—this new concerto exactly fulfilled the hope of the Annuity Agreement, that

*His performance of *Choral Fantasy* in December 1808 had been his final solo appearance with an orchestra.

he would "create works of magnitude which are exalted and which ennoble art."

It also demonstrated a quirk that was becoming noticeable in Beethoven's creative psychology: his way of following up one major work with another that was its mirror opposite. Just as the testosterone-charged "Prometheus" Variations begat the feminine Variations, Op. 35, and the *Eroica* begat the decidely unheroic Fourth Symphony, so did the spacious "Waldstein" Sonata produce the Sonata in F, Op. 54, a compact, two-movement jewel box, while the Fifth Symphony, all geothermal heat, subsided into the *Pastorale,* with its babbling brook and birdcalls. Now the Fifth Piano Concerto succeeded the Fourth—a work of the most translucent delicacy— much as Joseph II had succeeded Maria Theresia, with an exuberant display of power. Although dedicated to Archduke Rudolph, it inevitably came to be called the "Emperor."

And, with one exception soon to come, it was the last of Beethoven's "heroic" achievements. He was to write a few more luxuriously large, melodically sumptuous items before his style underwent a profound change. But they would lack the "Emperor" Concerto's fanfares and marches, its all-conquering solo and acclamatory tutti. Even as Beethoven composed the final climax, he allowed it to collapse, as if exhaustion and something very like fear was setting in: a gradual slowing of tempo down to near stasis, over drum taps that grew weaker beat by beat. Then, with a valedictory cadenza and much orchestral trumpeting, he bade farewell to his plumed troop.

He had to bid farewell to Rudolph, too. On April 9, Austria declared war on France, and three of the Archduke's elder brothers were dispatched to command points along the front. Rudolph was

too young to serve, but by May 4, with French troops (who better than they to understand the meaning of the phrase *déja vu*?) once again crowding Vienna, the remaining members of the imperial family had to leave town. A week later, a terrific bombardment shook the city. It continued, with return fire from the citadel, for seventeen hours. One cannonball landed in the courtyard of the house where Joseph Haydn lay dying. Beethoven, desperate to protect what was left of his hearing, took refuge in Caspar's cellar, clutching pillows to his ears. On May 12, the Grande Armée reoccupied Vienna, while Napoleon made himself comfortable in the now-familiar surroundings of Schönbrunn Palace.

The last day of the month brought news of Haydn's death. Beethoven was not moved to any comment, public or private. He had long since made his peace with "Papa," tearfully kissing the old man at a tribute performance of *The Creation.* They had envied each other and learned from each other, and the embrace they exchanged had been, to some eyes, symbolic of passage. But Beethoven had already moved on to musical regions where Haydn could not follow.

So when he composed a new piano sonata on the theme of leave-taking, actually writing the syllables *"Le-be-wohl!"* ("farewell") over its three opening notes, he was thinking not of his teacher but of his pupil, the brilliant boy who had just quit town. Now known as the "Les Adieux" Sonata, Op. 81a, the work bursts with youthful, clumsy ardor, intermixed with passages of desolate longing. Beethoven, normally given to abstract expression, allowed himself a personal passage in the coda to the first movement, when simulated horn calls, near and far, echo one another across a widening distance.

One result of the French occupation that summer was that he re-

ceived his first pilgrim from Paris, a junior member of Napoleon's council named Louis-Philippe de Vienney.* The young man found him living alone in the Walfischgasse in alarming conditions:

> Picture to yourself the dirtiest, most disorderly place imaginable—blotches of moisture covered the ceiling; an oldish grand piano, on which the dust disputed the place with various pieces of printed and manuscript music; under the piano (I do not exaggerate) an unemptied *pot de nuit;* beside it, a small walnut table accustomed to the frequent overturning of the *secretaire* placed upon it; a quantity of pens encrusted with ink . . . then more music. The chairs, mostly cane-seated, were covered with plates bearing the remains of last night's supper, and with clothing etc.

The chamber pot and plates imply that Beethoven's housemaid had the day off, but many other pilgrims over the years were to remark on the increasing slovenliness of his apartments.

He was charmed by de Vienney, who seemed to know all his works, and encouraged further visits. One day he treated him to a private piano recital. "I can only say," de Vienney wrote afterward, "that unless one hears him improvising when he is on form, and relaxed, one can hardly guess at the vast scope of his genius."

Beethoven reacted cagily to the idea of a concert tour of France, if peace ever came. "If I went to Paris, would I be obliged to salute your emperor?"

*Prematurely identified in most Beethoven literature as the Baron de Trémont.

De Vienney thought not, unless Napoleon ordered him to.

"And do you think he would order me?"

The question sounded more wistful than apprehensive. Sensing that Beethoven would, if necessary, risk his dignity just to be noticed by Napoleon, de Vienney replied as tactfully as possible, "He does not know much about music."

Napolean's victory at Wagram in early July was his bloodiest yet, with so many deaths on both sides that France now needed peace as much as Austria. Even so, the French occupation of Vienna lasted until well after the peace treaty signed at Schönbrunn on October 14. It was a miserable period for Beethoven—most of whose well-born friends stayed away from the city—but he worked with his usual industry, completing three piano sonatas and a string quartet and a number of lesser works, along with fifteen songs and a substantial book of counterpoint exercises for Rudolph.

Not until November 20 did the last foreign troops go, leaving behind them an economy in free fall. Under the terms of the treaty, Franz I had to find eighty-five million francs in war reparations, while losing the revenues of all his coastal possessions and the fealty of 3.5 million former subjects. With Stephan von Breuning now working as a secretary in the War Ministry, Beethoven could not fail to have felt some of the fiscal pessimism emanating from the Hofburg. His annuity had already devalued, in purchasing power, to less than the six hundred ducats Jérôme Bonaparte had offered him. "What do you say to this *dead peace*?" he wrote Breitkopf & Härtel. "I no longer expect to see any stability. . . . The only *certainty* we can rely on is *blind chance.*"

This pessimism may account for a certain perfunctoriness in the "heroic" music he now had to write for a revival of Goethe's *Egmont*

at the Court Theater. Beethoven dutifully whipped up triumphant climaxes in his best minor-to-major, *molto crescendo* manner, but for the first time in his career he sounded as if he was repeating himself. If, as the Danish literary critic Georg Brandes suggested, the ardent aspirations of German Romanticism in the Napoleonic era betrayed an "impotence itself disguised as power," Beethoven had become aware of the fallacy.

Rudolph returned to town, eager to resume lessons, and a large part of Beethoven's creativity was now devoted to inventing excuses as to why they could not meet more often. Much as he loved the Archduke, he hated teaching. Interlocution was difficult for him, and he lacked patience with young people.

He even showed signs of being bored with composition, pestering his editors at Breitkopf—which he seemed to regard as a publishers' clearinghouse—to send him the complete works of Goethe and Schiller, plus whatever other texts, ancient or modern, they could think of: "There is scarcely any treatise which can be too learned *for me.*" He read tragedies by Euripides, poems by the contemporary German playwright Johann August Apel, and found himself strongly attracted to Hindu religious writings. Never much interested in the music of his contemporaries, he applied himself to the study of Bach and Handel and their distant predecessors. "In the old church modes the devotion is divine. . . . God permit me to express it someday."

This scholarly impulse, plus a sudden decline in productivity as he entered his fortieth year, reinforces the impression that Beethoven was approaching a climacteric. His notebooks began to fill up with sterile ideas. There were occasions when he tried to improvise but could not. Something more than the "dead peace" was affecting his spirits.

It may have been sexual starvation. A pentimento of desire and loss floats through the blurry record of Beethoven's life from his rejection of the Kassel offer through the spring of 1810. Some facts and half facts may not directly relate, except that—as a review of them indicates—they link chronologically, and share the same protagonist.

Just after Countess Erdödy begins to campaign in behalf of the Annuity Agreement, Beethoven hears she has been secretly supplementing the wages of his servant. He fantasizes (in Maynard Solomon's diagnosis) that she is paying the man for sex. He scrawls among sketches for the "Emperor" Concerto: "You have received *the servant* from me instead of *the master*. . . . What a substitution!!!!" Shortly afterward, he leaves the house of "the huckster woman" and moves to the Walfischgasse house, which he knows to contain a brothel. He asks von Gleichenstein to find him a pretty girl to marry, with the bizarre caveat, "I cannot love anything that is not beautiful—or else I should have to love myself." Just then Stephan von Breuning's ravishing teenage wife, Julie, dies. Beethoven is too busy to console his shattered friend, while convincing himself that Julie loved *him*. (We may recall a similar inversion vis-à-vis Giulietta Guicciardi.) Rudolph leaves town, to the strains of Beethoven's articulated horn call in the "Les Adieux" Sonata. *Le-be-wohl!* Young de Vienney comforts his loneliness, then also leaves. *Lebewohl!* Napoleon, too, comes and goes, neglecting an opportunity to hear Beethoven conduct the *Eroica* Symphony. *Lebewohl!*

During the winter of 1809-1810, Beethoven is enraptured by eighteen-year-old Therese Malfatti, his doctor's daughter, and disgorges a flood of songs. He borrows a mirror, buys new clothes, and urgently requests Wegeler, in Bonn, to get his baptismal certificate copied for wedding purposes. (This is when he first discovers—and

refuses to accept—that he is two years older than he has always be-
lieved.) Therese is unreceptive. As spring returns to the Wienerwald,
Beethoven oscillates between rapture and self-pity. "I should be . . .
one of the happiest of mortals, if that fiend had not settled in my
ears." He flirts with sexy Bettina Brentano, but cannot go as far as
Goethe in asking if he may caress her breasts.* However, he com-
pares himself to Hercules. In May 1810, Therese rejects him.
"Farewell, honored T.," he writes.

Beethoven's "wild goings-on" (to use his own phrase) should not
be taken too seriously. They were more parodistic than genuine—di-
versions, almost, undertaken to reassure himself that he was better
off alone. "The mighty one," he wrote in one of his notes on Hindu
texts, "is he who is free from all desire." But then a chance encounter
brought about by Bettina Brentano afflicted him with more desire
than he could capably handle.

Bettina was an enchanting young woman, destined to become
famous one day as Bettina von Arnim, author of *Goethe's Correspon-
dence with a Child.* In the spring of 1810, she was visiting Vienna with
her brother Franz, a Frankfurt banker, and his Austrian wife, An-
tonie. Frau Brentano was locally remembered as "Toni" von Birken-
stock, daughter of one of the city's richest art collectors. Old Joseph
Melchior von Birkenstock had just died, and it was Antonie's half
pain, half pleasure to return home and liquidate the contents of his
vast mansion. As a born Viennese, she had never gotten used to life
in the dour north, and few doubted that she would spin out the cat-
aloging process as long as possible: there was enough in the house to

*This interesting story is told by Romain Rolland in his *Goethe and Beetho-
ven* (New York, 1931).

stock three or four museums. Thanks to Bettina—the kind of girl who liked to rush into a dining room hand in hand with any celebrity conquest—Frau Brentano was soon "Toni" to Beethoven, too.

And thanks to her calm, strong personality, he soon forgot about Bettina, Therese, Josephine, Giulietta, and every other woman he had cared for. Maynard Solomon has demonstrated beyond doubt that Antonie Brentano, over the course of the next two years, became Beethoven's famous *unsterbliche Geliebte*, the "Immortal Beloved" of a thousand speculative monographs and dissertations.

In May 1810 she was just thirty years old, the mother of four children, and an expert guitarist. Slender, pale, delicate, and intermittently depressive, she may have reminded Beethoven of his mother. In her cool way (so different from Bettina's gushing), she appreciated his human as well as his musical qualities: the courage, the curiosity, the ardent intensity. There was little likelihood of her ever yielding to him physically. Antonie was a loyal, if not loving, wife to Franz—a good-natured sort who came to treat Beethoven almost as her brother.

The romance did not blossom instantly. At first, Beethoven remained more interested in Bettina, who described him at length in a letter to Goethe. The great man probably had difficulty believing Beethoven was capable of such pomposities as "I am the Bacchus who presses out this glorious wine for mankind and makes them spiritually drunken." Still, there was enough hard reporting in Bettina's purple prose to interest Goethe in the idea of meeting the composer of the *Pastorale* Symphony. She evoked a man so possessed with music that he worked from before dawn till after dark, often forgetting to eat; who was friendless by choice; who was inspired as much by the rhythms of lyrics as by their meaning; who had absolute

confidence in the enduring value of his art, and claimed that music was "the mediator between the life of the mind and the senses."

Goethe wrote back, "Give Beethoven my heartiest greetings and tell him that I would willingly make sacrifices to have his acquaintance." He suggested Karlsbad, "where I go nearly every year," as a possible place to meet. Beethoven was equally positive, and equally vague, when Bettina spoke to him about it. The two supreme egos of German culture were clearly feeling each other out, neither wanting to seem too solicitous.

Coincidentally, Beethoven's position in that culture received its first authoritative affirmation in an essay on the Fifth Symphony by E. T. A. Hoffmann, published on July 4 and 11 in the *Allgemeine Musikalische Zeitung*. Hoffmann—composer, critic, painter, jurist, fabulist—was not yet famous as the author of fantastical tales, but his music reviews were widely read and discussed. This particular one, written just after the births of Chopin and Schumann, has attained classic status for its identification of Beethoven with "that endless longing which is the essence of Romanticism."

Drawing particular reference to the claustrophobic link between the scherzo and finale of the Fifth Symphony, Hoffmann spoke of "a fear which tightly constricts the breast" giving way to "radiant, blinding sunlight." Imagery aside, he heard something new in Beethoven's music, a metaphysical extension that transcended the pleasure of pure sound and approached dialectical argument. That was why it was better suited to symphony than song. There was hardly any melody in the Fifth's opening movement: just relentless reiteration of a four-note motif that operated like a formula in algebra, advancing the harmonic logic. The same motif reappeared in each movement that followed, connecting them so tightly that the third

and fourth actually were one vast structure. This insistence on process explained why Beethoven did not (Hoffmann felt) appeal to the masses. Unable to follow him, most people were bound to find his music imaginative but chaotic.

Beethoven had admitted as much to Baron von Braun: "I don't write for the galleries!" Nevertheless, the remark about him not being a natural vocal composer had to hurt. It was another kick at the corpse that was *Fidelio,* and it ignored the success of *The Mount of Olives.* Perhaps for this reason, Beethoven waited ten years before thanking Hoffmann for his review.

At last, however, somebody who understood words as well as notes had been able to articulate the musical revolution he had brought about. The age of *Affekt,* of familiar sounds in rationalized patterns designed to evoke specific emotions, was over. The age of Argument had begun: music that actually fought with itself, with the composer struggling to balance its contrary dynamics, and the performer struggling to master its difficulties—while the listener, caught up in the struggle, too, wondered which force was going to prevail. Both the Fifth and the "Appassionata" opened ominously: who could tell that the one would end in blazing triumph, and the other in a nihilistic frenzy? Even Beethoven's most serene music, such as the Fourth Symphony, was palpably the result of a herculean battle for order. Yet, amid all this order, how deeply the slow movement of that work stirred emotions too primal even to describe, let alone specify!

Hoffmann's *Ahnungen Ungeheuren,* translated by F. John Adams as "a presentiment of the colossal," was an attempt at such description. It went about as far as the German language could go in communicating what he felt to be the spirit of Romanticism. (To English speakers of the time, Wordsworth's "fallings from us, vanishings"

probably said as much.) Beethoven himself allowed that his symphonies were imbued with "something eternal, infinite, something never wholly comprehensible"—or so Bettina Brentano thought she heard him say. Even if that ultra-Romantic young lady was expressing her own inchoate response to Beethoven's music, she was of one mind, that summer, with E. T. A. Hoffmann.

Bettina soon moved on to Berlin, and marriage with the young writer Achim von Arnim. Antonie stayed in Vienna. Often ailing, she was touched by Beethoven's solicitude in stopping by the Birkenstock mansion even when she was unable to receive visitors. Ignoring everybody else in the house, he would seat himself at the piano in the antechamber to her bedroom, and communicate with her, as she put it, "in his own language." When he had "said everything and given solace," he would quietly leave.

By the new year of 1811, she was besotted with him. "He walks godlike among the mortals," she wrote her brother, "his lofty attitude set against the mundane world, and his sick digestion aggravates him only momentarily, because the Muse embraces him and presses him to her warm heart." The reference to intestinal trouble is in line with a report in the *Allgemeine Musikalische Zeitung,* dated January 8, that Beethoven's health "has suffered severely during the last few years." Mutual frailty might have been another factor drawing them together.

Neither diarrhea, headaches, nor the distractions of love prevented Beethoven from completing, in March, the most magnificent of all piano trios. Evidently he had recovered from his inspirational drought. Dedicated to Rudolph and therefore known as the "Archduke" Trio, it was the chamber equivalent of the "Emperor" Piano Concerto, full of golden melody. Both works, in their slow move-

ments, evoke the same doubt: that any music can ever sound more beautiful. The doubt is a delusion, of course, but it persists until the movements die away—in each case mysteriously.

Beethoven's stately flirtation with Goethe continued, with letters full of extravagant compliments passing back and forth. Goethe hoped that Herr van Beethoven would find it convenient to visit him in Weimar. Beethoven hoped that "Your Excellency" would be so kind as to comment on the music for *Egmont,* which Breitkopf & Härtel was sending by separate mail. Unfortunately, the publisher was dilatory in having the score copied, and Beethoven let Goethe's invitation lapse.

He did, however, break his usual routine that August, and traveled to Teplitz to see if Bohemian waters might help his stomach trouble. Since the Brentanos were wont to summer in nearby Karlsbad, it is also possible he went there hoping to see Antonie. In between baths, he composed two sets of incidental music for plays to be mounted in Budapest (*King Stephen* and *The Ruins of Athens*), and began to sketch his Seventh and Eighth Symphonies. The last two works were to preoccupy him for more than a year. Late in 1811 he wrote a poignant song, "*An Die Geliebte*" ("To the Beloved") and gave the score to Antonie. What she inferred from it can only be guessed, but to the piano accompaniment Beethoven added a highly unusual extra stave for guitar.

He was ill again for much of the winter, and depressed by a catastrophic devaluation of the Austrian currency. It had effectively reduced his annuity by two thirds. To make matters worse, Princes Lobkowitz and Kinsky were being dilatory with their quarterly payments, when they made them at all: Lobkowitz was rumored to be in deep financial trouble. Then, on February 12, 1812, the "Emperor"

Concerto premièred in Vienna, with Carl Czerny as soloist, and failed badly.

This was, in short, a winter of discontent for Beethoven. But if proof is needed of the absolute unrelatedness of worldly concerns and musical expression, it is the score of his Seventh Symphony, completed just after this dark period. "How it sounds!" Felix Mendelssohn used to say. Massive, muscular, louder than any of his other works, with high-crooked horns and throbbing drone basses, it is one long explosion of superhuman energy. The Eighth Symphony, which followed soon after, is as usual a contrast, being short and deliciously witty. Yet it is so boisterous in its high spirits (including loud raspberries deliberately blown off-key) that one might be pardoned for thinking that "Toni" had at last allowed Beethoven to sleep with her.

The truth is that when he again followed her to Teplitz on July 7, 1812, taking the half-finished score of the Eighth with him, she was pregnant with another child by Franz Brentano. Moreover, she had at last wound up her father's estate. With the coming of fall, she would close the great house in Vienna, and return permanently to Frankfurt, where her loyalties—if not her heart—committed her.

Before quoting the love letter Beethoven began writing "to you, my Immortal Beloved" on the eve of his arrival in Teplitz, it is necessary to repeat that only in modern times has the addressee been conclusively identified as Antonie Brentano. Maynard Solomon's researches into the case, first published in 1972, are as exciting as any detective story. Querulous arguments have been made in favor of Josephine Deym-Brunsvik, and even one of the princesses Esterházy, but all involve stretches of the imagination tolerable only in academe.

The Solomon thesis, too detailed to summarize here, speaks for itself. And so does Beethoven's unmailed letter, with a passion that still vibrates after nearly two centuries. Half appeal, half fantasy, it can be given only in part:

My angel, my all, my very self— . . . Why this deep sorrow when necessity speaks—can our love endure except through sacrifices, through not demanding everything from each other; can you change the fact that you are not wholly mine, I not wholly yours—O God, look out into the beauties of nature and comfort your heart with that which must be—Love demands everything and that very justly—thus it is to me with you, and to you with me. If only you do not forget that I must live for me and for you; if we were wholly united you would feel the pain of it as little as I— . . . We shall surely see each other soon. . . . My heart is full of so many things to say to you—ah—there are moments when I feel that speech amounts to nothing at all—Cheer up—remain my true, my only love, my all as I am yours. . . .

Evening, Monday, July 6
You are suffering, my dearest creature— . . . Ah, wherever I am, you are there also—I will arrange it with you and me that I can live with you. What a life!!!! thus!!!! without you—pursued by the goodness of mankind hither and thither—which I as little want to deserve as I deserve it—Humility of man towards man—it pains me—and when I consider myself in relation to the universe, what am I and what is He—whom we call the greatest—and yet—herein lies the divine in man— . . .

BEETHOVEN

*Much as you love me—I love you more—But do not ever
conceal yourself from me—good night—As I am taking the
baths I must go to bed—Oh God—so near! so far! . . .*

Good morning, on July 7

*Though still in bed, my thoughts go out to you, my Immortal
Beloved, now and then joyfully, then sadly, waiting to learn
whether or not fate will hear us—I can live only wholly with
you or not at all— . . . No one else can ever possess my heart—
never—never—Oh God, why must one be parted from one
whom one so loves. And yet my life in V[ienna] is now a
wretched life—Your love makes me at once the happiest and the
unhappiest of men—At my age I need a steady, quiet life—can
that be so in our connection?. . . Be calm, only by a calm
consideration of our existence can we achieve our purpose to live
together—Be calm—love me—today—yesterday—what tearful
longings for you—you—you—you—my life—my all—
farewell.—Oh continue to love me—never misjudge the most
faithful heart of your beloved*

L.

ever thine
ever mine
ever ours

Chapter Six

The Mountains of the Mind

"A TRUE ARTIST HAS NO PRIDE," Beethoven wrote to Emilie M., a fellow musician, on July 17, 1812. He was still at Teplitz, taking the waters and trying to adjust to the prospect of life without Antonie Brentano. Like many a recluse, he felt the need to unburden on a stranger.

"Unfortunately," Beethoven continued, "he sees that art has no limits; he senses darkly how far he is from the goal; and while he is perhaps admired by others, he mourns that he has not yet arrived to the point where his better genius shines as an example like a distant sun."

Emilie might have understood him better if she had been more than ten years old. All she had done was send him a fan letter. But by now Beethoven was a man talking mainly to himself.

With his Eighth Symphony sketched out and the full score well under way, he had written as much "public" music as he wanted to. The noble, expansive style that had made him famous over the last decade no longer came naturally to him. What did was a new, introverted, allusive style, not yet fully formed, which tended toward

extreme compression and a rejection of any harmonic or melodic sweetness. There had been hints of it in the "Razumovsky" Quartets of 1806 and the terse slow movements of the "Waldstein" and "Les Adieux" Sonatas, and more than a hint in his latest string quartet in F minor, which was as dense, black, and bitter as a pickled walnut.

It would be too much to say that Beethoven was already entering his "third period" of musical composition. He was actually in the early throes of a prolonged psychological transition, not just from style to style but from early to late middle age, and to acceptance of the near-certainty that he would die unmarried and stone-deaf. "For you there is no longer any happiness except within yourself, in your art," he wrote, in words echoing the Heiligenstadt Testament of ten years before. "O God! give me the strength to conquer myself, nothing at all must fetter me to life."

For the rest of the decade, a host of nonmusical problems were to threaten his security, and even his sanity. The suggestion by some biographers that he went creatively sterile after completing the Eighth Symphony is unfair. While his output did decline dramatically, down to almost zero in 1817, his creative experiments ranged farther afield than ever before—from a trio for one of Antonie's children to crowd-pleasers and sonatas of bewildering disparity.

The trio, a single-movement work (in B-flat, WoO 39) dedicated to Maximiliane Brentano, achieves the near impossible by accommodating itself to a little girl's technique without any condescension to parlor sentimentality. Only Schumann, in his *Kinderszenen,* ever wrote music so perfectly calibrated to delight adults and children alike. It formed part of a farewell package of parlor pieces for the Brentanos to take with them when they left Vienna for good. Beethoven inscribed several to "Toni," but offered her no formal dedi-

cation. Perhaps she understood that he was in no hurry, waiting until he had composed something that matched the size of his feelings for her.

Goethe and Beethoven finally met that summer, on at least four occasions in Teplitz and Karlsbad. But their conversation seems to have avoided profundities. At first the poet was impressed. "I have never met a more concentrated, more energetic, and more *inniger* artist," he wrote in his diary, using an untranslatable adjective that conveys, to Germans, a combination of inner integrity and expressive fervor. In a later letter, Goethe was more critical of Beethoven: "His talent amazed me. However, unfortunately, he is an utterly untamed personality, not at all wrong if he finds the world detestable, but he thereby does not make it more enjoyable either for himself or others."

Beethoven was equally disappointed. Teplitz was crowded with vacationing royalty and nobility in 1812 (all talking about Napoleon's invasion of Russia), and he sensed that Goethe hankered for their society. "Goethe is too fond of the court atmosphere, more than is dignified for a poet," he wrote Breitkopf & Härtel. "Why mock the follies of virtuosi, when poets, who should be the prime instructors of their countrymen, throw everything aside for the sake of such glitter?"

The last sentence betrayed Beethoven's belief in the role of the poet—*Dichter*—as a moral and aesthetic exemplar. He aspired to the same role, preferring to call himself a *Tondichter* (tone poet) rather than *Komponist* (composer). At this stage of his career, he clearly believed, with Spinoza and Schiller, that a creative artist should strive neither for royal favor, nor for the love of God, but only for works of rational beauty that would inspire and improve humanity as a

whole. The greater the genius, the righter must be his instincts. Of his own greatness and rightness, Beethoven had no doubt whatever: "Power is the morality of outstanding men, and it is my morality too."

Such grand-sounding sentiments were all very well in the world of art, but in the world of ordinary affairs he could be both irrational and petty. Caspar van Beethoven had already found this out. Now it was Johann's turn to feel Ludwig's astonishing capacity for vindictiveness.

Johann happened to have a good business head, and four years back he had bought, with his last kreuzer, an apothecary shop in Linz. He had succeeded beyond expectation, quintupling the value of its stock. Ludwig did not see why his brother should get rich while hyperinflation made *him* poor during the same period. But this resentment was mild compared to his rage upon hearing, in early October 1812, that Johann, age thirty-six, had decided to follow Caspar down the aisle.

The news, approximately coinciding with Toni Brentano's departure for Frankfurt, drove Ludwig into a frenzy. He hurried to Linz and found Johann not only determined to wed the curvaceous Therese Obermayer, but already enjoying her services as "housekeeper." Evidently, Therese was not lacking in sexual experience, having already acquired a daughter by another man. Revolted, Ludwig went straight to the Bishop of Linz and demanded a stop to the marriage. He had no luck, so then applied to the city council and somehow won a police order to expel Therese from town as a loose woman. When Johann protested, Ludwig behaved so violently that Thayer, his normally dispassionate biographer, could not bring himself to print the details half a century later. Johann settled the

matter by marrying Therese on November 8, two days before the police order would have taken effect.

Beethoven returned to Vienna (in an unconscious *pas de deux* with Napoleon retreating from Moscow) and heard further bad news: Prince Kinsky had been killed in a riding accident. He viewed the tragedy as a major inconvenience to himself. For as long as the Kinsky estate remained in probate, he was in danger of being deprived of his most generous source of annuity money. With little regard for the feelings of Princess Kinsky, he at once initiated a lawsuit to force her into honoring her husband's commitment.

All this ugly behavior did not prevent the flowering of his loveliest violin sonata, in G major, Op. 96. It marked a new stage in Beethoven's emancipation of the trill as a sort of musical aerodynamic, not necessarily resolving onto other notes but floating or soaring at will. Trills would proliferate in his work from now on, eventually reaching such ecstatic lengths that Claudio Arrau has likened them to "tremblings of the soul." The sonata premièred publicly on December 29 in Prince Lobkowitz's palace, with Pierre Rode, a French virtuoso, playing the violin part. At the piano was Archduke Rudolph.

Faithful as ever, Rudolph was probably the only intimate who could give Beethoven comfort during the year of loneliness that followed. Antonie was gone; Bettina married; Josephine Deym remarried; Ries emigrated, and von Gleichenstein was no longer available for unpaid services. Relations with Countess Erdödy, Stephan von Breuning, and Prince Lichnowsky had never been the same since past quarrels. Johann and Caspar (ailing with what looked like hereditary tuberculosis) were now both alienated.

The Archduke, too, was ill. He suffered from gout and arthritis

on top of epilepsy, and could not hope to play the piano much longer. A positive soul, he compensated by applying himself studiously to the rudiments of composition—when he could get Beethoven to share them—and by building up a library of rare musical books and manuscripts. He gave Beethoven free access to this archive, and told servants at the imperial palace to be tolerant of his teacher's eccentricities. All the same, Rudolph remained very much a Habsburg, and showed quick displeasure when Beethoven honored other people with works he wanted for himself. As a result, he was the dedicatee not only of the "Les Adieux" Sonata and "Archduke" Trio, but also of the Fourth and Fifth Piano Concertos, to which Beethoven now added the new violin sonata. Four further dedications, in coming years, were to identify the Archduke with more great music than any other patron in history.*

By the spring of 1813, Caspar's health had worsened so alarmingly that Beethoven took steps to reconcile with him. In a tormented way, Ludwig loved his brothers, and pined for them as much as he held them off. Even so, his present tenderness was not without motive. On April 12, he coaxed Caspar to sign the following document, in the presence of four other witnesses:

> Inasmuch as I am convinced of the frank and upright disposition of my brother Ludwig van Beethoven, I desire that after my death he undertake the guardianship of my son, Karl Beethoven, a minor. I therefore request that the honorable court appoint my brother mentioned to the guardianship

*The Piano Sonatas Op. 110 and 111, the *Missa Solemnis,* Op. 123, and the *Grosse Fuge,* Op. 133.

after my death and beg my dear brother to accept the office
and to aid my son with word and deed in all cases.

The most notable feature of this declaration was the absence of
any reference to Caspar's wife, Johanna.

She may not have been a model mother. Just two years before,
she had been convicted of misappropriating a pearl necklace, and
only narrowly escaped being sent to jail. The record of the case is
murky: Caspar, himself something of a wheeler-dealer, appears to
have been involved. As a couple, they were often in financial diffi-
culties, although they owned a large boardinghouse and lived lav-
ishly. Beethoven was probably correct in reading their marriage as
loveless and threatening to the best interests of his nephew.

Karl was now six and a half years old, a bright child who was
likely (unless his uncle in Linz managed to sire a late son) to be the
only Beethoven of the next generation. If he was more attached to
his mother than to Caspar, that was hardly surprising: the latter was
a harsh father and husband, and had once stabbed Johanna through
the hand with a table knife. Karl could not help seeing the scar on a
daily basis, and sharing with her a sense of vulnerability.

Ludwig's own feelings as the boy's newly designated guardian are
not of record. But they can be inferred from his chilling reaction
when Caspar's disease went into remission. He sank into the worst
melancholy he had suffered since the death of Maria Magdalena
twenty-six years before. "O God, God, look down upon the unhappy
B.," he wrote in his *Tagebuch,* a volume of jottings he had begun to
keep around the time of Antonie's departure. "Do not let it continue
like this any longer."

He became "positively *schmutzig* [dirty]," to quote an artist who

encountered him in Baden. Two old friends, the piano makers Johann and Nanette Streicher, were so shocked at the condition of his clothes that they bought fresh ones to replenish his wardrobe. He admitted that he was in a bad way: "A number of unfortunate incidents have really driven me into a state bordering on mental confusion." He went to prostitutes for sexual relief, then suffered agonies of moral guilt: "Sensual union without a union of souls is bestial and will always remain so."

His deafness was by now so severe that people found conversation with him exhausting. In the words of the violinist Ludwig Spohr, "One had to shout so loudly that it could be heard three rooms distant." Beethoven began avoiding the stares of strangers. We can see exactly what they saw, in a gypsum life mask made around this time by the sculptor Franz Klein, and preserved in Bonn: the clamped lips and wrenched chin, the terrible frown, the eyes downcast beneath the pocked forehead. Recoiling, one's first thought is how small Beethoven is, in contrast to the craggy-featured giant of so many heroic busts. If this is the face of a great man, it is also a reminder that Gerard Manley Hopkins's "mountains of the mind" rise beyond dimension, under a dome of their own.*

And sometimes even a great man feels the mountains whitening. For the rest of 1813 Beethoven was unable to produce a single original piece of music. The only exception—if it can be called music— was a "Battle Symphony" on British and French march themes, suggested and sketched for him by Johann Nepomuk Mälzel, "Court Mechanician" to the Habsburgs. Sound spectaculars, preferably involving real cannonades and the loudest possible ruffles and flour-

*See illustration, p. xii.

ishes, were in great demand during the Napoleonic Wars. But because of the large performing forces involved, they were difficult to take on tour. Mälzel thought he had invented an ideal machine to solve the problem—and rake in huge fees in Austria and Britain. He called it the "Panharmonicon." It consisted of a giant wind chamber, perforated with military brass instruments, and pressurized from within by a bellows powerful enough to blow them all *fortississimo e senza pausa.* Keyed, revolving cylinders could be inserted, music-box fashion, to control the distribution and duration of notes.

Mälzel's suggestion to Beethoven was that they should jointly create, and profit from, the mother of all cylinders. It would celebrate the Battle of Vittoria in the Spanish War of Liberation, news of which reached Vienna on July 13. Widely seen as a portent of Bonaparte's coming demise, the battle had elevated the British general Sir Arthur Wellesley to glory as Duke of Wellington. Beethoven must therefore—Mälzel insisted—quote "God Save the King" repeatedly, and even weave it into a final fugato, as if running up a giant Union Jack. He should also satirize French vainglory by mockingly quoting the old war song *"Malbrouk s'en va-t-en guerre"* (better known across the Atlantic as "The Bear Went Over the Mountain").

It says much for Beethoven's semicatatonia that he actually accepted these instructions. But he owed Mälzel a favor, the Mechanician having designed and built no fewer than four ear trumpets to combat his deafness.* He went about the task of composing the

*Beethoven also agreed to endorse the Court Mechanician's latest invention, a little upright pendulum designed to tick preselected tempi for musicians in rehearsal. To this day, "Mälzel's metronome" continues to tick atop pianos around the world.

"Battle Symphony" (known in Germany as *Wellingtons Sieg,* or "Wellington's Victory") with typical professionalism, expanding it to two movements and throwing in "Rule Britannia" for good measure. After scoring it for the Panharmonicon, he composed an alternative version for grand orchestra. This enabled him to indulge his love of military field drums, beginning the piece with two enormous rattling crescendos in contrasting rhythms, as if marshaling his aural forces. In the ensuing "battle," he marked 188 exact cues for cannon fire, with solid dots for British artillery and open ones for French, plus twenty-five musket volleys of precise length and direction, indicated by tied, trilled ghost notes. He synchronized all these salvos with his music so precisely that at the height of the conflict, six cannonades and two musket volleys went off within three seconds.

The "Battle Symphony" is by scholarly consensus the worst pot-boiler Beethoven ever composed, infamous for noise and naïveté. Yet its disparagers ignore that he obviously enjoyed writing it, and that its huge popular success—fanned by Prince Karl Schwarzenberg's defeat of Napoleon at Leipzig in mid-October—helped pull him out of the Slough of Despond.

Certainly Beethoven's body language was not that of a man still struggling with depression when he conducted the orchestral pre-mière, at a benefit for war victims on December 8. Spohr, playing in the second row of violins, registered it for the future inspiration of Leonard Bernstein:

Whenever a *sforzando* occurred, he tore his arms, which he had previously crossed on his breast, asunder with great ve-hemence. At a *piano,* he bent himself down; the softer he wanted it, the lower he bent. If a *crescendo* then entered, he

raised himself gradually again, and at the entry of the *forte* sprang up high. To increase the *forte* still more, he sometimes joined in with a shout without realizing it.

A contemporary newspaper reported that the applause for *Wellingtons Sieg* "rose to the point of ecstasy." But surely more satisfying to Beethoven was the reception of the uproarious Seventh Symphony, also receiving its public premiere. Its second movement was encored, setting a precedent that was to last for most of the nineteenth century.

One wonders if the sixteen-year-old Franz Schubert was in the audience that night. He was an early victim of the "Beethoven fever" that now began to sweep across Europe. It is a fact that the slow-quick-quick-slow rhythm of the Seventh Symphony's allegretto runs through Schubert's later music to the point of mannerism.

The concert went so well that it was repeated four days later, generating more than four thousand florins after expenses. Unfortunately for Beethoven, all the profit was earmarked for charity. His finances were only slowly improving, along with those of the Austrian state, as the threat of Napoleonism receded in the west. He was still waiting for annuity arrears owed by Prince Lobkowitz and the Kinsky estate. But he did not seem to know how to economize. Somehow, he had managed to spend 18,800 florins since 1809. Even now, he could not restrain his profligate rentals of multiple apartments and free spending on servants, copyists, and expensive books.

Thus, when Caspar asked his help in paying off a daunting number of doctor's bills, Beethoven found himself short of ready cash. He arranged for one of his publishers, Sigmund Steiner, to lend Caspar 1,500 florins, with himself as guarantor, and so conquered his

distaste for Johanna van Beethoven that the money was put in her care.

When disease, and money maneuvers, and family politics, and eccentricity mix as much as they do in Beethoven's personal dealings from 1813 through 1820, speculation as to what was going on in his mind is even more risky than it normally is in biography. We cannot even be sure that he was in conscious control of himself. He was, after all, an artist, subconsciously driven much of the time, and there were further spells of delusory depression. Yet if young Karl is taken to be his principal obsession during these years, a sense of cold purpose does seem to emerge from his constant skirmishes with Johanna and the law.

Maynard Solomon believes, for example, that Beethoven's anguished *Tagebuch* entry of May 13, 1813, quoted above, was prompted by despair over his inability to marry Antonie Brentano the year before. This is a plausible assumption, since in the same entry, Beethoven confessed to a frustrated "longing for domesticity." Yet the date places this longing much closer to Caspar's designation of him as a substitute father for Karl. Another assumption is therefore possible: that the domestic partner Beethoven fantasized that spring was not a wife but a son.

The last word is not too extreme. Beethoven soon enough began using it himself, in preference to "nephew." And by then the ostensibly generous loan arrangement looked, in retrospect, like a ploy to put both Caspar and Johanna under a sense of obligation.

These were but the first stages of a seven-year legal saga hardly less tortuous than *Jarndyce v. Jarndyce.* Editha and Richard Sterba, two Viennese psychoanalysts, have devoted a substantial book to the story, concluding that while Beethoven the composer redeemed him-

self with perfect works of art, Beethoven the man was "deeply disturbed, even psychotic." Their arguments are persuasive, although it is the nature of psychobiography to infer what cannot be proved. The basic story is simple, and as old as law. After C. dies, litigants L. and J. battle for possession of object K., in a protracted struggle; the courts themselves begin to squabble; litigant L. first loses, then wins. His reaction to the verdict, however, is unusual, being a prolonged effusion of the most sublime music ever written.

Caspar's remission extended through 1814 into the early months of 1815, postponing for a year and a half any further designs Beethoven might have had on Karl. This was the strangest period of his life as a composer, marked by a return of productivity but a continued dearth of original inspiration. Ironically, the new music he wrote—with the exception of a lovely but rather pallid piano sonata in E minor—was hailed as a return of his "heroic" style, appropriate to Vienna's sudden transformation into the power center of Europe. For this was also the time of the great Congress summoned by Prince Clemens von Metternich, the Austrian Foreign Minister, to plan for a future without Napoleon. Beethoven was famous enough for all the incoming delegations to find him the ideal bard of the moment, a sort of composer laureate with a gift for resolving discord into concord. One cannot blame him for cranking out the kind of big, bland loud things that politicians always recognize as Art. Beethoven was no fool, and could take advantage of folly. ("It is certain that one writes most prettily when one writes for the public, and also that one writes rapidly.") He was aware that Their Excellencies, if sufficiently impressed, would go home and proclaim his worth to publishers and concert agents. What the Consulate had been for Jacques-Louis David, the Congress of Vienna might be for him.

On January 2, 1814, he set the tone for an ambitious year by holding a benefit concert for himself in the Grosse Redoutensaal, Vienna's most imposing auditorium. His own advertisement promised that the program would feature, along with some choral music, "my grand instrumental composition on 'Wellington's Victory.'" Johann Mälzel was given no credit for having thought of the piece in the first place, let alone planned and promoted it. Beethoven, unconcerned, presided over a performance that was even more successful than the première, with the drum tattoos physically approaching each other down the corridors that flanked the Redoutensaal left and right. Although there were some missed cues due to his deafness, the public once again reacted with "ecstasy" (the word is the *Wiener Zeitung's*), and Beethoven was begged to conduct his music "again and often."

Clearly he had a hit on his hands—and this time, the box-office profit as well. His "Note of Thanks" to contributors, published in the *Zeitung* on January 24, again failed to mention Mälzel. Another Beethoven *Akademie* was announced for February 27.

Meanwhile, in a consequence of incalculably greater import, three star singers of the Imperial Court Opera approached him. They had attended his first concert, and been so struck by the beauty of the choral numbers that they wondered if he would consider reviving *Fidelio*. The opera's failure could surely be ascribed to the effect of the French occupation of Vienna in 1805. Now, with Napoleon discredited and Allied troops closing in on Paris, the situation was reversed. Viennese morale was high (as anyone could see from the way the "Battle Symphony" went over), and *Fidelio's* theme of rescue from imprisonment would be taken as symbolic of the deliverance of Austria from twenty years of French aggression.

Beethoven needed little persuasion. For eight years *Fidelio* had been an ache in his heart. He agreed on condition that he be allowed to revise the score with the help of Georg Friedrich Treitschke, the Court Opera's resident librettist and stage manager. The singers were delighted. By the time of his second *Akademie*, Beethoven was already absorbed in recomposing *Fidelio*, scene by scene and note by note. "I must think my way back into it."

Treitschke turned out to be an ideal collaborator: inventive, highly professional, and tolerant of Beethoven's incomprehension of the word *deadline*. He saw at once that *Fidelio* was hampered by having its whole second half set in a dungeon. A concluding translocation to "full daylight upon a bright green courtyard," he proposed, would dramatize Leonore's and Florestan's happiness at being reunited in freedom. Beethoven accepted this, and made his own cuts and transitions in the first act. They were stage-savvy enough to bely E. T. A. Hoffmann's suggestion that he was primarily an instrumental composer. Treitschke was impressed, as any librettist would be who sees a composer voluntarily tearing whole numbers out of a score.

Even more surprising—until one remembered that Beethoven came from a line of vocalists—was his willingness to accommodate the visceral desire of a lead tenor for some aria-ending high notes, regardless of dramatic sense. The new Florestan, an Italian tenor named Radicci, was no exception, even though the plot called for him to be discovered at the start of act 2, chained to a rock and starving. Beethoven had already composed a magnificent aria, ending pianissimo in F minor. But how to recast it without damage? Treitschke had the saving idea of delirium: Florestan, near death, would be transported by a vision of Leonore. Beethoven seized on this, and could hardly wait for the new lyric to be written.

By seven that same evening it was ready. The poet later recalled:

I handed it to him. He read, ran up and down the room, muttered, growled, as was his habit instead of singing—and tore open the pianoforte. My wife had often vainly begged him to play; today he placed the text in front of him and began to improvise marvelously—music which no magic could hold fast. Out of it he seemed to conjure the motive of the aria. The hours went by, but Beethoven improvised on. Supper, which he had purposed to eat with us, was served but—he would not permit himself to be disturbed. It was late when he embraced me, and declining the meal, he hurried home.

For the next two and a half months Beethoven was absorbed in what he called "*Fidelio* 1814"—effectively the third version of his opera, dramatically tautened and musically enriched. "Good heavens," he wrote, "my kingdom is in the air; like the wind, the tones whirl around me, and often in my soul." When working with such intensity, he was barely able to function as an ordinary human being, although little domestic memoranda show that he tried. "Shoe brushes for polishing when somebody visits," reads one jotting. And: "Rest and find diversion only in order to act all the more forcefully in art." And, enigmatically: "For example, the diagnosis of the doctors about my life—If recovery is no longer possible, then I must use—???"

He seems barely to have noticed Napoleon's abdication on April 4, nor the death that same month of his most loving benefactor, Prince Karl Lichnowsky. His only public appearance was at the première of the "Archduke" Trio on the eleventh. The dedicatee was by now so

crippled in his hands that he could not hope to play it, so Beethoven agreed to substitute. Spohr heard him rehearse, and doubted that he would be much improvement on Rudolph: "In forte passages the poor deaf man pounded on the keys till the strings jangled, and in piano he played so softly that whole groups of notes were omitted. . . . I was deeply saddened at so hard a fate."

The actual concert went somewhat better. Ignaz Moscheles, who attended, noted that while Beethoven no longer played with clarity or precision, the "intellectual element" was paramount, and there were many touches of his former "grand" manner. Beethoven coordinated with other musicians now only by watching them. His eye was lynx-like, in compensation for his atrophied ears: he could even tell when players were ignoring expression marks written into the score. But he was unable to grade his own tone by feel alone. With the exception of a repeat performance of the trio a few weeks later, and one impulsive decision to accompany a singer in his song "Adelaide," he never played in public again.

Fidelio was revived on May 23, too soon for Beethoven to complete yet another new overture for it. He was found asleep the morning of the performance, with a burned-out candle and goblet of wine beside him, and sheets of manuscript scattered all over the bed and floor. In desperation, the management of the Kärnthnerthor Theater substituted his overture to *The Ruins of Athens,* which had been heard in Budapest but not Vienna. The audience was none the wiser, although Beethoven, conducting, felt ashamed of himself. He also had to suffer the indignity of another conductor, Michael Umlauf, standing behind him and correcting his beat when he failed to hear the orchestra properly. But, after five weeks of rehearsals, the cast and players were in splendid form, and it soon became evident that

Fidelio was going to be a success. "Herr van Beethoven," the Vienna *Sammler* reported, "was stormily called out even after the first act, and enthusiastically greeted."

Three days later, its proper overture "was received with tumultuous applause and the composer again called out twice." Beethoven being Beethoven, he continued obsessively to revise and recompose. *Fidelio* cannot, therefore, be said to have received its final form before July 18, when it was advertised as a benefit for himself. There was such a demand for tickets that free ones already given out were invalidated.* Anticipating a full house, Beethoven bought space in the *Friedensblätter* to publish "A Word to His Admirers." The text showed that he had emerged from his depression of the year before with ego intact:

> How often in your chagrin, that his depth was not sufficiently appreciated, have you said that van Beethoven composes only for posterity! You have, no doubt, been convinced of your error since if not before the general enthusiasm aroused by his immortal opera *Fidelio,* and also that the present finds kindred souls and sympathetic hearts from that which is great and beautiful without withholding its just privileges from the future.

Thus primed, the audience at the benefit applauded extravagantly, as others have continued to do for nearly two centuries. *Fidelio* has earned the adjective Beethoven gave it in his advertisement.

*The eighteen-year-old Franz Schubert sold his schoolbooks to hear this revival of *Fidelio.*

It is unique among operas for the humanity of its theme, the unsentimentality of its emotions, and the purity of its music.

We still see it as a saga both universal and autobiographical, in which the forces of repression and deliberate cruelty are overcome by those of idealism, constancy, and physical courage. The opera's overall metaphor (recalling a certain early work of Beethoven's) is that of *Aufklärung*, or passage from darkness into light. There is no moment in opera more moving than the emergence of the prisoners in act 1, when at Leonore's request they are allowed to walk for a while in the sunny fortress garden. Beethoven makes them begin singing almost inaudibly, in discordant major seconds, as if they can hardly express their rapture: *O welche Lust! in freier Luft* . . . "O what joy, to freely breathe in open air! Here alone is life, our prison but a tomb." The discords resolve into swelling, four-part male harmony as the rapture reaches its climax, only to subside again to whispers as the prisoners are sent back underground.

Of all attendees at the revival, Stephan von Breuning probably best understood where the radiant melody of Leonore's and Florestan's final duet with chorus, *O Gott! O welch' ein Augenblick!* came from. Note for note, it was the cantilena Ludwig had written at age nineteen at a similar climax in his *Cantata on the Death of Emperor Joseph II.* For nearly a quarter of a century the unperformed melody had burned inside him, finding its apotheosis now: "O God! What a moment! O inexpressibly sweet delight!"

After two profitable benefit concerts and the huge double success of the "Battle Symphony" and the Seventh Symphony, Beethoven was entitled to wonder, as the curtain came down on the Congressional performance of *Fidelio,* if things could get any better for him. Indeed they could: on November 29, in the Redoutensaal, an even

more glittering international audience, including Tsar Alexander I of Russia and King Friedrich Wilhelm II of Prussia, wildly applauded his latest composition, a cantata written to celebrate the Congress of Vienna. It was, if anything, an even worse piece of music than his battle extravaganza—also on the program that night. Its very title, *Der glorreiche Augenblick* ("The Glorious Moment") seemed to mock the finale of *Fidelio*. He thus had the experience of attaining the peak of his career with the nadir of his achievement.

Gorgeously tooled leather-bound copies of the cantata were put on sale at the staggering price of two hundred florins each. Beethoven's former admirer, the Czech composer Johann Tomášek, was saddened to find him "among the crassest of materialists." But the attention span of socialites is short. When Beethoven tried to cash in with a repeat performance for his own benefit, only four days later, the Redoutensaal was half-empty. Plans for yet another *Akademie* had to be abandoned. The Congress of Vienna proceeded without any further notice of him, except for a gift of four thousand silver florins from a committee of nobles. And then, on the last day of the year, the fabulous palace of Count Razumovsky burned to the ground.

Its black smoke had a sadder, more symbolic reek for Beethoven than for most Viennese, who cared little that their city's age of aristocratic patronage was at an end. The petite-bourgeoisie was adjusting to a more democratic way of life, now that Napoleon had been exiled to Elba. In between balls and receptions, Congressional delegates were restoring ancient frontiers, giving the archetypical Austrian *Bürger* a feeling of liberation from the duty of serving a Great Power. The Holy Roman Empire was history; *Aufklärung* had faded into the light of common day; there was no longer any need to be stern, austere, heroic—poses that, in any case, Austrians had

always thought were better struck by their German cousins. One such German, of course, was Ludwig van Beethoven. Although he had by now lived in Vienna longer than he ever had in Bonn, his northern accent and uncompromising work ethic were the opposite of *Gemütlichkeit* and *Biedermeier*, those cozy characteristics which would soon become clichés of the city's younger generation.

He was, nevertheless, cheered in the early months of 1815 by the restoration of his annuity payments from Lobkowitz and Princess Kinsky. Both of them agreed to compensate him at pre-inflation levels, and to do so retroactively. "Although I have reason to be anything but satisfied with the behavior of Beethoven toward me," Lobkowitz remarked, "I am nevertheless rejoiced, as a passionate lover of music, that his assuredly great works are beginning to be appreciated." Since one account was thirty months in arrears, and the other almost forty, this comprised a windfall of nearly seven thousand florins. With at least four thousand florins earned in 1814, and 3,400 florins a year henceforth guaranteed for life, he was more than prosperous (at a time when the average middle-class salary was under one thousand florins). But no amount of money ever made him feel secure. The more he earned, the more aggressively—and deceitfully—he pushed publishers and promoters to the limits of their tolerance. He was convinced that some unimaginable disaster was always just around the corner—and on March 7, 1815, bombshell news from Genoa suggested he might be right. Napoleon had escaped from Elba ten days before.

Subsequent dispatches reported that Bonaparte was marching to Paris at the head of a new army. All eight powers attending the Congress of Vienna signed a treaty of support for Louis XVIII, only to hear that His Majesty had vacated the Tuileries in favor of its former

occupant. By March 20, Napoleon was once again in control of France, and the Duke of Wellington hurriedly left Vienna, destination Flanders.

"So all is illusion—friendship, kingdom, empire, all is just a mist which a breath of wind can disperse and shape again in a different way!!" Beethoven wrote on April 8. He was actually trying, in his clumsy way, to be jocular about quite another matter, but the notion that no reality, outside that of artistic truth, could be trusted was ingrained in him. And the plight of France was much on his mind. "Tell me," he went on in the same letter, to a collector in Prague, "do you want a musical setting of *the soliloquy* of a refugee king or a song about the usurper . . . ?"

The story of Napoleon's Hundred Days, ended by Wellington at Waterloo in a *Sieg* that erased all memories of Vittoria, does not need to be retold. For most of that period the Congress of Vienna numbly went about its business. On June 9, nine days before the great battle, all parties signed a Final Act, which preserved the balance of European power for the next forty years.

So much for Beethoven's theory of universal mutability. If anything kept blowing away mistily that spring and summer, it was his own creative gift. He tried to write a sixth piano concerto and another trio, and failed both times. Sketches for two pagan operas, one Greek, one Roman, petered out. The pieces he did complete were either specious or derivative, with the exception of a pair of cerebral cello sonatas, Op. 102, and a spellbinding setting for chorus and orchestra of Goethe's *Meeresstille und glückliche Fahrt*. (For obvious reasons, English-language programmers prefer to advertise this work as *Calm Sea and Prosperous Voyage*.)

One flash of inspiration, however, possessed Beethoven around

the middle of the year, just before the last music in him ran out. He was emerging from his house into a night bright with stars when a theme any music lover will recognize sounded out of nowhere:

He jotted it down entire, along with the annotations "Fugue" and "Slow ending," and let his future Ninth Symphony sink back into his subconscious.

Chapter Seven

The Raven Mother

IN THE FALL OF 1815, Caspar van Beethoven's tuberculosis became terminal. Ludwig's determination to acquire control of young Karl resurged. On November 14, he managed to intercept before signature a sentence in Caspar's will, "Along with my wife I appoint my brother Ludwig van Beethoven coguardian." Exercising who knows what force, he got Caspar to delete the first four words, and alter the last to "guardian."

Johanna van Beethoven found out later that day, just in time to make her own furious feelings known. Caspar then executed a codicil, allowing that "the best of harmony does not exist between my brother and my wife." In view of the fact that Ludwig wished to take Karl "wholly to himself" and "withdraw him from the supervision and training of his mother," he was amending his will:

I by no means desire that my son be taken away from his mother, but that he shall always and so long as his future career permits remain with his mother, to which end the guardianship of him is to be exercised by her as well as my

brother. . . . For the welfare of my child, I recommend *com-pliance* to my wife and more *moderation* to my brother.

The next day Caspar died, age, forty-one.

Beethoven's peculiar response to the codicil was to accuse Jo-hanna of poisoning her husband. He pressed this delusion so ur-gently that a doctor was compelled to examine the corpse, and report that there was no evidence of murder. Meanwhile, the amended will was accepted by the Imperial-Royal Landrecht, a court charged with adminstering the affairs of the aristocracy.

Officials there accepted it without asking for proof of Caspar's noble birth. He was, after all, the brother of the famous "van Bee-thoven," who had been moving in the highest circles of Viennese so-ciety since 1793. No local snob had ever suggested (as a northern snob might) that the Dutch *van* was not the equivalent of the German *von*, a sure guarantee of nobility. Ludwig was even listed as "Herr von Beethoven" in the imperial secret-police files. Had he not moved freely among *têtes couronnées* during the recent Congress? Were there not published stories that he was of Prussian royal blood?

Beethoven himself had no doubts about his ancestry. He felt noble; he wrote noble music; nobles deferred to him. These facts were good enough for him, and for the Landrecht, too, apparently. Johanna, in contrast, must strike the court as irredeemably bourgeois.

Pausing only to get himself named an honorary citizen of Vienna, he challenged his sister-in-law's coguardianship on De-cember 13, stating that he "could produce weighty reasons for the total exclusion of the widow." He wanted the Supreme Guardianship Board to know that she had conceived Karl out of wedlock, and been convicted of domestic theft. The Landrecht expressed interest,

whereupon Beethoven applied to a lower court for a record of its judgment against Johanna. Armed with this evidence, he asked the Landrecht, just before its Christmas recess, to negate the codicil on the grounds that Frau van Beethoven was lacking in the "moral and intellectual qualities" necessary to bring up her son properly.

Johanna was as taken aback by his legal and public-relations blitz as Joseph Bonaparte had been by Wellington's charge at Vittoria. On January 9, 1816, the court ruled in Beethoven's favor. He was appointed sole guardian of Karl, age nine, and given custody ten days later. The boy was taken from home on February 2 and boarded at the Giannatasio Institute, a prestigious private school in Vienna. Johanna was forbidden to visit him unless his uncle consented—an unlikely prospect. "There," Beethoven wrote, "he will hear and see no more of his bestial mother."

If she ever received the poison-pen letter he drafted around this time on music paper, she would have been even more bewildered. Clearly drifting toward paranoia, Beethoven railed against her "spiteful tricks" and suspicious displays of "friendliness," which did not deceive him. His scribblings became incoherent: "You were not absolved from your punishment—order is fitting to the momentousness in view of your sacred dead—and mine."

This was only the beginning of a hostile campaign against Johanna that soon assumed manic proportions, with a strong element of sexual prurience, possibly cloaking lust. At times Beethoven believed she was stalking him, at others giving his servant money for some unmentionable reason. Johanna quickly became, in his mind, half prostitute, half the shrill mother figure in Mozart's *Magic Flute.* "Last night," he wrote Kajetan Giannatasio in mid-February, "the *Queen of Night* was at the Artists' Ball until three o'clock, exposing

not only her mentality but *her body*—for 20 florins, people whispered, she was to be had! O horrible!"

He might have associated Johanna more readily with another character in opera. Of all the accounts that survive of her desperate attempts to see Karl, the most pathetic is that of her dressing as a man in order to sneak into the school ground and watch him at play. One hears the sad horn calls in act 1 of *Fidelio,* and Leonore's voice declaiming, *"Ich foig' dem inner'n Triebe"* ("I am drawn by an inner compulsion").

Beethoven, however, was now playing his own role in what he took to be a real-life rescue drama. "I have fought a battle for the purpose of wresting a poor, unhappy child from the clutches of his unworthy mother," he wrote Toni Brentano. It was important that so worthy a mother as *she* recognize what a hero he had become. The role metamorphosed rapidly during the spring and summer of 1816, becoming more and more delusional. "Regard K as your own child," he told himself in his *Tagebuch.* Then, to Countess Erdödy: "I am now the real natural father [*wirklicher leiblicher Vater*] of my deceased brother's child." Then, to Franz Wegeler: "You are a husband and father. So am I, but without a wife." Thus nephew became "son," and uncle became "father," and brother became "husband," and widow became "wife"—unless by the last word he meant the departed Toni.

His letter to her seems to have stirred suppressed longings, because in April he began to write *An die ferne Geliebte* ("To the Distant Beloved"), an extraordinary series of songs on the theme of unconsummated desire. Each song mutates into the next, and the yearning theme of the introduction—a phrase that ardently rises, only to fall—is as wistful as anything in *Tristan und Isolde.* It recurs at the end, with a final chord that does not satisfy. Robert Schumann

was fascinated by the theme, and used it twenty years later in his Piano Fantasy in C major, another work encoded with amorous meaning.

Beethoven himself never got nearer to musical autobiography than in *An die ferne Geliebte.* After completing it, he confessed to Kajetan Giannatasio that, five years before, he had fallen in love with a woman he could not bring himself to propose to. Marriage to her "was not to be thought of, almost an impossibility, a chimera." Nevertheless, "it is now as on the first day." These sentiments, transcribed by Giannatasio's daughter, Fanny, echo those of *An die ferne Geliebte.* With its evocations of blue horizons and a love that transcends space and time, it expressed, for the first time in music, the notion of yearning distance already palpable in the cloudscapes of Caspar David Friedrich and Goethe's "Kennst du das Land." Beethoven had in fact set the latter poem to music some years before, with singular insensitivity—which further suggests that *An die ferne Geliebte* represented an evolution of his consciousness, stimulated by the emotional turmoil of 1816.

His only other work of that summer, the Piano Sonata in A major, Op. 101, was so strangely constituted, with intimacy shoved aside by bristling march rhythms and a grotesque fugue, that it only fueled rumors that he had nothing "beautiful" left to say. Or as one of the Brunsviks wrote to a friend, "I learned yesterday that Beethoven had become crazy."

Modern sensibilities detect a new kind of lyricism in the sonata's opening and slow movements, concentrated yet pure, impossible to tire of. This last quality, surely definitive of supreme beauty in any art, was not shared by two other styles that became the rage of Vienna that year: "Biedermeier" parlor pieces, all sugar and tears, and the

bustling frivolity of a new opera by Gioacchino Rossini, *The Barber of Seville*. It was Beethoven's misfortune that his famous "third period" style, nascent for years but maturing finally in Op. 101, should announce itself at the very moment that popular taste turned against him. The Imperial secret police, which included culture in its surveillance, had already noted the formation of "an overwhelming majority of connoisseurs who refuse absolutely to listen to his works hereafter."

By "connoisseurs" the police meant those conservatives who had always found Beethoven too radical, and were turning to Rossini now, as they had to Paisiello and Salieri in the past—any composer, it would seem, whose name ended in a vowel and who could be relied on to stay in the same key. Beethoven had never cared much for the florid, oompah-pah, Italianate style, and he even parodied it in the slow movement of his Op. 31 No. 1 piano sonata, which might be described as Rossini with brains. He had more recently had a shot at the Biedermeier manner in the rondo of his Op. 90 sonata, but the effect was that of Goethe trying to write a ladies' romance: a high seriousness kept breaking in.

Beethoven, in fact, was incapable of imitating even himself. Even more now than in the past, every fresh work had to be unique. After writing the first great song cycle in the German language, he did not dream of writing another. But the thought of an opera full of unresolved dissonances was intriguing. . . . So was any kind of creative paradox. His "inner compulsion" drove him back and forth in time, to master contrapuntal techniques that were archaic even to Bach, and to invent futuristic noises, such as long, rumbling bass trills and eerie semitonal slidings in and out of key. The private élite who alone could understand it (let alone play it!) were steadily shrinking in

number. Kinsky and Lichnowsky were dead; Waldstein bankrupt, doomed to die a pauper; Razumovsky recalled to Russia, taking Schuppanzigh and the rest of his quartet with him. By the end of the year, Lobkowitz, too, would be dead, and Vienna's last private orchestra disbanded. Even the sweet-natured Archduke Rudolph had become dyspeptic, and was showing an increasing desire to enter the Church.

Solomon has described the period around 1816 as "one of the turning points in music history," when not only Beethoven but his younger contemporaries were adjusting to the end of High Classicism. Weber was twenty-nine, and about to begin his magic-infused opera *Der Freischütz;* Schubert was nineteen, and had just composed *Erlkönig,* the prototypical German lied. Berlioz was twelve, Mendelssohn seven, Chopin and Schumann six, and Liszt four. Every one of them looked to Beethoven as they formed their anti-intellectual styles.

He himself remained, despite his phenomenal imaginative reach, a creature of the Age of Reason. "The miracle of Beethoven's music," Paul Henry Lang writes, "is that in its liberty and individuality it is also finitely organic and compelling." The compulsion is always toward logic, whether of form—no matter how unusual—or of harmony or polyphony. Even when writing *molto appassionato,* his emotions are cerebral: the most heaven-storming climaxes in his later works are arrived at through counterpoint. His reluctance to yield to the promptings of the heart was not due to insensibility, as *An die ferne Geliebte* proved. He was simply consumed for the rest of his career by the challenge—paradoxical, again—of perfecting a music that would be both rational *and* passionate, infinitely expandable or contractible, and adaptable to all forms and combinations, from

miniature solo pieces for piano to epic works for chorus and orchestra. So far, only Johann Sebastian Bach had managed to do that, but Bach's actual style had changed little in the process. "My sphere extends further, and our empire is not so easily reached," Beethoven wrote to a friend in Leipzig.

Beethoven in the second half of 1816 was therefore more artistically isolated than he had ever been. Given the novelty of what he had achieved in his Piano Sonata in A major, Op. 101, it is no wonder he put off his next project for almost a year. All his fierce energies focused instead on Karl.

Fanny Giannatasio wrote in her diary that Beethoven's "stern appearance" and "cold behavior" on visits to the school gave her "a most unpleasant feeling." She suspected he might soon withdraw his nephew, and saw early signs of a campaign for domination. "I asked the boy why he had cried and he answered that his uncle had forbidden him to tell"—what, Fanny never found out.

Beethoven's determination to "wrest" him from Johanna was such that when Karl developed a hernia and had to be operated on in September, he refused her written request to attend. "She is all the less to be allowed to see him, since all impressions might be easily renewed in K., which we cannot permit." At the same time, he stayed away himself, in a summer apartment at Baden. He always made a point of being scarce during emergency situations that might make demands on him. Lavish displays of affection, when things were going well, cost him nothing. But the love that crisis calls for was not in his emotional supply.

He recognized his own selfishness, and made a show of guilt about it. "That I wish to hear what progress my dear son [*sic*] is now making, you can well imagine," he wrote to Kajetan Giannatasio

after the operation. "You might take me for an indifferent half barbarian . . . it causes me grief not to be able to share the sufferings of my K."

Beethoven's grief was allayed as soon as "K." was strong enough to make the fifteen-mile journey separating them. Fanny accompanied the convalescent boy, and recoiled from the force of his uncle's physical aggression. At dinner, Beethoven "dickered with the waiter about every roll," and the next morning appeared with a scratched face, having gotten into a fight with his servant. Both Fanny and Karl von Bursy, another visitor around this time, felt that his now almost total deafness was fueling his paranoia. "Venom and rancor raged within him," von Bursy wrote in a diary entry. "He defies everything and is dissatisfied with everything and blasphemes against Austria and especially against Vienna and his life here. He speaks fast and with great animation. Often he beat his fist upon the piano so violently that it made a clear echo in the room."

This raises the question as to whether Beethoven beat Karl, as his own father had beaten him. Evidence is lacking, but he certainly encouraged Giannatasio to flog the boy when necessary. The son of the composer Emmanuel Förster has left an earlier account of winter piano lessons with Beethoven, who whipped his freezing fingers "with one of the iron or steel needles used in knitting the coarse yarn jackets worn by women in service."

The impression of a man dangerously on edge in his late forties is inescapable. Yet one must allow that Beethoven was just as explosive in his positive behavior, being overengined in mind and body. Karl, an intelligent and affectionate child, yielded to him but was not terrified of him. Uncle and nephew bonded quickly, and observers were struck by the happiness in Beethoven's eyes whenever they ex-

changed glances. There is a charming anecdote of the boy falling asleep as Beethoven played a piece by another composer. At the first sound of something very different, Karl woke up with a smile: "That is music by my uncle."

Johanna van Beethoven, meanwhile, reacted to the abduction of her son as any mother would. She sought legal advice as to how she could get the Landrecht to reverse its ruling and at least make her coguardian again. But the odds against this were insuperable as long as Karl remained at the Giannatasio Institute, which he did throughout 1817. The school had such a good reputation that Johanna could not claim that her son was not being well looked after. For a while, Beethoven permitted her to see Karl monthly, having forced her to invest two thousand florins for the boy's tuition. She had to sell her house to raise the money. This caused Beethoven one of his rare moments of contrition. "God, God, my refuge, my rock, my all," he wrote in his *Tagebuch,* "Thou seest my inmost heart and how it pains me to be obliged to compel another to suffer by my good labors for my precious Karl!!!" But soon he was again conspiring with Giannatasio to exclude her.

It was a miserable year for him physically, since he was afflicted for much of it with "a severe and feverish *Katarrh*" (bronchitis). He feared this might be tuberculosis, talked of suicide, and developed an obsessive habit of spitting. A letter from Ferdinand Ries, married now and living in London, briefly cheered him in June. It contained an invitation to visit England during the upcoming season, and offered, on behalf of the London Philharmonic Society, three hundred guineas for "two grand symphonies." Beethoven accepted, but further bad health caused him to postpone both the trip and the commission.

Johanna's chance came in 1818, after a winter that had seen Bee-

thoven's health deteriorate further, and his deafness reach the point that interlocutors now had to write their questions to him in "conversation books." Having borrowed the loudest piano in Johann Streicher's showroom, he was struggling to complete the longest keyboard sonata ever composed, aptly designated *für das Hammerklavier* (Op. 106, in B-flat). Its final fugue was so discordant, with well over one hundred shuddering trills, that one could only pity his neighbors on both sides of the Gärtnergasse. The "shipwreck" of his accommodations—to use Beethoven's own image—was worse than ever, as was his temper: he attacked his housekeeper with a heavy chair. In the midst of all this turmoil, he had impulsively removed Karl from the Institute and installed him "at home."

To prepare her case for custody, Johanna needed testimony that would prove to the Landrecht that Beethoven was domestically ill-equipped to be the boy's guardian. He was aware of that himself, and had hired a new housekeeper and cook, as well as a full-time tutor, as replacements for the Giannatasios. But to hire is to become an executive. Beethoven found to his bewilderment that while the servants had to feed him, he had to feed them. Unable, because of his suspicious nature, to trust them with anything, he quarreled over every kreuzer and fanatically monitored supplies of dishrags, salt, and socks. The tutor needed to be told what to teach. And after-hours, a motherless twelve-year-old boy required listening to—something Beethoven could not manage any more.

What he could do was prevent Johanna from finding out just how incompetent he was as a head of household, and how sick in mind and body. Karl and the Giannatasios being the best witnesses, he denied Johanna access to all of them, and even tried to keep secret the fact that Karl now lived with him. Naturally, Johanna found out.

Desperate after six months of separation from her son, she purchased the confidence of Beethoven's servants.

This was easy. Beethoven was as abusive of his new help as he had been of uncounted others who had allegedly cheated, poisoned, robbed, and betrayed him over the years. Johanna gave them coffee, sugar, and money, and they repaid her in kind. Just before Beethoven and Karl moved to nearby Mödling in May, they arranged for the boy to have a clandestine meeting with his mother. It was the first time Johanna had been alone with him in more than two years.

Beethoven seems to have been told about this meeting in an anonymous note. He reacted with "terror"—his own, psychologically significant word—placing Karl in a private Catholic class in Mödling, and firing both servants. But the damage was done: Johanna had her information. "My heart has been terribly shaken up by this affair and I can scarcely recover myself . . . ," Beethoven wrote Frau Streicher. "*Nevertheless it will not be necessary to send me to a lunatic asylum.*"

In view of his galloping delusions over the next two years, as he felt his hold on Karl slipping, incarceration might have been a merciful alternative for him. But then we might not have had the genesis of his greatest symphony, greatest set of variations, and greatest choral work, following the completion of his greatest piano sonata. All these perfections arose out of psychosis, like nebulae spun out of deep space. Although they related to Beethoven's everyday life no more than any of his other works, perhaps, in their serene centeredness, they kept him from falling apart.

In September, as soon as the Landrecht opened after its summer recess, Johanna petitioned the court to have Beethoven removed from control over her son's education. Her petition was promptly re-

jected, whereupon she filed another, citing Beethoven's deafness and ill health and asking for permission to send Karl to a state institution, the Imperial-Royal Konvikt. Beethoven, who was now having him tutored for entrance into the Academic Gymnasium, ignored the court's summons to testify. But Johanna's determination, and the Landrecht's ominous use of the word *coguardian* in its summons, cautioned him to reply in the medium of a terse lawyer's letter.

It reminded the court that Frau van Beethoven's "moral incapacity" had been the basis for the earlier judgment against her, and accused her of "base-mindedness" in drawing attention to his "deafness, as she calls it." He insisted that he communicated with intimates "in the easiest manner." This phrase smoothly avoided any mention of conversation books. He claimed that the Konvikt's lax visiting rules would allow Johanna unsupervised access to "my ward," and emphasized his heavy spending to give Karl the best education possible. "The tenderest father cannot take better care of his own child."

On October 3, Johanna's second petition was rejected, and Karl became a scholar at the Gymnasium, with extra lessons at home in music, French, and drawing. Then, on the evening of December 3, he took matters into his own hands by running away to his mother, leaving a reproachful letter behind him.

Fanny Giannatasio was with her father the next morning when a tearful Beethoven burst in on them and showed them the letter. "He is ashamed of me!" Johanna acted responsibly, writing immediately to say that she would send Karl back but, in view of the fact that she "had not seen him for a long time," was in no hurry to do so before sundown. Beethoven was convinced that she intended, in the interim, to spirit Karl out of town, and take him to his brother's house in Linz. He seemed dementedly to be imagining that Johann,

whom he had not spoken to in six years, was conspiring with Johanna to deprive him of his "son."

"To see this man suffering so, to see him *weeping*—it was touching!" Fanny wrote in her diary, greatly enjoying the drama. Beethoven rushed off to enlist official aid in retrieving Karl. Johanna herself took the boy to a police station at four o'clock. Besides being tough, she was evidently no fool in legal matters. The incident had given her an excellent opportunity to reopen her case, and she did not intend to prejudice it by any show of defiance.

Karl slept that night in Beethoven's apartment, showing no distress at being back. He was of equable temperament, unlike his uncle, who lay in torment. Clearly, the boy had had plenty of time to tell Johanna what she and her lawyer needed to hear—for example, that he had fled because he was afraid Beethoven was going to punish him for stealing candy money. Both the threat and the naughtiness could be taken as evidence of bad guardianship.

The next morning, December 5, Karl was back at the Giannatasio Institute. With another court action inevitably coming, Beethoven felt the boy should be in professional hands. "He told me that he had been so wrought up about the matter that it took him some time to gather his thoughts," Fanny wrote. "During the night his heart had beat audibly." The adverb, coming from a deaf man, strikes with particular force.

December 11, 1818, turned out to be the most humiliating day in Beethoven's life. He was summoned to the Landrecht and compelled to listen to devastating testimony against him. Johanna and Karl were coolly factual under interrogation. They made plain they bore him no ill will. When asked if Beethoven had ever been abusive, Karl replied, in the court's reporting, "He had often punished him, but

only when he deserved it; he had been mistreated only once and that had been after his return; his uncle had threatened to strangle him."

Johanna would not say that she had been "forbidden" to see her son, only that when interviews had been promised, "he was not there." In support of her renewed petition for coguardianship, she then submitted an impressively written appeal by her stepuncle, Hofconzipient Jacob Hotschevar. This dignitary had been a tutor to many noble children and was familiar with all the Beethoven brothers. He informed the court that all three were "eccentric." In the course of his ensuing argument, he managed to apply the word to Ludwig five times, while repeatedly acknowledging the composer's "good intentions" and "kindheartedness" toward Karl. However, the boy, "whose talents attract attention at first sight," could not be left under Beethoven's exclusive control, "except at great danger to his well-being and with the danger of being morally and physically warped."

Two powerful documents completed Johanna's case against Beethoven. One, written by the parish priest at Mödling, stated that Karl was unruly and cunning, able to manipulate his uncle by simple use of the phrase "raven mother." The other was a letter Caspar van Beethoven had written, complaining that Ludwig had forced him, in exchange for a loan of 1,500 florins, to sign over guardianship rights: "*Never* would I have drawn up an instrument of this kind if my long illness had not caused me great expenses."

Beethoven, in his own defense, could only bluster that Johanna had bribed his servants and connived with the Mödling priest to discredit him. He had told Karl to "speak nothing but the truth" about his mother, and the boy had said he did not love her. His immediate plans were either to hire a full-time tutor or to return Karl temporarily to the Giannatasios.

Then came the fatal insolence, as recorded by a stenographer: "After half a year he would send him to the Mölker Konvikt, which he had heard highly commended, or *if he were but of noble birth,* give him to the Theresianum."

The court pounced. Were the Beethoven brothers in fact noble, "and did he have documents to prove it?"

For three years, Beethoven had counted on the aristocratic jurisdiction of the Landrecht as his best assurance of continued control of Karl. Now he stood naked, stripped of all dignity before Karl, Johanna, and the Viennese press. He had brought about this moment of truth, and found that he could not lie. "*Van,*" he responded, "was a Dutch predicate which was not exclusively applied to the nobility; he had neither a diploma nor any other proof of his nobility."

On December 18, the case of *Beethoven v. Beethoven* was referred to the Stadt-Magistrat, a court for commoners. Early in the new year, Beethoven's guardianship of Karl was suspended, pending hearings by the Stadt-Magistrat, and Johanna received her son back. Beethoven felt for the first time what it was like to have a child taken away by law, and wrote to the Magistrat on February 1 in tones of near madness. His protestations were familiar, but the language he employed was vainglorious, when it was not sexual or infantile:

A Philip did not think it beneath his dignity to direct the education of his son Alexander and give him the great Aristotle for a teacher . . . a *mother of this sort* seeks to involve her child in the secrets of her own vulgar and evil surroundings . . . to awaken in him lusts and desires which are harmful . . . *morality* must be *implanted* early when a child has the misfortune to suck in *such mother's milk. . . .*"

With this letter, by no means the craziest he wrote over the course of the next year, Beethoven the man and Beethoven the composer spun into a whirl of litigation, fantasy, intrigue, and hyperactivity that resulted in a double precipitate: pain for all the human beings involved, and music that was, almost beyond credence, pure and grave and grand. Except for an exquisite song setting of Goethe's *Abendlied unterm gestirnten Himmel* (Evening Song under the Starry Sky), this music was so epic in scale as to require completion after the whirligig suddenly stopped. Yet to 1819 and the early months of 1820 we owe the first two movements of the *Missa Solemnis,* the first movement of the Piano Sonata in E major, Op. 109, and nineteen of the *Thirty-three Variations on a Waltz by Diabelli.* Beethoven laid aside, however, his sketches for the Ninth Symphony. This required some discipline, because its pregnant opening was already fully scored in his head.

In some other, less controlled area of consciousness, countless monsters, sirens, tricksters, and sworn enemies kept him "harried on all sides like a wild beast, misunderstood, often treated in the basest way." Chief among them was the bewitching Raven Mother, her breasts oozing poison as well as milk, mutating sometimes into Circe, sometimes into a snake, sometimes a "raging Medea." Her "pestilential breath" spread through his "plague-ridden neighborhood," spreading "abominable defamations and wicked insinuations about me." It was *she* who questioned his nobility in court, *she* who had made Karl run away, *she* who had seduced the priest, that Sunday drinker and sadistic bircher of small boys. As for Karl, *he* belonged "to the viper's breed of his bestial mother." Callous, cold, he had twice—*twice!*—withdrawn his hand from Beethoven's: "I have cast him from my heart, wept many tears over him, the good-for-nothing."

On March 26, the Magistrat responded to his letter by appointing one of its own councillors, Matthias von Tuscher, in his place as guardian. Beethoven was hurt, but not altogether discouraged. He had actually recommended Tuscher as an acceptable substitute. The Magistrat seemed to have gone out of its way to defer to a famous and well-connected litigant. But it could not overlook an ugly incident that caused Beethoven much embarrassment: when Karl was still in his care, he had yanked him too roughly off a chair, and the boy's hernia scar had begun to bleed.

In June, Johanna succeeded in persuading the Magistrat to place Karl in Joseph Blöchlinger's prestigious school for boys. Beethoven might have tolerated this court order, had Blöchlinger not permitted her to visit her son, like any other parent. "My heart is lacerated," Beethoven wrote the principal, unmoved by an affectionate letter from his nephew.

Johann van Beethoven also became the object of Ludwig's paranoid enmity, when he joined Johanna in cooperating with the Magistrat, albeit only to protect Karl from Beethoven's dangerous delusions. By now his behavior was the talk of Vienna. "Some say he is a lunatic," Carl Friedrich Zelter, the German composer, wrote Goethe. This was obviously near the truth in the summer and early fall of 1819, though credit should again be given to Beethoven's good intentions, and the genuineness of his love for Karl. His desire to possess the boy "wholly" was not physical. He had used Antonie Brentano's influence to get Karl accepted at a top boarding school in Bavaria, and if the Magistrat had not objected, he would have seen little of him for four years. Nor, it must be said, was there the slightest evidence of any sexual involvement between them. Boy and man were minutely observed, in their short periods together, by live-in

domestics, tutors, and by Beethoven's perpetual flow of visitors. If Johanna had received any hint of pedophiliac behavior, she would have seized upon it.

And Beethoven had better reason to question *her* moral influence on Karl. She was, at the very least, casual about money and sex. Her "Queen of Night" appearance at the Artists' Ball, with a lover in tow, three months after Caspar's death, had not been the act of a responsible mother. But Karl was as forgiving of her as he was of his uncle. He may even have admired her: the record shows Johanna to have been a tough legal operator, one of the few people in Vienna not intimidated by Beethoven. Seven decades before Freud, she shrewdly sensed that her brother-in-law's hostility toward her was erotic, and said as much in court. A note in Beethoven's conversation book for November, scrawled by his friend Joseph Karl Bernard, reads: "I saw too that the Magistrat believes everything that it hears, for example that she said that you were in love with her." The reply was oral, but can almost be heard.

Johanna, in short, knew how to torment him. Suggesting Johann for guardian was another deliberate goad. One cannot blame her tactics, outspent and outclassed as she was by Beethoven's legal manpower. (He used Archduke Rudolph as an agent of influence at the Hofburg.) She might even be thanked for her most inspired dig of all, which adds a welcome touch of humor to the whole squalid story. Wisely, however, she delayed it until after she was finally beaten. She got herself pregnant and gave birth to an illegitimate daughter, baptized as Ludovica. In those days when everybody knew a little Latin, few failed to recognize the name as the feminine version of "Ludwig."

Beethoven won his case in much the same way he composed: by driving with furious energy toward a resolution, repeatedly post-

poned, that seemed unattainable in view of self-imposed difficulties. That made the conclusive chord—a rejection, by Emperor Franz I himself, of Johanna's final appeal—as satisfying as anything in his symphonies. Having lost to her three times in common-court proceedings, he petitioned the Imperial-Royal Court of Appeal on January 7, 1820, to reverse his reversal, and followed up with a forty-eight-page "memorial" of grievances that rightly should have had him institutionalized. Instead, over the objections of the Magistrat, the appellate judges ruled in his favor on April 8. (Personal lobbying of two of the three justices by Beethoven appears to have been the deciding factor.) They entrusted him once more with control of Karl's affairs, and appointed Court Councillor Karl Peters as a friendly co-guardian. It was agreed that Karl was to remain for the next three years with Herr Blöchlinger. On July 24 Johanna was notified that the case was closed. By then, young Ludovica was well on the way.

The iconography of Ludwig van Beethoven has many empty frames. We have no images of his mother, or of Caspar or Johanna. But of all these blanks, the most tantalizing is a missing portrait of Beethoven himself, painted at Mödling in the summer of 1818, just before he lost his "nobility" and, for a long while, much of his mind. We can half see it, because the artist, August von Klöber, has described it in writing, and a partial cartoon, in pencil, exists at the Beethovenhaus in Bonn. Beethoven stands with his bluish gray hair tossed by the wind, his complexion pocked but tanned and tough looking. He is loosely dressed in a light blue frock coat with yellow buttons, a white vest, and a white cravat. In his hand is a pencil and a notebook, containing, we may assume, parts of the *Hammerklavier* Sonata. His expression is stern but serene. At his feet, lazing under a tree, eternally twelve years old, lies his "beloved son."

Chapter Eight

The Other Side of Silence

"IN THE WORLD OF ART, as in the whole of our great creation, *freedom and progress* are the main objectives," Beethoven wrote to Archduke Rudolph, after Karl was safely installed in the Blöchlinger School.

He had been researching old scores in his pupil's magnificent music library, pursuant to an idea that had possessed him ever since he heard the announcement that Rudolph would be elevated to Cardinal, and installed as Archbishop of Olmütz on March 9, 1820. It was to write a mass in honor of the occasion that would remind the world that Ludwig van Beethoven was still capable of heaven-filling effects. "The day on which a High Mass composed by me will be performed during the ceremonies solemnized for Your Imperial Highness will be the most glorious of my life," he rhapsodized. It occurred to him that Rudolph might be looking forward to a little glory, too. "God will enlighten me," he added hastily, "so that my poor talents may contribute to the glorification of that solemn day."

As has been noted, Beethoven did manage to write the opening movements of his *Missa Solemnis* in 1819—the Kyrie, the huge

Gloria, and possibly some of the even more gigantic Credo. But the size of the work he began to see looming beyond these portals made him realize that he would never complete it in time. He therefore set it aside and concentrated on the last stages of his lawsuit, which overlapped Rudolph's elevation by a month.

Doubly liberated from teaching and litigation, he rejoiced in being able to exchange them for his twin desiderata as an artist, "freedom and progress." Beethoven so rarely discussed the creative side of composition (perhaps because he felt it was beyond words), that his letter of advice to Rudolph is worth pondering. He made clear that "freedom"—imagination operating beyond constraints— and "progress"—a constant originality of achievement—were impossible without scholarship. It was necessary to study the baroque masters, whose music had been so different from that of Mozart and Haydn. "Among them, of course, only *the German Handel and Sebastian Bach* possessed genius." But even the lesser ones, and composers earlier still, dating back at least to Palestrina, had something to teach. What Beethoven admired was the complexity of their counterpoint. "We moderns," he told Rudolph, "are not quite as far advanced in *solidity* as our *ancestors,* yet the refinement of our customs has enlarged many of our conceptions as well."

He was itemizing the essentials of his own new style, evident in the *Hammerklavier* Sonata dedicated to Rudolph: a vast freedom of modulation and variation, a progressive sense of going where music had not gone before, passages of such contrapuntal density as to approach solid state, refining unexpectedly into episodes as light and tuneful as *opera buffa*, and an overall feeling of enlargement that had nothing to do with length—although a fugue longer than the last movement of the *Hammerklavier* was hard to imagine. Beethoven

obviously could not relate to his successors, as he could to his ancestors. He knew nothing of Schubert. But in this same fugue, Schönberg and Busoni jostled Bach, while Beethoven himself produced the most terrifying noises to come out of the piano until the late years of Liszt.

In contrast, the slow movement of the *Hammerklavier* looked backward as well as forward, combining past, present, and avant-garde formulations into music of eternal quality. Here (if His Highness's gouty fingers could manage them) were Bach-like melodies flowering into unpredictable filigree, giddy key shifts, weird dance rhythms, shock silences, operatic changes of scene, Italian and French turns of phrase, plus sound effects unique to Beethoven: "vault" voices in the deep bass, a constant interplay of damped versus undamped strings, and irregular, echoing monotones, like wind chimes. Most noticeable of all was the spaciousness of the harmony: the piano's highest and lowest registers seemed to have drifted farther apart than ever before, while held by the same center of gravity.*

Beethoven had, demonstrably, achieved a universal style even before he started to compose the *Missa Solemnis.* He was no longer in any hurry to complete that work, now that Rudolph's "solemn day" had come and gone. He was determined to make it his magnum opus, and knew from his experiences with *Fidelio* and the *Eroica* Symphony that masterpieces have their own momentum. There was no sign—as yet—of a return of the flooding inspiration that had possessed him in his thirties. But ideas continued to come, and he no

*Largely through Beethoven's demands, Viennese piano makers had by now expanded the instrument's tonal range to six and a half octaves (seventy-eight keys).

longer had to struggle as much to perfect them. His main labor these days was to avoid cliché: never to write the kind of conventional passagework that even Mozart had spun out by the yard. Every note must be sized, weighed, tested for strength, then "listened to" in the soundproof box of his head.

Much as Beethoven complained about his "closed senses," being myopic as well as deaf, it is a fact that his music became sonically richer as he adapted to life "on the other side of silence." John Russell, an Englishman visiting Vienna in 1820, was a rare witness to the composer communing with himself at the keyboard:

> When playing very *piano,* he ofen does not bring out a single note. He hears it himself in the "mind's ear." While his eye, and the almost imperceptible motion of his fingers, show that he is following the strain in his own soul through its dying gradations, the instrument is actually as dumb as the musician is deaf.

Beethoven even made art out of the disintegration of sound—for example, in his setting of Goethe's *Meerstille,* when syllables expressive of deathly calm (*To-des-stil-le*) detach from one another, each whispered consonant accompanied by pizzicati that are not so much plucks as dry, fingertip caresses.

Occasionally his disability led to miscalculations, as when the blare of the orchestra drowns out the bass return of the main theme in the first movement of the Eighth Symphony. But such instances were few. The numerous passages of real ugliness in late Beethoven are not accidental but deliberate, differing only in degree from similar moments in Bach. He "heard" discord just as precisely as he cal-

culated every last nuance in, say, the hushed "Et incarnatus est" of the *Missa Solemnis.* This exquisite section, marked *dolcissimo,* calls for a radically reduced string band, moving in close, keyless harmony like a consort of Renaissance viols. Above the chanting of male choristers, solo voices proclaim the mystery of Mary's conception, while a solo flute twitters bird-like at an extreme altitude: the Holy Ghost as dove.

Considering the extent of Beethoven's researches into the Mass and its mythology, it is not improbable that he came across the belief, held by some medieval divines, that the Virgin was impregnated through her ear. He had, in a way, been ravished through the same channel, the first time he ever heard Bonn's church bells and Gregorian chants. But further than this, speculation should not go. Mystery speaks to mystery in music and religion. Beethoven stopped complaining about deafness in the last years of his life, preferring to keep the sources of his inspiration private.

About his personal faith, Beethoven was less shy. When Karl stayed with him, he insisted on kneeling prayers morning and evening. He spoke and wrote conventional pieties in times of stress. But he was no churchgoer, having had his fill of ritual as a young organist in Bonn. Orthodox Catholicism was less important to him than a sort of general deism, freely if vaguely expressed. During the summer, this tended to degenerate into an even vaguer pantheism, in which the pagan note—that piping shepherd—sounded distantly. "Surely woods, trees, and rocks produce the echo which man desires to hear," he wrote, himself unconsciously echoing Wordsworth. One of his favorite books, much scribbled in, was Christoph Christian Sturm's *Betrachtungen über die Werke Gottes im Reiche der Natur* (Reflections on the Works of God in the Realm of Nature). He felt that his *Pastorale* Symphony was a religious utterance, rather than a piece

of musical impressionism, and made a point of formalizing its imitations of quails, cuckoos, and nightingales, so as not to be accused of naïve "tone painting."

Inevitably, however, his studies for the *Missa Solemnis* stimulated a more theological interest in Christianity, while leftover pain from the lawsuit made him seek comfort in a variety of religious writings. He corresponded with the liberal Catholic reformer Johann Michael Sailer, a friend of Antonie Brentano, and copied out spiritual apothegms from Mediterranean, Indian, and Far Eastern sources. Three redundancies from Ancient Egypt impressed him so much that he copied them out in block capitals and framed them in glass: "I AM THAT WHICH IS," "I AM ALL THAT IS, WAS, SHALL BE; NO MAN THAT LIVES HATH RAISED MY VEIL," and, "HE IS OF HIS SOLE SELF, AND FROM THIS ALONE COME ALL THINGS THAT BE." These texts appealed mainly to his egotism, yet something of their monosyllabic self-certainty can be heard in the four-note "Cre-do, Cre-do" theme of the mass.

Beethoven built his giant structure up, stone by musical stone, over the course of three more years. Allowing for the sections he had already written, it took him four years in all, the most time he had spent on any project. The labor was not continuous, but rather concentrated into long spells of exclusive effort—twenty-nine months of it. In between these spells, as his productivity picked up, he wrote a large quantity of superlative piano music. The *Missa Solemnis* proved to be his longest work, with the exception of *Fidelio*: a solid eighty minutes of music alternately majestic, intimate, ethereal, elemental, and even brutal in its uncompromising demands on singers and listeners alike. Beethoven had no doubt that it was his masterpiece, and said so (although there was music yet to come that would

cause him to change his mind). As an expression of faith and con-
summation of all his technique, it is fully the equal of Bach's
B-minor Mass, and even exceeds that great work in its textural in-
tegrity. Bach built much of his mass from music written in earlier
years for different purposes. Beethoven cut and shaped from the
same block of rock.

Before reverting to the Credo after Rudolph's elevation, he ac-
cepted a commission for three new piano sonatas, and began to write
the first (in E major, Op. 109) as soon as he had settled in Mödling
for the summer. It developed from a wispy motif of only two notes,
floating in his sketchbook among designs for the *Missa Solemnis,* like
dandelion seeds blown through a cathedral door. The fundamental
paradox of Beethoven's late style is that its giganticism accommo-
dates microscopic detail—which is probably what he meant when he
wrote Rudolph about "refinement" and "enlarged conceptions."

As sonata followed sonata, and the mass took its time, Beetho-
ven began to show signs of premature old age. Since the Congress of
Vienna, he had been, in the words of a modern medical researcher,
"a sick man who was never to recover his health." The catalog of his
ailments through his fiftieth birthday on December 16, 1820, includes
ulcerative colitis, rheumatism, lung inflammation, fevers, heart fatigue,
rapidly worsening sight, and recurrent cracking headaches. Yet there
had been long interludes in which he remained relatively well, and
could exult in the strength of his squat, hyperactive body.

In 1821, however, he was sick almost the entire year, starting with
a near-fatal, six-week attack of rheumatic fever. "All friends of Art
feared for him," the *Allgemeine Musikalische Zeitung* reported. He
also suffered prolonged jaundice, an indicator of liver disease, and felt
that his body had become moribund. News of the death of Napoleon

in May hit him with especial force, since he had so long identified with that Promethean figure. Now his own fire was ebbing. He declined to write an elegiac piece, saying, "I have already composed the proper music for that catastrophe"—most likely the funeral march in the *Eroica* Symphony. Or was he thinking of the funeral cantata he had written for another emperor, at age nineteen? It may be significant that around this time Beethoven began talking of a return visit to the Rhineland, "to visit my parents' graves," and speculated that he might die of a stroke, like his grandfather Ludwig.

He remained silent about the death, also that year, of Josephine Deym. Although he continued to correspond with the Immortal Beloved, in language designed not to alarm her husband, he showed no further romantic interest in women. The friends, aides, and comforters of his last years were exclusively male. He was still capable of the odd clumsy flirtation, and he patronized prostitutes when he needed to. There is a remarkable invitation in one of his conversation books: "*Wollen Sie bey meiner Frau schlafen? Es ist so kalt.*" ("Would you like to sleep with my wife? It is so cold.") It may have been a joke, but the author, Karl Peters, was about to leave town for a few days, and Frau Peters was famously hospitable in bed. Apparently Beethoven availed himself of her favors only once, because later in the same notebook Peters teased him about his "sole visit to my wife," while another friend wrote: "I salute you, O Adonis!"

Beethoven retained a disconcerting ability to hear odd sounds at odd moments, but for most of the time was deaf even to close screams. More and more, he "listened" through his spectacles, avidly scrutinizing written questions and answering them while the pencil was still moving. When his works were played in rehearsal, he watched the movement of bows and fingers, and could instantly tell when a player

departed from the printed text. He relied less and less on the piano for composition, but got some satisfaction from a six-octave instrument sent to him as a gift from the English firm of John Broadwood & Sons. It was massively constructed out of mahogany, and featured a tin dome that scooped and threw every note back into his face.*

Out of this sound chamber, we may guess, there reverberated the last fortissimo chords of the Piano Sonata in A-flat major, Op. 110, which Beethoven completed on Christmas Day, 1821. It was the only substantial piece he produced in that year of illness, apart from on-going work on the mass, and much of it was written when he was racked with diarrhea. Earaches plagued him in the new year ("My usual trouble at this time"), and "thoracic gout" followed for many months, almost two of which he spent in bed. Yet his creative output suddenly surged. In addition to completing the first full draft of the *Missa Solemnis* in 1822, he plotted "two great symphonies, each different from the other, and each also different from all my other ones." He composed what proved to be his last piano sonata, No. 32 in C minor, Op. 111, along with eleven bagatelles, Op. 119, the *Consecration of the House* Overture, and several choruses and songs. Finally, he finished his biggest piano work, which he had set aside some years before. This was the *Thirty-three Variations on a Waltz by Diabelli,* Op. 120, at once a stupendous practical joke and an intellectual tour de force rivaled only by Bach's *Goldberg Variations.*

In 1819 Antonio Diabelli, a Viennese music publisher, had asked fifty composers, including Schubert and the young Hungarian prodigy, Franz Liszt, to write one variation each on a tripping theme

*This historic instrument was later owned by Franz Liszt. It can be seen today in the Hungarian National Museum, Budapest.

of his own invention. Beethoven had refused to be associated with such lowly company, and such a *Schusterfleck* ("cobbler's patch") of a tune. But he found the waltz's harmonic structure fascinating. It was strong enough to support any weight of music—as he now proved, with variations that sounded as if they had been written by thirty-three composers, all of them superior to Diabelli's fifty. When his set was issued separately in June 1823, the publisher wrote a blurb of rare eloquence, which still applies: "We present here to the world Variations of no ordinary type, but a great and important masterpiece worthy to be ranked with the imperishable creations of the old Classics."

In dedicating the *Diabelli Variations* to Antonie Brentano, Beethoven said more than he could say in words about what the music, and she, meant to him.

By that time Beethoven was ready to begin serious work on his long-postponed Ninth Symphony, and to honor a commission from Prince Nikolas Galitzin, a Russian connoisseur, for three string quartets. He was overflowing with musical ideas ("It seems to me that I have only just begun to compose!"), and needed to rid himself of a major encumbrance: the vast manuscript of the *Missa Solemnis.* The fact that it was still unsold was entirely his own fault. Diabelli had offered him one thousand florins for it, on top of two hundred florins for the *Variations,* if he would only agree to publish it immediately. But marketing the mass had become Beethoven's new obsession, now that he had secured Karl as his son and heir. He wanted it to make him more than prosperous, more than famous. It was, he insisted, "the greatest work which I have composed so far," and should guarantee him not only security but immortality.

Interest in the score had been extraordinary even before the en-

thronement of Rudolph in 1820. Beethoven's revived popularity, for which multiple productions of *Fidelio* were largely responsible, only increased the excitement among publishers in London, Paris, Leipzig, Berlin, and Vienna. Yet one after another were turned away, enraged or bewildered by his mendacity in dealing with them. Ever since, embarrassed hagiographers have tried to prove that the genius behind the *Missa Solemnis* was not as crooked as a clef.

The word "hagiographer" makes it necessary to introduce, at this point, Anton Felix Schindler. One of those colorless young men who attach themselves like lampreys to the great, Schindler began to suck up to Beethoven in November 1822. He was an aspiring violinist, but neglected his studies when he saw that Beethoven, mired in negotiations over the mass, urgently required an assistant. (Franz Oliva, who had served in that capacity since the days of Baron von Gleichenstein, had relocated to St. Petersburg.) Schindler's posthumous role as the card-carrying "Friend of Beethoven," forger of documents and author of an influential, hugely distorted biography does not alter the fact that he served his master well until a later quarrel parted them. And he would return.

It is not clear from the conversation books how much Beethoven took Schindler into his confidence to begin with. But a surviving letter, dated November 22, 1822, does show that the *Missa Solemnis* had mutated, for haggling purposes, into two masses. "Here is the state of things regarding the Mass," Beethoven informed the Peters publishing house of Leipzig. "I have already completely finished *one*, but another is not yet complete. *I still do not* know which of these two Masses you will get. Harrassed on all sides—" And there followed one of his myriad complaints about distractions that kept him from his work.

Earlier that year he had specifically offered Peters the *Missa Solemnis* for "at least" one thousand silver florins. But Peters was merely one of many publishers similarly cajoled and put off. The first to imagine that the mass was under contract, at nine hundred florins, was Nikolaus Simrock of Bonn, who had once proudly put out the "Kreutzer" Sonata. As way of getting money out of him while the Credo was still in sketches, Beethoven had appointed Franz Brentano, Antonie's banker husband, to be his publishing agent, and borrowed the full amount in advance. In 1821, he assured Brentano that the mass was finished, while secretly offering it to Adolf Schlesinger in Berlin for one thousand florins. Schlesinger bought it (or thought that he bought it) for a bargain 975 florins, whereupon Beethoven resold it to Peters for 1,000 florins, accepting 360 florins as another advance. The coins had hardly settled in his bank when he offered it to Artaria in Vienna, consoling Peters with the "two Masses" letter quoted above, and bullying Simrock into a 1,000-florin commitment. By 1823, the *Missa Solemnis* had mutated further, into three masses, none of which any publisher had seen. He then conceived a scheme to produce beautiful manuscript copies of the original, for private subscription by royal courts. This, he hoped, would encourage the ruling class to shower him with money and medals. Ten subscribers signed up at fifty gold ducats per copy, on the understanding that no print edition would appear for a considerable time. They included Tsar Alexander of Russia, King Louis XVIII of France, and the ever-loyal Rudolph. (Beethoven's music seems never to have appealed to Emperor Franz I.) It was at this point that Diabelli tried to get the mass for 1,000 florins, but even Beethoven worried about the consequences of trading away exclusivity before his patrons got their copies. He waited for at least some of the subscrip-

tion ink to dry before offering the mass to yet another publisher—
this time Moritz Schlesinger, Adolf's son, who ran a separate house
in Paris. The firm of Probst in Leipzig received a similar offer. Si-
multaneously, Schott's Sons of Mainz asked him to write an article
for their journal. He declined the article, but sold them his mass and
new symphony together for 1,600 florins—having already netted as
much again from subscriptions. (A month later he tried to resell the
symphony to Probst for 1,000 florins.) The score of the *Missa Solem-
nis* was finally delivered to Schott's in January 1825.

These are only the main moves in six years of publication poker
that involved multiple negotiations over other works great and small.
Although Beethoven relied on Schindler and a variety of other in-
termediaries to help him, there is no evidence that anyone was guilty
of deception except himself. The question of whether he was con-
sciously—which is to say, clear-headedly—venal is difficult to
answer. Any objective reading of his business correspondence dis-
closes a man of high intelligence and an even higher level of inse-
curity, cognitively unfit to handle his own affairs because what he
imagined or hoped for or promised on any given day was, to him, at
once true and real: truer than any contract signed yesterday, realer
than any long-overdue debt. The only currency he really understood
was music. His reaction to a legal letter demanding repayment of an
advance was to offer a grab bag of unpublished trifles, or a new work
"almost finished"—Beethoven-speak for "not yet begun."

The fact that he was arithmetically challenged—unable to mul-
tiply or divide, and prone to countless mistakes in addition and sub-
traction—did not prevent him developing a mania for sums in these
last years of his life. No folio margin or toilet door was safe from his
figuring. Challenge, to Beethoven, was inspirational: the more dif-

ficult a problem, the more it excited him. "Difficulty is beautiful, good, great." In the congenial world of music theory, this led to beauty and order. In business, it made him, as one sympathetic friend remarked, a puzzlehead.

Incomprehension hampered him, to a certain extent, as the salesman of his own merchandise. His maneuvers over the *Missa Solemnis* incurred as many liabilities as profits, and reinforced a long-standing impression among music executives that he was not to be trusted. "For God's sake, don't buy anything of Beethoven!" a London publisher cautioned the agent Charles Neate. But a compulsion overriding confusion is palpable in all Beethoven's wheelings and dealings—palpable, indeed, in his lifelong behavior: the urge to own and control everything and everyone, whether he was qualified to or not. Franz Grillparzer, the Austrian poet, reported that Beethoven, crossed, "became like a wild animal."

The vast majority of his approximately 1,700 surviving letters relate to business. It is primarily a manipulator who emerges, planning, postponing, administering, cajoling, recruiting, rejecting, and at times lying so blatantly that it is marvelous so few of his victims took umbrage. (Franz Brentano, for one, never forgave him.) In a superior sense, Beethoven's music, too, was manipulative: themes or harmonic blocks, almost always grouped in antitheses, forced together, forced apart, forced to break in further disarray, then forced together again, with a strength so great that they fused inseparably.

This strength was at its most herculean in late 1822, when he was working eighteen-hour days, revising the last pages of the *Missa Solemnis* and exulting, "Thank God, Beethoven can compose." Two foreign commissions reached him almost simultaneously: Prince Galitzin's request for "one, two, or three new quartets," and another

letter from Ferdinand Ries, offering fifty English pounds, on behalf of the London Philharmonic Society, for a new symphony. Although the first offer was potentially far more lucrative (Galitzin was willing to pay any fee), strength and the desire for another gigantic challenge won out. Beethoven accepted both commissions, gave the prince an illusory date of delivery, and plunged into the composition of his Ninth Symphony.

Of all his works, this was the longest in gestation, and his most ambitious attempt—more so than even the *Missa Solemnis*—to employ all his skills, orchestral and choral. Mention has already been made of Beethoven's youthful vow to set Schiller's "*An die Freude*" "strophe by strophe," as well as the flashing theme that hit him in 1815 when he stepped out into a starry night, and his 1817 sketch of a pregnant opening.

Just how pregnant may be gauged from its effect on May 7, 1824, in Vienna's Kärnthnerthor Theater. Emotion among the packed audience was running high, because a rumor had circulated earlier in the year that Beethoven no longer respected Viennese musical taste, and was planning the European premiere of his Ninth Symphony in Berlin. This was true, and it was also true that Prince Galitzin was already first in line to perform the *Missa Solemnis* in St. Petersburg. Thirty influential Austrians had placed an open petition in the *Theater-Zeitung*, begging "*the one* man whom all of us are compelled to acknowledge as foremost among living men" not to deny Vienna a first hearing of "the latest masterworks of your hand." Flattered, Beethoven had agreed, and left Schindler to organize the last great concert of his life.

Because of the enormous length of the mass, only three sections were given, preceded by the *Consecration of the House* Overture. After

the intermission came the billed "Grand Symphony, with solo and chorus entering in the finale on Schiller's ode, *To Joy*." For obvious reasons, Beethoven could not conduct, but he was encouraged to mount the podium with Michael Umlauf and set the tempo for all four movements.

It was his downbeat, therefore, that produced the most revolutionary sound in symphonic history: a long, hovering, almost inaudible bare fifth on A, seemingly static yet full of storm. High over this cloud layer, like reflections of distant lightning, a series of broken fifths dropped pianissimo and very slowly. They repeated themselves, no louder but more often, while the hovering fifth prevented any sense of acceleration. Odd wind instruments joined the general drone on A (was the whole universe tuning up?), then, unexpectedly and quite off the beat, a low bassoon sounded D. At once, still without any crescendo, the sense of space filling the hall gained an extra dimension. This was not a symphony in A, but an epic in D. Now the broken fifths began to proliferate wildly, the drone swelled to a roar, and a huge theme built of all the elements crashed down fortissimo. Beethoven's Ninth was under way, and for the rest of the century, symphonic composers would struggle in vain to write anything that sounded bigger.

Accounts differ as to when, exactly, the following happened: either after the scherzo (with its shock drum solo, throwing the "flashing" theme off-beat) or after the choral finale (with its climactic double fugue praising Joy and embracing Millions). At whichever moment, while the audience erupted with delight, Beethoven stood with his back to the hall, absorbed in the score before him. One of the soloists, the teenage soprano Caroline Unger, had to take him gently by the sleeve of his coat and turn him around so that he could see the tumult.

"Never in my life," Schindler wrote in his conversation book afterward, "did I hear such frenetic and yet cordial applause." The symphony was in fact interrupted four times by rapturous demonstrations, until the city police commissioner had to call for order. Only the imperial box remained silent, for the good reason that it was empty. Ten years before, at the première of *Der glorreiche Augenblick,* Beethoven had been the toast of European royalty. He was now, in perhaps the strangest turn of his career, a hero of the people. The Ninth Symphony's success was extraordinary (a repeat performance had to be scheduled), and not least because in it Beethoven managed without intellectual condescension to strike the populist note. Connoisseurs could revere its contrapuntal and formal complexities, and details such as the long appoggiatura on C in the theme of the slow movement, poignant almost beyond bearing. But the *Millionen* felt themselves addressed in the compulsively singable, anthem-like tune of the finale, and the fivefold invocation of "all humanity" at the end.

Four years before, around the time Beethoven won custody of Karl, and began to emerge from his period of musical and psychotic turmoil, his fellow metaphysicist Percy Bysshe Shelley had published a great poem, coincidentally entitled *Prometheus Unbound.* Its prose preface carried a haunting image: "The cloud of mind is discharging its collected lightning." Although Shelley was describing the imminent birth of Romanticism, his metaphor was applicable to the opening of the Ninth Symphony, which Beethoven already carried fully formed within him. And there was much of Romance in the music, after the storm finally broke: as many starry pulsations and yearning harmonies as bolts of lightning.

Applicable, too, were Shelley's continuing words: "The equilib-

rium between institutions and opinions is . . . about to be restored."
Beethoven the artist had discharged his last public work, commis-
sioned by a society and petitioned for by a delegation. He was now
free, in the summer of 1824, to do what he had wanted to do ever
since undertaking the "Razumovsky" Quartets: devote himself en-
tirely to music's most cerebral medium.

Free, except for an immediate obligation to write some short
piano pieces for—of all people—Johann van Beethoven, who could
not tell the difference between an E-flat and an earring. The two
brothers had reconciled after their differences over Karl's education.
This was in part because Johann was now wealthy enough to have
retired to a large estate at Gneixendorf, near Krems, while main-
taining an apartment in the city. Ludwig's financial entanglements
required occasional emergency loans, and Johann was always good
for a bag of silver. Hence, he had to be cultivated, tolerated, and at
times repaid. He was a kindly soul who felt inferior to his famous
brother, and longed to be accepted by sophisticates, so the gift of a
set of bagatelles, to profit from as he pleased, was enough to make
him forgive Ludwig's current indebtedness of 1,500 florins.

Pausing only ungratefully to fire Schindler ("I feel a kind of fear
that someday a great misfortune may befall me because of you"),
Beethoven retired to Baden and wrote the Six Bagatelles, Op. 126.
Then, in June, he decided on E-flat major, the key of so many of his
past "heroic" works, for the first of the string quartets requested by
Prince Galitzin. As if bowing to his younger self and the ghosts of
Mozart and Haydn, he wrote three long, rich chords in tonic, dom-
inant, and subdominant harmony—the pillars of Classical style—
then allowed the last to drift and vaporize into music neither new
nor old but timeless. No composer, not even the blind Bach or the

octogenarian Verdi, has so fully transcended the music of his youth.

Beethoven's creative life extended another two and a half years. During that last lease, itself interrupted by long periods of debilitating illness, he fulfilled his obligation to Galitzin by finishing the String Quartet in E-flat major, Op. 127, and writing two more, in B-flat major, Op. 130, and A minor, Op. 132. He followed up with a final pair, composed because he simply could not stop the flow of his inspiration: Op. 131 in C-sharp minor, and Op. 135 in F major. All five, plus the *Grosse Fuge*, Op. 133, are generally agreed to represent the summit of instrumental music in the West. Beethoven himself rated Op. 131 as his most perfect single work.

Words, except for the revelatory technical analyses of a Joseph Kerman or a Robert Winter, are wasted on these quartets. They speak for themselves, in the most precise of languages—as, for example, when the yearning theme of *An die ferne Geliebte* floats suddenly through an aural window in the C-sharp minor quartet. To an alert listener, the evocation of Beethoven's lost love is as heart-catching as the similarly fenestral appearance of a young woman in Monet's *The Red Scarf.**

When Karl turned eighteen in the fall of 1824, he was an attractive, rather glib youth whose main problem was Beethoven's obliterative possessiveness. He was now a philology student at Vienna University, living with his uncle and drawn to a military career. Eighteen is the age of throbbing male libido, and Karl's occasional nights away from home, which he believed to be his own business, drove Beethoven half mad with worry. He fantasized that Karl was having

*This painting is in the permanent collection of the Cleveland Museum of Art.

an affair with their housekeeper, and arranged to have the youth spied on: "One is anxious on account of a growing young man, what with this poisonous breath of dragons!" He developed a violent hostility toward Karl's best friend. There were such loud quarrels between uncle and nephew, or "father and son" in Beethoven's language, that their landlord in the Johannesgasse asked them to leave.

Not surprisingly, Beethoven was against Karl's desire to become a soldier, which would likely post him to foreign parts. In the spring of 1825, Karl temporized by registering for commercial studies at the Polytechnic Institute. Beethoven again removed to Baden, ailing with acute colitis and lung trouble ("I spit up rather a lot of blood . . . often it streams out of my nose") and fretting about leaving his nephew in town. Thirty-five letters kept distracting Karl from his studies: complaints, myriad shopping requests, weekend summonses, endearments, appeals for sympathy ("I am growing steadily thinner. . . . Where am I now wounded, torn?"). Failure by the youth to make scheduled visits sent Beethoven into agonies of despair: one letter was signed, "Unfortunately your Father or better not your Father." He threatened to cut off the youth's tuition, and berated him as a drain on his income. Johann (estranged again from Ludwig) and Johanna reappeared as imaginary enemies, joined by Johann's wife and stepdaughter, "his whore of a Fatlump and Bastard . . . creatures so far beneath me."

Clearly, Beethoven was caught up in another firestorm of paranoia. Yet at the same time he wrote these last words, he was recovering from his intestinal inflammation and composing the slow movement of the A minor Quartet, Op. 132, superscribed "Hymn of thanks from a sick man to God in his recovery." Cast in the white-key, Lydian mode of Ancient Greece, it exudes an unearthly calm.

That fall, Beethoven moved into what proved to be his last residence, a five-room suite in Vienna's Schwarzpanierhaus ("black Spaniard house," a name derived from its onetime occupation by Spanish Benedictines). The days when he had been called "Spaniard" himself were long gone: his complexion now was permanently sallow, and his hair pale gray.

Karl, who had enjoyed living alone during the summer, accepted their renewed codomesticity without enthusiasm. Another winter and spring of Beethoven's obsessive surveillance placed such strains upon the young man that he began to crack emotionally. He was cramming to matriculate at the Polytechnic in midsummer 1826, and began to stay away from home, not for sex but simply to avoid Beethoven's alternate rages of love and disapproval. Tormented by debts his uncle would not pay, fearing for his examinations, he dropped a few careful hints of suicide, then bought a pair of pistols, went to the high Rauhenstein ruins outside Baden and, on Saturday, August 6, shot himself in the head with both barrels.

One bullet missed, and the other lodged at a safe distance from his brain. He was found by a drover and carried bleeding down the cliff. Regaining consciousness, he asked to be taken to his mother in Vienna. It was there that an agonized Beethoven found him.

"Do not torment me now with reproaches and complaints," Karl scrawled in the proffered conversation book. "It is past."

What was past was Beethoven's power to hold and control him. After an operation to remove the bullet, Karl recovered in the Vienna General Hospital, and talked with determination about his intent to join the army. Required by a magistrate to state why he had tried to kill himself, he simply stated, "*Weil mein Onkel mich so sekkiert hat.*" ("Because my uncle harassed me so").

Beethoven, who since the accident had begun to look like a man of seventy, admitted defeat. "All my hopes have vanished," he wrote to Schindler's replacement, a young violinist named Karl Holz. "All my hopes of having near me someone who would resemble me in at least my better qualities!"

Back into the story, like some High Dutch Ichabod Crane, stalks the angular, walleyed, trap-mouthed figure of Johann van Beethoven, laughed at by elegant Viennese for his *nouveau* clothes and black-dyed hair. For years, whether fighting Ludwig or not, he had repeatedly invited his brother to come and stay at Gneixendorf, promising that the Fatlump and Bastard would not disturb him.

After Karl was released from the hospital on September 25, Johann renewed his invitation, saying that both uncle and nephew might benefit from a holiday in the beautiful wine country above Krems. Ludwig, who was again jaundiced and showing signs of chronic edema, needed a period of peace and in-house services in order to complete his last quartet, Op. 135 in F major. Karl needed to grow enough hair to cover his scar before being interviewed by Field-Marshal Joseph von Stutterheim, the commander of his hoped-for regiment. So on September 28, the two of them set off up the Danube Valley.

The countryside around Johann's estate, which they reached the next day, reminded Beethoven pleasantly of "the Rhine country . . . when I was young." The house itself, a big walled-off manor, loomed about half a mile from the village of Gneixendorf. Beethoven's rooms were high and spacious, with long views back toward Vienna. Here he settled in with every appearance of contentment, and at once began his usual country routine of rising at 5:30 A.M., lacing himself with strong coffee, and working for a couple of hours at his desk. As

he wrote, he beat out rhythms with his heels and sang. After break-fast with the family, he stomped off into the fields with his notebook, shouting and gesticulating. Locals not knowing who he was stared at his shabby clothes and swollen ankles and dismissed him as a *Trot-tel* (imbecile).

When not out sketching, Beethoven sat in his room working on the fair copy of the F-major Quartet. He finished it in mid-October, basing the finale on an enigmatic double cryptogram: three slow notes labeled *Muss es sein?* ("Must it be?") and three fast ones labeled *Es muss sein!* ("It must be!). These mottos—Schumann would have called them "sphinxes"—have afforded scholars almost as much spec-ulation as the Immortal Beloved. Some have interpreted them as Bee-thoven's heroic resolve to face the imminence of death; others, as his acceptance of the loss of Karl; others, as representing the yin-yang du-alism of the universe. Since Beethoven never explained, the possibil-ity also arises that, with his peculiar sense of humor, he was deliberately setting out to mystify. We know that on odd days, almost to the end, he could hear the occasional piercing noise. Is it conceivable that the *Es muss sein* phrase, with its raucous falling fourth repeated through-out the movement, represents the crow of a Gneixendorf rooster?

At any rate, this last was not his last. He had one more piece of music to complete before returning to Vienna for the winter: a new finale for the B-flat major Quartet, Op. 130, in place of the *Grosse Fuge*. Mathias Artaria was willing to pay extra for it, saying that the fugue was so big and difficult, it should be published separately. By November 22, the substitute movement was done and put in the mail.

Although Johann enjoyed having his brother under his manor-ial roof—they were linked by childhood memories of much worse accommodations—he began to notice that Ludwig was in no hurry

to pack. The reason dawned as December approached: Beethoven was deliberately delaying his departure, in order to hold on to Karl. It would soon be too cold for an ailing man to travel anywhere. So Johann was obliged to write Ludwig a "Dear Brother" note, urging him to take "this talented young man" back to town for his recruitment interview. "It is your duty, if you do not wish to be reproached by yourself and others hereafter, to put him to work at his profession as soon as possible."

The result was an acrimonious parting early on the freezing morning of December 1. Johann did not offer the use of his closed carriage. Beethoven and Karl had to huddle in an open one that headed south across a windswept plateau to where the post road ran east to Vienna. The journey was slow, and they were compelled to spend the night in an unheated village inn with no winter shutters. Around midnight, Beethoven awoke coughing and feverish, his sides knifed with pain. He did what he always did when his blood overheated, and drank a few measures of ice-cold water. After that he could not sleep. He had to be lifted into the carriage the next morning, dangerously ill with pleurisy. Another long day of bouncing, swaying travel lay ahead.

He had no heavy coat to protect him, having absentmindedly packed only summer clothes. One item, however, he had been sure to include: the manuscript of a unfinished string quintet, which he had begun to write at Gneixendorf immediately after sending off the Op. 130 quartet movement. So maybe Johann had been wrong about the reason for his not wanting to leave.

Many years later, Antonio Diabelli patched the fragment together as best he could, and issued it as "Beethoven's Last Musical Thought."

Valedictory

BEETHOVEN WAS PUT straight to bed upon arrival at the Schwarzpanierhaus late on Saturday, December 2, 1826. Karl and Karl Holz busied themselves to take care of him and get the best medical help. Dr. Ignaz Wawruch, a professor of medicine and practicing physician, was recruited on December 5, writing in Beethoven's conversation book, "One who greatly reveres your name will do everything possible to give you speedy relief."

He found Beethoven to be suffering from pneumonia as well as pleurisy, and spitting blood. Within a week, Dr. Wawruch had fulfilled his promise, and Beethoven was able to walk around and write letters. He was not strong enough to write music, except for the little canons and humorous song snatches that he habitually scribbled in letters to friends.

Karl, meanwhile, was accepted for the regiment of Field-Marshal von Stutterheim, and ordered to enter service on December 14. On the eve of that day, Dr. Wawruch found Beethoven "greatly disturbed and jaundiced all over his body." He had had "a frightful choleric attack" over some "great grief" the night before. "Trembling and

shivering he bent double because of the pains which raged in his liver and intestines, and his feet, hitherto moderately inflated, were monstrously swollen."

Dropsy—the nineteenth century's synonym for fatal edema—sent Beethoven back to bed. He was relieved at least to read, in his conversation book, a note from Karl: "I shall be here for 5 or 6 days more." Uniform measuring and other procedural delays further postponed the young man's departure. Johann van Beethoven arrived from Gneixendorf, to offer the services of a trained apothecary.

On December 16, Beethoven turned fifty-six.

By the twentieth, his dropsy was so advanced that he felt he was suffocating. Dr. Wawruch was compelled to perform an abdominal tap in the presence of Karl, Johann, and an insidiously revenant Anton Schindler. Twenty-five pounds of fluid spurted out. Beethoven managed a joke: "Professor, you remind me of Moses striking the rock with his staff." But as the afterflow continued, totaling 125 pounds, he sank into depression.

A magnificent gift from Johann Stumpff, one of his London admirers, afforded him some relief. It was a forty-volume edition of the works of Handel. The books were so big, Beethoven could read them only by propping them against the wall. As he turned the pages, marveling, he was heard to say, "Handel is the greatest, the ablest composer that ever lived. I can still learn from him."

His auditor was Gerhard von Breuning, the thirteen-year-old son of Stephan von Breuning, another frequent attendant during these last days. Stephan himself had been thirteen when he and Beethoven first met. These ghosts from the past, and a reading of an affectionate letter from his other oldest friends, Franz and Eleonore

Wegeler ("Don't you ever want to see the Rhine?") turned Beethoven's thoughts increasingly toward Bonn. He remembered how Franz had once whitewashed his room "and given me such a pleasant surprise." Eleonore's silhouette portrait, which he had always kept, seemed to symbolize "everything good and lovely from my youth."

Karl treated him with especial sweetness over the holidays, knowing it was unlikely they would see each other again. On January 2, 1827, he could delay reporting for duty no longer, and left Vienna for Iglau, where his regiment was stationed. Beethoven reached for pen and paper the following morning and wrote in a shaky hand, "Before my death I declare Karl van Beethoven, my beloved nephew, my sole and universal heir of all the property I possess." Thus, in extremis, he at last abandoned the notion that Karl was his son. But the first letter he received from Iglau unequivocally addressed him as "My dear Father."

Field-Marshal von Stutterheim was rewarded for favoring Karl with the dedication of the C-sharp minor Quartet, Op. 131—thus at once becoming the most honored soldier in history.

Beethoven lingered on for nearly three months, undergoing three more abdominal taps, the last on February 27. His spirit remained quarrelsome, and Dr. Wawruch was obliged to give way to Dr. Giovanni Malfatti, whose daughter, Therese, Beethoven had once wanted to marry. Malfatti prescribed, to the patient's delight and destruction, a regimen of frozen fruit punch and other laced fomentations. He had noticed—or maybe long known—that Beethoven was a lover of fortified wines. Predictably, Beethoven abused his prescription, and became drunk and diarrhetic. Primitive steam baths

amid piles of hot, soaked hayseed and cabbage leaves did little but increase his thirst. Unslaked, and still thinking of Bonn, he begged Schott's in Mainz to send him "a small number of bottles [of] Rhine wine, or Moselle."

There was one explosion of his famous temper, when he was presented with a lithograph of a house captioned, "Joseph Hayden's Birthplace." He noticed the misspelling and turned red with rage. "Who wrote that, anyway? ... Can't even spell the name of a master like Haydn."

Another spell of depression reawakened his perennial worry about money, and he sent a pathetic plea of poverty to the Philharmonic Society in London. One hundred English pounds (one thousand florins) was hurriedly voted by the society and sent to him, arriving on March 15. Beethoven was so overjoyed that his abdominal puncture burst. "*Plaudite, amici, comoedia finita est*," he said, quoting the old tagline of many Latin plays: "Applaud, friends, the comedy is over."

Friends were not in short supply as word got around Vienna that Beethoven was dying: Count Moritz Lichnowsky, Ignaz Schuppanzigh (back, now, from Russia, and regularly leading performances of the late Beethoven quartets), Diabelli and von Gleichenstein and Streicher and even a former landlord, forgiving all and bearing gifts of pastry. Many other pilgrims beat a path to the Schwarzpanierhaus. But one young man was too shy, having long hovered in Beethoven's orbit without daring to address him: the worshipful Franz Schubert.

On March 23 Beethoven wrote a one-line codicil to his will, on the advice of Stephan von Breuning. It ensured the continuity of his legacy to Karl and Karl's descendants. He signed it "Luwig van

Beethoen" and dropped the pen. "There! Now I'll write no more."

A case of 1806 Rüdesheimer Berg came from Mainz the next day. But by then Beethoven had already received the last rites. "Pity, pity—too late!" he whispered. Toward evening, he fell into a coma and lay for forty-eight hours with the death rattle in his throat. Late on the afternoon of March 26, storm clouds gathered over Vienna, sullen and full of snow. Schindler and Stephan von Breuning went out to choose a grave in Währing cemetery, leaving Beethoven in the care of Anselm Hüttenbrenner, a composer and friend of Schubert's. The only other person in the room was an unidentified woman, probably Beethoven's housekeeper.

At 5:00 P.M.—the exact time, on the same March day, that Beethoven had made his debut as a child prodigy—lightning illuminated the window, followed by a violent clap of thunder. The startled Hüttenbrenner swore that he saw Beethoven lift his right hand and clench it for several seconds, with staring eyes. Then the hand dropped, and he died.

The thunderstorm precipitated a heavy snowfall that night. "Almost," one of Antonie Brentano's friends wrote her in Frankfurt, "as if the elements were rebelling against the death of this great mind."

On March 29, an endless procession followed Beethoven's body out of the courtyard of the Schwarzpanierhaus and up the Währinger Gürtel to the cemetery. Estimates of the size of the crowd ranged from ten to thirty thousand. "All Vienna seemed to be on the move," Gerhard von Breuning reported. A brass band and chorus preceded the coffin. Eight Kapellmeisters carried the pall. Among the twenty top-hatted torchbearers was Schubert. Before the

next year was out, he would be buried in the same plot as his hero, just one monument away—dominated, in death as well as life, by the huge name

BEETHOVEN

Epilogue

A N AUTOPSY DISCLOSED that Beethoven died of macronodular, post-hepatitic cirrhosis of the liver. This is not the kind of cirrhosis that derives from alcoholism, although he was certainly a heavy drinker, as his father and grandmother had been before him. His auditory nerves were found to be "shriveled and marrowless," while the neighboring auditory arteries were "dilated to more than a crow's quill, and like cartilage." The vascular information, combined with Beethoven's well-known propensity for red-faced rages, suggests that his deafness may have been consistent with arterial disease, aggravated by the side effects of chronic diarrhea. But if he indeed did contract typhus in the summer of 1796, noticing his first hearing loss soon afterward, he may well, according to the medical historian Dr. Edward Larkin, "have had the specific form of immunopathic disease known as Systemic Lupus Erythematosus, which typically commences in adult life with a fever . . . accompanied by mental confusion. It becomes chronic, with periods of intermission and with phases of emotional instability." This speculative

diagnosis accords with the lupine roughness of Beethoven's face, his colitis and rheumatoid arthritis, and arterial and liver diseases.

His estate realized ten thousand florins—to the ire of the Royal Philharmonic Society—after unclaimed assets had been auctioned. It might have brought more, if Schindler had not stolen many precious items, including 138 conversation books, uncounted manuscripts and memorabilia, and the letter to the Immortal Beloved. Years later, Schindler inserted imaginary dialogues into the conversation books (while obliterating others), to "show" how close he had been to the great man. After publishing his enormously influential life of Beethoven in 1840, Schindler sold his treasure trove to the King of Prussia, and lived off the proceeds until his death in 1864. His forgeries were not discovered until the 1970s.

One document Schindler treated with respect was the Heiligenstadt Testament, which he arranged to have published in the *Allgemeine Musikalische Zeitung* at the same time as the auction. It communicated to the world, as no memoir could do, the full poignancy of Beethoven's disability, and is preserved now in the library of Hamburg University.

Stephan von Breuning died only five weeks after Beethoven, leaving to his son Gerhard two miniature portraits that he had kept from the auction. They can be seen at the Beethovenhaus museum in Bonn. Both are of women, painted on ivory. One was early identified as a likeness of Giulietta Guicciardi, the dedicatee of the "Moonlight" Sonata. For more than a century, the other was believed to represent Countess Erdödy. Recent research indicates that the large almond-shaped eyes, the soft curls, and the long neck are those of the Immortal Beloved.

Antonie Brentano outlived Beethoven by more than forty-two

years, dying in 1869 at the age of eighty-eight. Her later life was sad, marked by the insanity of two children and other family problems. But she was sustained by religion, and her art-rich mansion, often visited by Goethe, became the social center of old Frankfurt.

Karl turned out to be an excellent and popular officer. He left the army after five years, married in 1832, and inherited Johann van Beethoven's 42,000-florin estate in 1848. This, plus his earlier legacy, enabled him to retire young and live as a prosperous private citizen of Vienna. He died at fifty-two, of liver disease.

Of Karl's five children, only one was a son, born in 1839 and baptized Ludwig. He traded on his ancestry for as long as he could, selling a variety of fake memorabilia, then descended into a life of petty crime that resulted in a jail term. Of this Ludwig's six children, only one boy, Karl Julius Maria, grew to adulthood. He never married, and died as a soldier in World War I, the last man to bear the name Beethoven.

Karl Julius's great-great-uncle lay with Schubert in Währing churchyard until 1863, when their bodies were transferred to Vienna's Central Cemetery. The original monuments remain in what is today known as Schubertpark—a name that may soon relate more to automobiles than trees and grass, judging from the amount of concrete and blacktop the city is laying down.

The bicentennial of Beethoven's birth in 1970 brought about a predictable flood of biographies, conferences, and record releases, including one audio package of the "complete works" that was designed like a suitcase and retailed for one thousand dollars. All this did about as much for Beethoven's reputation as the Shakespeare quadrennial had done for the Bard's, six years before. Indeed, the only lasting effect of the bicentennial may have been to exhaust the

energies, and budgets, of its promoters. "Beethoven sites" in Bonn, Vienna, Baden, and Mödling have a tired, touristy, stop-at-the-shop quality to them. Guides recite Schindler's fake anecdotes, and shrug when challenged. One or two quiet islands of authenticity survive. It is still a moving experience to take the steetcar to Heiligenstadt (long ago absorbed into metropolitan Vienna), to walk up the little street from the church and stand in the room where Beethoven wrote his Testament. Across the courtyard, the museum of the Beethoven Society preserves a few memorabilia. It is hardly ever open.

One site alone, high above Krems, appears not to have changed at all. Johann's big house sits still outside Gneixendorf, surrounded by the same high wall. One can stroll along the manure-muffled lane from the main road, leaving the noise of the twenty-first century behind, and step—with care—right back into the third decade of the nineteenth. Cows bellow to be milked, and every now and then a rooster crows, *Es muss sein!* The air smells of honey and dung. Clearly visible over the tops of some fruit trees are the windows to the room in which Beethoven sketched his "Last Musical Thought." Beyond are the fields he trudged waving and shouting, unconscious of wondering stares. One follows in his footsteps, until brought up short by a historical marker: *STALAG XVIIB.*

This book began with an account of the C-minor weather that paralyzed New England in February 1978, until sunshine, and the C-major fanfare of Beethoven's Fifth Symphony, brought a sense of resurgent life. It may as well end with another New England scene, in the late summer of 2004: the concluding concert of a Beethoven quartet cycle at Music Mountain, above Falls Village, Connecticut.

On that hot Sunday afternoon, the Shanghai String Quartet performed before an audience of two hundred and fifty people, fanning

themselves in short sleeves and sandals. As the players dug into the opening measures of the *Grosse Fuge*, the music shed—a cedarwood box designed to resonate like an enormous violin—transmitted its sonorities outside to other listeners on the lawn. Fifteen minutes later, a festival official interrupted the applause to announce that a nearby house was on fire. But the blaze looked manageable, and a fire truck from the village was on its way. "We'll keep you informed. Now, enjoy the intermission, folks."

Lemonade and cookies went on sale. Men, women, and children strolled about, idly watching the plume of smoke rising two hundred yards away. One of the quartet members came out with a digital camera. Somebody wisecracked, "It's all the fault of you guys, for throwing off sparks during the *Grosse Fuge*."

Firefighters had not yet arrived when the concert resumed with Beethoven's last quartet, Op. 135, completed at Gneixendorf a hundred and seventy-eight years before. Programs stopped waving during the slow movement. Only after the finale came to an end, with eight exultant reiterations of the *Es muss sein!* motto, did word circulate that no fewer than four ladder companies were trying to save the house across the estate.

Knowing that great music was being performed in the shed, they had come up the mountain without sirens, and were plying their hoses in silence.

Glossary of Musical Terms

Many musical terms, such as sonata *and* concerto, *have meant different things in different epochs. Definitions below reflect the common understanding of Beethoven's time (1770-1827). Those descriptive of form should not be read rigidly. Even in the High Classical period, musical designs were as flexible as those of genre painting or strophic poetry. Italicized words in the definitions are themselves defined here.*

appoggiatura A *resolving* dissonance that usually settles a step below.

aria A self-contained vocal solo, generally melodic and formal in construction, with a tendency to recyle its opening material—although operatic arias often proceed in linear fashion.

cadence A closing phrase or harmonic sequence that ends a melody, or a movement, or any other self-contained musical passage. If the cadence is in the *tonic*, it gives a feeling of *resolution*. A cadence in any other key, while satisfying in itself, is not totally conclusive (like the ending of a prose paragraph).

cadenza Italian for *cadence*, but usually denoting a stretch of flamboyant solo singing (including improvisation), or solo-intrument

display toward the end of a concerto movement. In *Classical* concertos, the cadenza is heralded by a suspenseful "six-four" chord in the orchestra, which then falls silent until it hears an end-of-riff *trill* from the soloist. Beethoven magically tranformed this concluding formality in his Third and Fourth Piano Concertos.

canon A strict form of *counterpoint*. Voices of different register enter in a steady sequence, echoing one another exactly. The timing of the entries, and the intervals that separate each strand of sound, produce overlapping harmony. One of the most beautiful canons is the quartet "Mir ist so wunderbar" in *Fidelio*.

cantata A sung composition of some length and elaborateness, usually involving orchestral and choral forces along with solo singers.

cantilena A long vocal outpouring of especially melodic contour, with a clear beginning and end.

cavatina An *aria*-style number, strophic in form, slow in tempo.

cembalo The harpsichord that can be heard tinkling in a baroque or Classical orchestra, keeping time and occasionally filling in harmony. During the "crossover period" of Beethoven's youth, when pianos gradually supplanted harpsichords, *cembalo* could mean either instrument. See also *clavier*.

chaconne A variation form built on a rigid harmonic sequence, usually short and dictated by a stepped bass movement.

Classical In Western music history, the period (roughly 1720-1815) following the Baroque and preceding the Romantic. Its mature ("High") characteristics are simplicity of *theme*, importance of *modulation*, and overall architectural symmetry, expressed in organized forms such as the *sonata* and *rondo*.

clavier, clavecin Based on "*Klavier*" in German. Early in Beetho-

ven's life it denoted any stringed keyboard instrument, but later meant simply "piano."

coda In Italian, "tail"—a concluding passage, growing out of the main body of a work, that emphasizes the *tonic* key. *Classical* proportions require it to be short. However, many a Beethoven coda can seriously be described as "the tail that wags the dog."

coloratura An ornate, decorative style of writing for the human voice, intended to show off its virtuosity.

concerto A large-scale work in *sonata form* usually pitting just one instrumentalist against the orchestra, in the historic interplay of orator and crowd.

copyist A clerk trained in musical calligraphy, expensively hired by the composer to render his manuscript into a "fair copy," or individual *parts*.

counterpoint Melodic strands moving independently yet relatedly through several parts, or "voices." Their progression in time may be compared to the linearity of a carpet whose horizontal warp is more prominent than its vertical weft.

dominant Akin to the dominance, strong but temporary, of a helicopter over gravity. It is the fifth degree of an ascending scale, which, when harmonized as a major chord, needs to *resolve* onto the *tonic*, or key note. This need becomes especially acute when the interval of a seventh is mixed in.

episode In a *fugue*, a subsidiary passage, usually lighter in texture, that separates thematic statements. In Classical music, episodes often attain near equal status, becoming strongly thematic in themselves. (See *rondo.*)

forte, fortissimo Loud or very loud; the opposite of "piano," "pianissimo," soft or very soft.

fugue A strict form of *counterpoint* (but less strict than *canon*) in which a number of voices, or parts, follow one another in a sort of stately chase (*fuga* means flight in Latin). A *theme*, or "subject," is announced by a solo voice at the beginning. While another voice answers in duplicate, but at a different pitch, the first voice continues with a "countersubject." That is similarly answered as the third voice comes in. (Five voices are about as many as fugal argument permits.) The voices pass both subject and counter-subject back and forth, along with a certain amount of subsidiary, linking material. Any voice may vary any subject, by "inverting" it (notes played upside down), "augmenting" or "diminishing" it (notes changed in time value), and, very rarely, making it "retro-grade" (notes played backward). *Episodes* of looser texture afford relief from the contrapuntal discussion. The penultimate stage of a fugue generally has voices crowding one another ("stretto" effect) to a climax, before *resolving* in a final *cadence.*

harmonics The high acoustical overtones, all integral multiples of the frequency of a fundamental note.

harmony Usually a concord of sounds at different pitches, chang-ing under a melody as it proceeds, but not always in synch with it. The effect of harmony can be highly emotional, as when the sounds clash into temporary discord (e.g., at the opening of the fourth movement of Beethoven's Ninth Symphony). It is possi-ble for a Bach or Bruckner to achieve greatness without much gift for melody, but composers who lack harmonic imagination (e.g. Vivaldi and Weber) are permanently disqualified.

improvisation The art of creating music spontaneously, either as a free fantasia or as *variations* on a *theme*, often as not suggested by someone in the performer's audience. Not to be confused with

the mindless note spinning of New Age music: Bach, Mozart, and Beethoven were quite capable of improvising *fugues*.

Kapellmeister Music master of a royal, aristocratic, or municipal Kapell—literally, "chapel," i.e., department of musical services.

key A system of compatible tones that "unlocks" the melodic and *harmonic* potential of any degree of the musical scale. Although these systems—twelve in all—differ only in pitch, musicians tend to associate them with particular moods or colors. Note, e.g., Beethoven's habitual use of C minor for works of *Sturm und Drang*.

legato Smoothly, the notes melting into one another; the opposite of *staccato*.

major, minor The two main melodic modes of post-Renaissance music. The major scale, corresponding to the seven white notes from C to B on a piano, has a smoother, more easily tuneful profile than the minor, which flattens the third and sixth notes. When flattened, the latter note (A-flat in the C scale) is separated by a tone and a half from the seventh note, which wants to resolve upward onto another C. The separation, and the slight drag both flattenings put on the ascent of the scale, give minor melodies a contour, and minor harmonies a poignancy, that composers exploit for emotional effect. Moving from minor to major almost always lightens the musical mood—as Beethoven famously demonstrated in his Fifth Symphony.

modulation, modulate A move from one harmonic plateau to another. Just as in geography a plateau may have several different levels that "belong" together geologically, so in music: changes of harmony that relate naturally to one another do not involve modulation. Only when the air and climate alter can one say that one

has been transported to new territory. See the link between the second and third movements of Beethoven's *Emperor* Concerto.

motive, motif A musical fragment, sometimes as short as two notes, of decorative and/or constructive importance.

opus number An index to the order in which a composer publishes his works. Those issued in sets may be further indexed as, e.g., "Op. 10, No. 3." Note: opus numbers are an unreliable guide to when works were actually composed.

ostinato Italian for "obstinate." A musical figure that repeats itself over and over, for cumulative effect.

part The line of music, usually laid out on a single *stave,* that a chamber or orchestra player follows. These parts have to be unwoven by a copyist from the composer's full *score,* like threads from a tapestry.

perfect pitch An aural instinct so compelling to some musicians that they cannot bear to hear music played out of key.

polyphony Separate melodic strands heard simultaneously, as opposed to "homophonic" chordal blocks. See *counterpoint.*

quaver, semiquaver, etc. Quarter note, eighth note, etc. The author, trained in British musical nomenclature, confesses his fondness for these beautiful words, and his inability to write "thirty-second note" without wondering what happened to the other thirty-one.

recitative The nearest vocal music comes to actual speech: words sung or half sung in their natural rhythms, over the barest possible accompaniment.

relative major The *major key* into which a *minor key* most naturally slips, since they have a large number of notes in common.

répétiteur Rehearsal pianist for a ballet or opera company.

resolution, resolve The need of all art, not to mention science or

philosophy, to *resolve* complexity into some sort of unity is at its most compelling in Classical music. A typical melody will have *suspensions* even as its larger shape, rising or falling, reaches toward a feeling of completeness, or *resolution*. Chords (except *tonic* chords) want to *resolve* into other chords—or at least, transfer their inner tensions along a harmonic chain that will eventually achieve concord. (See *cadence*.) No composer struggles more constantly toward *resolution* than Beethoven, even when his deliberate protraction of the struggle reaches the point of pain.

rests Periods of prescribed silence in music. Not to be confused with pauses, left to the discrimination of the performer.

rondo A formal structure built around a theme that regularly comes "round," after intervening *episodes*.

scherzo In Italian, "jest" or "caprice." Haydn used the term to describe some of his speeded-up, high-spirited, triple-time minuets. Beethoven invigorated the scherzo even more, to the point that its triple beat accelerates to a one-beat rhythm—and those beats, in turn, are subsumed into great blocks of beats, pulsing with irresistible power.

score The manuscript, or printed sheets, of a musical composition for more than three players or singers. A "full score," used by conductors, has all the *staves* laid out on the page in a stratified arrangement, from deepest bass to highest treble. Individual performers use only the *parts*, or single *staves*, that they need. A "closed score" compresses the harmony into two *staves* for easy reading.

sforzando A strong accent, on or off the beat, that in Beethoven often sounds spasmodic but is in fact meticulously timed.

sonata A multimovement work, usually for a solo instrument or

instrumental duet. Expanded further, it becomes a trio, quartet, septet, etc. In full orchestral dimensions, it is called a symphony or (with solo instrument) a *concerto.*

sonata form The shape normally assumed by the first movement of a *sonata* or symphony. (It may be assumed by other movements as well, but rarely by all.) In the hands of an innovator such as Haydn or Beethoven, *sonata form* is capable of astonishing variety, but its architecture is essentially that of the arch. An exposition of contrasting *themes* (joined, like building blocks, by nonthematic mortar) is balanced by a parallel recapitulation. Between these two towering masses is a shorter development section, which subjects the thematic material to various kinds of stress, such as expansion, combination, or fragmentation. Stress merely strengthens the overall design, since the exposition and recapitulation share the same solid tonal foundation. (See *key.*) Yet they differ in one vital respect. The exposition stands on tilted ground, *harmonically* speaking. Its thematic material begins in the *tonic,* but then rises (*modulates*) to the *dominant.* The development, following on, has to reverse this shift, or there will be no feel of a return to "ground level" when the recapitulation arrives in the *tonic.* The *Classical* recapitulation generally stays on that level, by avoiding any further *modulation,* and adding an even more "grounding" *coda.*

staccato A style of delivery in which notes are detached from one another by tiny periods of silence, their relative shortness determined by the speed of the music. Beethoven took elaborate pains to specify the exact length of the interstices between slow staccati.

stave The horizontal bar of five ruled lines on which musical notes

are written. Notes too high or too low for the stave carry their own extra "ledger lines."

Sturm und Drang In German, "storm and stress."

suspension A subsidiary note that wants to *resolve* onto a main note, from either above or below. This resolution is so logical that the main note needs no emphasis. Listen to the prolonged suspension that ends the slow movement of Beethoven's Fourth Piano Concerto.

theme A musical phrase of memorable shape, usually not long enough to rate as a melody, but suitable for development after its initial statement. A theme may itself consist of one or more *motives*.

tonic The home *key* of a musical work, essential to its feel of overall "groundedness." Composers of the eighteenth and most of the nineteenth centuries accepted this fundamental tonality as scientists did Newton's law of gravity. Atonal music had to await the coming of Einstein.

triad The three most harmonious notes (1, 3, 5) of the musical scale, together forming a common chord. Their harmony does not change if they are transposed up or down, but their sound does. The triad 5, 1, 3, held by an orchestra, gives that feeling of incomplete suspense that (in *concertos*) heralds the *cadenza*.

trill A rapid undulation of two neighboring notes. Generally cadential, but transformed by Beethoven into a free device expressive of many musical emotions, from terror to rapture.

tutti In Italian, "all": the full orchestra sounding.

variation Melodic ornamentation, or harmonic restructuring, of a *theme* whose basic shape continues to be felt, even in sequences of great complexity.

Bibliographical Note and Acknowledgments

A LL WRITERS ON Beethoven are indebted to two eminent bi-
ographers, both American, who devoted the better parts of
their lives to *his* life, and who published their books at virtually the
same point in their respective centuries. Alexander Wheelock Thayer
(writing for direct translation into German) completed his majestic,
three-volume *Ludwig van Beethovens Leben* in 1879. Maynard
Solomon (writing in English) put out his *Beethoven* in 1977.

Both books revolutionized Beethoven scholarship, yet both, par-
adoxically, were inadequate. The very extent of their revelations com-
pelled Thayer and Solomon to continue with further research and
writing. Thayer died before republishing his biography in the en-
larged form he dreamed of. Other scholars added to it, and it finally
materialized as the hybrid but indispensable pair of volumes known
as *Thayer's Life of Beethoven,* edited by Elliot Forbes (Princeton Uni-
versity Press, 1967).

Maynard Solomon's biography is available in a revised edition
(Schirmer, 1998), importantly complemented by his *Beethoven Essays*

(Harvard University Press, 1988) and *Late Beethoven: Music, Thought, Imagination* (University of California, 2004).

Since I am unable, given the format of a short biography, to give citations, I must emphasize that hardly a page of this book is free of debt to the above-named gentlemen.

Other essential works of reference (which, however, require an advanced knowledge of music) are Lewis Lockwood's *Beethoven: The Music and the Life* (Norton, 2003) and Joseph Kerman's *The Beethoven Quartets* (Knopf, 1967). The standard English edition of Beethoven's letters is that edited by Emily Anderson in three volumes (Norton, 1961/1985). It has been superseded in German by Sieghard Brandenburg's new edition, *Ludwig van Beethoven: Briefwechsel Gesamtausgabe,* 7 vols. (Henle, Munich, 1996-1998). Beethoven's conversation books are not available in English, except in dated, partial translations marred by the forgeries of Anton Schindler. A definitive German edition has just been completed: *Ludwig van Beethovens Konversationshefte,* Karl-Heinz Köhler et al., eds., 11 vols. (Hesse, Leipzig, 1968-2003).

The following works were also consulted for this biography: Ilse Barea, *Vienna* (Knopf, 1966); David Benjamin, *Beethoven: The Ninth Symphony* (Yale University Press, 2003); Barry Cooper, *The Beethoven Compendium* (Thames and Hudson, 1991) and *Beethoven* (Oxford University Press, 2000); Martin Cooper, *Beethoven: The Last Decade, 1817-1827* (Oxford University Press, 1970); Tia DeNora, *Beethoven and the Construction of Genius: Musical Politics in Vienna, 1792-1803* (University of California Press, 1995); George Grove's evergreen *Beethoven and His Nine Symphonies* (1898, Dover reprint, 1962); Kristin M. Knittel, "From Chaos to History: The Reception of Beethoven's Late String Quartets" (PhD. thesis, Princeton University,

1992); H.C. Robbins Landon, *Haydn: His Life and Music* (Indiana University Press, 1988); Paul Henry Lang, *The Creative World of Beethoven* (New York, 1971); Frederick Noonan, trans., *Remembering Beethoven: The Biographical Notes of Franz Wegeler and Ferdinand Ries* (London, 1987); Charles Rosen, *The Classical Style: Haydn, Mozart, Beethoven* (New York, 1997); Joseph Schmidt-Görg's magnificently illustrated *Ludwig van Beethoven* (Bonn, 1970); Oscar G. Sonneck, *Beethoven: Impressions of Contemporaries* (New York, 1926); and Editha and Richard Sterba, *Beethoven and His Nephew* (New York, 1954). Among countless scholarly articles on Beethoven, one especially evokes Virgil Thomson's phrase, "the honorable word, 'academic.'" It is Warren Kirkendale's classic "New Roads to Old Ideas in Beethoven's *Missa Solemnis*," *Musical Quarterly* 56 (1970).

I hereby express great gratitude to Antony Beaumont, Jesse Cohen, Timothy Mennel, and Sylvia Jukes Morris for critical readings of my manuscript, and to Irene Köller and Alexandra Walsh for research assistance in Austria and Great Britain.

DATE DUE
